VAN GOGH AND BRITAIN PIONEER COLLECTORS

VAN GOGH AND BRITAIN

Martin Bailey

with an essay by Frances Fowle

PIONEER COLLECTORS

National Galleries of Scotland

Edinburgh · 2006

NATIONAL GALLERIES OF SCOTLAND

Published by the Trustees of the National Galleries of Scotland to accompany the exhibition *Van Gogh and Britain: Pioneer Collectors* held at Compton Verney, Warwickshire, from 31 March to 18 June 2006 and at the Dean Gallery, Edinburgh, from 7 July to 24 September 2006.

© Trustees of the National Galleries of Scotland 2006

ISBN 1 903278 77 5 (978 1 903278 77 2)

Designed by Dalrymple
Typeset in Albertina and Magma by Brian Young
Printed in Belgium by Die Keure

Front cover: detail from *A Wheatfield, with Cypresses* (cat.17)
Back cover: detail from *Rain – Auvers* (cat.11)

Compton Verney is a registered charity, no.1032478

Compton Verney House Trust was founded by Sir Peter Moores and is supported by the Peter Moores Foundation.

PETER MOORES FOUNDATION

FOREWORD

Today, Van Gogh is one of the most famous of all artists and his works, on the rare occasions when they come on to the market, can command astounding prices. In his own all too brief lifetime, however, he was little known and his intensely personal paintings and drawings did not sell. Within a few years of his suicide in 1890 the situation had changed dramatically. His work was increasingly influential on the avant garde in Europe and his revealing and fascinating letters fostered the legend of the tormented genius who paid for his art with his sanity. Moreover, enlightened collectors began to acquire his works, often for such modest prices as to make the eyes water!

This exhibition traces the story of the pioneer collectors of Van Gogh in Britain up to the outbreak of the Second World War. The reasons for such collecting were many and varied and the personalities involved ranged from the obscure to those at the very heart of British cultural life. Their histories have been pieced together by our guest curator, the journalist and author Martin Bailey. We offer our thanks to him, to our distinguished Committee of Honour, and to the generous lenders to the exhibition. Both venues have been supported by the Royal Netherlands Embassy, London. Sponsorship for the Edinburgh showing has kindly been provided by Brodies LLP and the catalogue that accompanies the exhibition has been splendidly supported with a generous grant from the International Music and Art Foundation.

The exhibition represents a collaboration between Compton Verney and the National Galleries of Scotland. Many colleagues past and present have worked hard to ensure its success. We would like to thank in particular Janis Adams, Head of Publishing, for overseeing the production of the catalogue; Frances Fowle, Curator of French Art, for her fascinating essay on the Scottish collectors and for coordinating the Edinburgh showing of the exhibition; Richard Gray, formerly Director at Compton Verney, who was involved in the initial negotiations for the show; and Antonia Harrison, Assistant Curator, for organising the loan requests and supervising the installation at Compton Verney. We are also mindful of the support and advice afforded throughout by our colleagues at the Van Gogh Museum in Amsterdam, whose Director, John Leighton, has recently taken up his duties as Director-General of the National Galleries of Scotland.

MICHAEL CLARKE
Director, National Gallery of Scotland

KATHLEEN SORIANO
Director, Compton Verney

SPONSOR'S PREFACE

Brodies LLP is delighted, once again, to continue its sponsorship
of major exhibitions at the National Galleries of Scotland. In 2002, we
sponsored the enormously popular Duane Hanson show, which was
held at the Scottish National Gallery of Modern Art. This exhibition,
Van Gogh and Britain: Pioneer Collectors brings together some of Van
Gogh's most outstanding paintings and drawings, and is the first one-
man exhibition of his work to be held in Scotland for nearly sixty
years. It is also the first show to concentrate on the early collectors in
Britain, a significant number of whom were from Scotland. These
collectors with their avant-garde tastes and an eye for originality and
colour appreciated Van Gogh's revolutionary art long before it was
fashionable to do so. They were indeed pioneers, not only successful
in business but also passionate about their art collections, buying
works they liked and having the courage of their convictions in doing
so. We feel a great affinity with them and are proud to have assisted
the National Galleries of Scotland with this remarkable exhibition,
which we are sure would have had the approval of the collectors.
We hope that you will enjoy the exhibition as much as we have
enjoyed contributing to its success.

JOYCE CULLEN
Chairman, Brodies LLP

AUTHOR'S ACKNOWLEDGEMENTS

I would first like to acknowledge the research of colleagues. In recent years, the most important provenance research on Van Gogh has been done by Swiss specialist Walter Feilchenfeldt, who has concentrated on early German collectors. I would also like to acknowledge the importance of Dr Madeleine Korn's invaluable and detailed investigation of early British collectors of modern foreign art, a subject she first researched for her unpublished PhD thesis (University of Reading, 2001), and her articles in the *Van Gogh Museum Journal 2002* and the *Journal of the History of Collections*. Frances Fowle has written extensively on Scottish collectors, particularly Alexander Reid. She has contributed an illuminating essay to this publication, and has provided invaluable editorial expertise. Teio Meedendorp, Jose ten Berge and Martha Op de Coul have researched Dutch collectors.[1]

Above all, I am grateful for the assistance of my colleagues at the Van Gogh Museum in Amsterdam, who have been unfailingly generous with their time and knowledge – particularly Nienke Bakker, Monique Hageman, Sjraar van Heugten, Leo Jansen, Hans Luijten, Fieke Pabst, Patricia Schuil, Chris Stolwijk, Louis van Tilborgh, Marije Vellekoop and Anita Vriend. Probably no artist is better served by a museum that has such extensive documentation and expertise.

I would also like to record my thanks to all those who assisted my research in various ways. Although I cannot name them all, I should particularly like to acknowledge David Brooks, Ron Dirven, Antony Griffiths, Mary Griffiths, Anne Halpern, Vivien Hamilton, Colin Harrison, Liesbeth Heenk, Cornelia Homburg, Charles Horton, Alice Kadel, Stefan Koldehoff, Margaret Laster, Ulrich Luckhardt, DeCourcy McIntosh, Steven Miller, Henry Travers Newton, Katia Pisvin, Arlette Playoust, Christopher Riopelle, Rosemary Speirs, Thérèse Thomas, Anne Thorold and Jon Whiteley.

Grateful thanks should be expressed to the members of the exhibition's Committee of Honour, all of whom provided great support: Douglas Druick, Walter Feilchenfeldt, John House, John Leighton, Susan Alyson Stein and Richard Thomson.

At Compton Verney I am very grateful to Director Richard Gray and Curator Susan Jenkins, both of whom made important contributions until their departures in 2005, and also to Kathleen Soriano (who took over as Director shortly before the opening of the exhibition). At the National Gallery of Scotland, Director Michael Clarke played the key role, and I would also like to thank Curator of French

Art Frances Fowle and Head of Publishing Janis Adams. I want to particularly single out Antonia Harrison, Assistant Curator at Compton Verney, who organised the loan requests and effectively coordinated the project.

I would like to thank the descendants of many of the collectors; one of the greatest pleasures of the research was making contact with the children or, more frequently, the grandchildren of the early owners. Above all, I am grateful to the lenders, who have enabled us to step back into time and to present the works of the pioneer collectors.

MARTIN BAILEY

COMMITTEE OF HONOUR

Douglas Druick
The Art Institute of Chicago

Walter Feilchenfeldt
Zurich

Professor John House
Courtauld Institute of Art, London

John Leighton
National Galleries of Scotland, formerly
Van Gogh Museum, Amsterdam

Susan Alyson Stein
The Metropolitan Museum of Art, New York

Professor Richard Thomson
University of Edinburgh

Amsterdam, P. & N. de Boer Foundation

Amsterdam, Van Gogh Museum

Boston, Museum of Fine Arts

California, Mrs Frank G. Wangeman

Cardiff, National Museums & Galleries of Wales

Chicago, The Art Institute

Edinburgh, National Gallery of Scotland

Edinburgh, National Library of Scotland

Geneva, Fondation Garengo, Musées d'art et d'histoire de la ville de Genève

Glasgow, Kelvingrove Art Gallery and Museum

London, The British Museum

London, Courtauld Institute of Art Gallery

London, The National Gallery

London, Tate

Manchester, The Whitworth Art Gallery

Melbourne, National Gallery of Victoria

New York, The Metropolitan Museum of Art

Oklahoma, Fred Jones Jr Museum of Art

Oxford, Ashmolean Museum

Oxford, Bodleian Library

Pembrokeshire, Picton Castle Trust

Lord Sandwich

Saint Louis Art Museum

Washington, National Gallery of Art

and private collectors who wish to remain anonymous

'Maniacs or pioneers?' – this was the headline on a newspaper review of the show which introduced Vincent van Gogh to Britain. Commenting on the 1910 *Manet and the Post-Impressionists* exhibition, the *Daily Chronicle* critic Lewis Hind reported on heated exchanges at the opening. Strong views, for and against, were voiced on the Post-Impressionists – 'they are the maniacs of art, or they are pioneers opening new avenues of expression and emotion.' For Hind, Van Gogh represented 'the fiery spirit of revolt'.[1]

At her home near Amsterdam, Hind's article was the first one which Vincent's sister-in-law, Jo (Johanna) van Gogh-Bonger, cut out and pasted in her scrapbook. It was to be followed by dozens of other reviews, mostly mocking, for the London exhibition was seen by many as a source of amusement or even scandal. What was not realised at the time was that the show would add a new term to art history: Post-Impressionism.

The exhibition organiser Roger Fry had decided to begin with Manet, and include the artist's more radical Continental followers. Shortly before the opening Fry discussed possible titles for the show with a journalist friend, suggesting the word 'expressionism'. The writer was unenthusiastic, so Fry casually responded, 'oh, let's just call them Post-Impressionists; at any rate, they came after the Impressionists'.[2] The term stuck, and is now so universal that its London origins are often forgotten.

The accepted wisdom is that the British came late to Van Gogh, and were among the last to appreciate his revolutionary art. Although there is some truth in this, our research has revealed that right from the start there were far-sighted collectors. By 1896, seven (possibly nine) Van Goghs had been acquired by British collectors, although the standard catalogue by De la Faille only records two. A further eight were bought before the outbreak of the First World War in 1914.[3] During the 1920s a considerable number of paintings and drawings came to Britain. By 1939 around ninety Van Goghs had been acquired by British collectors.[4]

Who, then, were the British pioneers? Many had close links with the Continent, and travelled frequently to Amsterdam, Paris or Berlin – cities where Van Gogh's work could be seen at commercial galleries. Not surprisingly, the collectors generally had avant-garde tastes. Among them was a playwright (Alfred Sutro), a publisher (Fisher Unwin), a musician (Victor Schuster), an architect (Frederick

Detail from cat.18

Herrmann) and a fashion designer (Edward Molyneux) – those who would now be described as from the 'creative industries'. Two were important artists (Lucien Pissarro and Matthew Smith). Although the artist Augustus John never bought a Van Gogh, two of his female associates did so on his advice, his mistress Eve Fleming and his friend Elizabeth Carstairs.

One collector was a Member of Parliament (Victor Cazalet), with two others having earlier served as MPs (James Murray and Lord Sandwich). Others were tycoons in fields ranging from mining (Chester Beatty) to rayon (Samuel Courtauld). One was a marmalade producer (William Boyd) and another developed freeze-dried orange juice (William Coolidge). A significant number of collectors were from Scotland, with a particular concentration in Dundee (William Boyd, Matthew Justice, John Tattersall and Royan Middleton).

For the purpose of this catalogue, 'British collectors' is taken to mean British residents, although some had been born abroad.[5] Along with private collectors, we have also included public galleries which acquired Van Goghs. The cut-off date for the show is 1939, the start of the Second World War. By this time the artist's reputation was firmly established, even if prices remained relatively low, at least compared with those of recent decades.

Provenance – the history of ownership of an artwork – is being increasingly recognised as an important aspect of Van Gogh studies. The pattern of acquisitions, together with the display of works in exhibitions, tells the story of the early critical reception of an artist. There is also widespread concern about Van Gogh fakes, and tracking a provenance dating back to the artist's lifetime is important in helping to confirm authenticity. Recent concerns about Nazi-era looting (1933–45) means that it is important to establish a secure provenance.

The starting point for research on Van Gogh provenance is the catalogue by Jacob-Bart de la Faille, initially published in 1928 and then revised in 1939 and 1970. Although the latest edition is a magnificent compendium, it has become rather dated. Information on ownership and exhibitions given in De la Faille is occasionally incorrect, but more often incomplete (paintings and drawings are identified in our catalogue by De la Faille numbers, preceded by 'F' and reference to the Jan Hulsker catalogue are indicated by 'JH'). Our findings, together with sources, are at the end of this publication – and also an alphabetical guide to the collectors.

Research for the exhibition has yielded some important discoveries. The original portrait given by Van Gogh to his friend Alexander Reid, which was always assumed to have been lost, has been identified as a work now in Oklahoma (cat.1). The provenance of another painting was established thanks to writer Stephen Spender spotting it in the home of his homosexual lover in the 1920s (cat.29). A Van Gogh which was sold in a Staffordshire auction for £4 as the work of an anonymous artist is now thought to have been acquired by a farmer in settlement for a debt for grain and straw (fig.14). It has also recently emerged that the Courtauld's *Peach Blossom in the Crau* (cat.26) was earlier owned by the only person known to have bought a Van Gogh during the artist's lifetime, Anna Boch. A 'lost' fake Van Gogh, once exposed in a sensational case in 1928, was tracked down to a castle in Wales (cat.15).

In the course of new researches, much more information emerged about early exhibitions of Van Gogh's work in Britain. It was a surprise to find that individual pictures had been included in eight shows across the country as early as 1911–13 (in London, Leeds, Liverpool, Dublin and Edinburgh), although none of these is recorded in the De la Faille catalogue. Equally astonishing was to find that one of the finest landscapes, *Peach Blossom in the Crau*, had in 1935 been lent to a village hall in Essex, for a Utopian exhibition organised under the slogan 'Art for the People'.

Not all the puzzles have been solved, and one of the intriguing results of the research is to record a number of Van Goghs which went 'missing' in Britain in the early years of the last century. The first drawing sold at auction in the UK, in 1922, *Interior with Woman Spinning*, has not been conclusively identified.[6] Another drawing, *The Thatched Hut* [F875], was owned by Frank Wilson and last exhibited at the Tate in 1926; since then it seems to have disappeared. A third drawing, *The Roofs of Paris and Notre Dame* [F1389] was acquired by the British art historian Victor Rienaecker in 1926, and has also gone missing. There is always a chance that our exhibition might lead to a 'rediscovery'.

Despite the many hundreds of Van Gogh shows held across the world since the artist's death, *Van Gogh and Britain* is the first to concentrate on collecting.[7] The exhibition provides the visual treat of offering thirty of the artist's works (twenty-six at Compton Verney), including twenty-one paintings. All the paintings, bar one, are from his French period, when he was at the height of his powers. They

therefore provide a representative sample of pictures from Van Gogh's finest years, offering a mini-retrospective.

The show also represents the largest exhibition of 'non-family' paintings by Van Gogh ever held in Britain. Van Goghs owned by the artist's family did come to Britain on a number of occasions before they eventually went on display at the Van Gogh Museum in Amsterdam in 1973, but otherwise *Van Gogh and Britain* will be the biggest show in terms of numbers of paintings from outside the family collection.[8]

The pictures on display are a mixture of the familiar (since many hang in our public galleries) and the much less well known. Our gratitude goes to all the lenders, who have so generously parted with their works. We are particularly delighted to be able to show the *Portrait of Alexander Reid* from Oklahoma (cat.1). It has mainly been hidden away in private collections (apart from two brief exhibitions in the 1950s) until its bequest to the Fred Jones Jr Museum of Art at the University of Oklahoma in 2000. We are excited about the prospect of hanging it next to the other portrait of Reid from Glasgow, for the first time since they left Theo van Gogh's apartment in 1887. It is also a privilege to be able to show *Basket of Apples*, the other painting given to Reid, which is on loan from the Saint Louis Art Museum (cat.3).

Another special loan is *Two Crabs* (cat.5), which we have established was bought by William Robinson, when he was the British consul in the Netherlands. It was purchased in 1893, making it one of the earliest Van Goghs to be sold anywhere. *Two Crabs* has always remained in private ownership and, until its auction in 2004 and subsequent loan to the National Gallery in London, it had not been shown in public (other than at short exhibitions in Paris in 1925 and 1960). Among far-flung loans, we are particularly delighted to have *Head of a Man* (cat.32), from the National Gallery of Victoria, in Melbourne, which was once owned by Lieutenant Colonel Victor Cazalet MP. Three other major paintings are coming from American museums, from New York, Boston and Chicago. Public galleries in Britain have also been exceptionally generous.

Finally, our thoughts should turn to the artist, who once worked as a trainee dealer in London – and later dreamt of opening up the British market to Impressionism. In 1888 Vincent wrote from Provence to his brother Theo, who was a dealer in Paris, suggesting that they both think of moving to Britain to sell modern art. 'My dear brother, If I were not broke and crazy with this blasted painting, what a dealer I'd make just for the Impressionists.' He encouraged Theo to head for London, pointing out that 'except for the climate, it is infinitely better than the Congo'.[9] Vincent even felt that one day his own work might sell in London. He once explained to a friend why he signed his paintings with his Christian name: 'Van Gogh is such an impossible name for many foreigners to pronounce; if it should happen that my pictures found their way to France or England, then the name would certainly be murdered, whereas the whole world can pronounce the name Vincent correctly.'[10]

MARTIN BAILEY

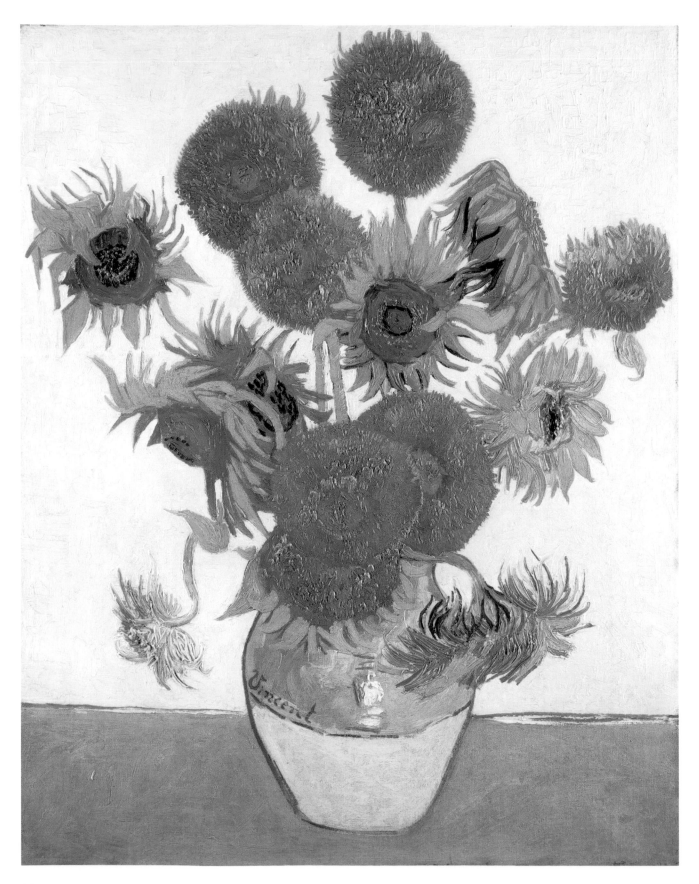

16

THE BRITISH DISCOVER VAN GOGH MARTIN BAILEY

Vincent van Gogh (1853–1890) is an extraordinary figure, whose art and life were inextricably and tragically intertwined. He is seen by many as the archetypal misunderstood, tormented genius. Astonishingly, he was only active as an artist for less than ten years, during which his style changed dramatically from the dark, Realist work of his early Dutch period, via what he learned in Paris from Impressionism, to the highly personal paintings done in Provence and Auvers with their writhing brushwork and powerful colours. In his own day, perhaps unsurprisingly, he remained relatively unacknowledged outside a small circle of friends and admirers, his cause not helped by his difficult and unpredictable character. This exhibition examines the fascinating story of how his work gradually came to be appreciated and collected in Britain – a country in which he had lived from 1873–6, whose language he spoke and wrote, and whose literature he admired.

He is said to have sold only a single painting in his entire life. This has become enshrined as an important part of the Van Gogh legend, although this may not be the whole truth. The failure to sell must have been particularly galling for Van Gogh, because few artists can have had better access to the art market. Two of his uncles were dealers and his brother Theo was manager of a Paris gallery which sold modern art, the branch of Boussod & Valadon (formerly Goupil) in Boulevard Montmartre. Van Gogh had also started work as an art dealer at Goupil in 1869, first in The Hague, then London, and finally in Paris. In 1876 he was sacked, on the grounds that he lacked the suitable temperament for the job. After short spells as a bookdealer and a student, he decided to enter theological college, but failed to graduate. He then moved to the Borinage, a coal-mining area in Belgium, where he preached to the miners, and lived a life of abject poverty. The miners showed little interest in his ministry.

In August 1880 Van Gogh decided to abandon missionary work, to become an artist. 'In spite of everything I shall rise again: I will take up my pencil, which I have forsaken in my great discouragement, and will go on with my drawing. From that moment everything has seemed transformed for me,' he wrote to Theo.[1] At the end of the year he moved to Brussels but, in April 1881 he returned to his parents' home at Etten, where he continued to draw. Relations were difficult with his family, and soon he moved to The Hague, where he stayed for nearly two years, living for much of the time with the former prostitute Sien Hoornik. There he made real progress with his drawing, and took up painting. After a short spell in Drenthe, a remote area in the north of the Netherlands, he returned to his parents, then living in Nuenen.

Fig.1 · *Sunflowers* [F454]
The National Gallery, London

Van Gogh was almost entirely self-taught as an artist. He enrolled at the Antwerp art academy in November 1885, but failed to complete the course. In February 1886 he moved to Paris, where he lived with Theo. There he met many of the avant-garde artists of the day, and this soon had an impact on his own paintings. His palette lightened, moving from the dark tones of the Dutch painters of the period to the brighter colours of the Impressionists. Although Van Gogh briefly studied at the Atelier Cormon, for most of his two years in Paris he worked by himself, making great progress. In February 1888 Van Gogh headed south to Arles, where he produced most of his finest work. Later that year he was joined by the artist Paul Gauguin in the Yellow House, in an idealistic attempt to set up a 'Studio of the South'. Their collaboration was brought to an abrupt end when Van Gogh severed part of his ear, on 23 December. From that point onwards his psychological problems became ever more apparent and in May 1889 he moved to the asylum at St-Rémy, twenty kilometres from Arles. Despite severe bouts of depression and illness, he continued to paint. After a year at St-Rémy he headed north to the village of Auvers-sur-Oise, outside Paris. He worked there for two months, but on 27 July 1890 life proved too much of a burden. In the wheatfields he shot himself, dying two days later. He was thirty-seven years old.[2]

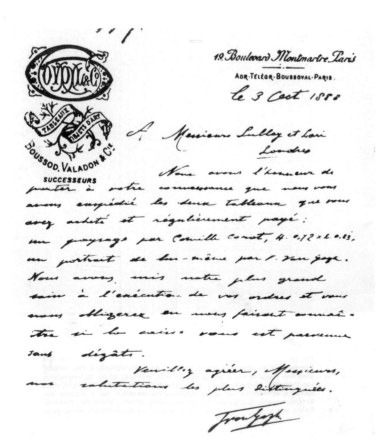

FIRST SALES

Van Gogh's life was dominated by poverty or, at least, fear of poverty. While working as an artist he was entirely financially dependent on allowances sent to him by his brother Theo. The only painting he is said to have sold, *The Red Vineyard* [F495, now in the Pushkin Museum, Moscow], was bought in February 1890 by the Belgian artist Anna Boch. Fascinatingly, it has recently emerged that she also purchased another Van Gogh, which later came to Britain. In May 1891, less than a year after Van Gogh's death, she acquired *Peach Blossom in the Crau*, a magnificent landscape which was eventually bought by the English collector Samuel Courtauld in 1927 (cat.26).[3]

There has also been an intriguing suggestion that Van Gogh may have sold a second painting during his own lifetime – one which came directly to Britain. The evidence is contained in a letter, which his brother Theo sent to a London art dealer (fig.2). Writing on 3 October 1888, Theo explained that he was sending two pictures: a landscape by Camille Corot and 'a self-portrait by V. van Gogh.' A photograph of the letter was reproduced in a relatively obscure Dutch publication by the respected Van Gogh scholar, the late Mark Tralbaut, but unfortunately he never recorded where he had seen it.[4] But is the letter authentic? The handwriting appears to be that of Theo, although it is difficult to be certain from a photograph. However, further evidence has emerged to suggest that the letter may well be genuine. Sent from Paris, it is addressed to 'Sulley et Lori, Londres', and the recipient has recently been identified as the Old Bond Street dealer Lawrie & Co, run by Arthur Sulley and W.D. Lawrie. Theo, who was fluent in French, could easily have transcribed 'Lawrie' as 'Lori'. It has also been established that Lawrie & Co did indeed buy Corot paintings from Goupil.

Assuming the letter is genuine, then the Van Gogh legend needs updating. Vincent sold two paintings during his lifetime – and the first one came to Britain. The question, then, is what happened to the picture, since it cannot be linked with any of the thirty or so surviving self-portraits. Could it now be hidden in an attic somewhere, unrecognised as a Van Gogh?

GIFTS TO FELLOW ARTISTS

The first Van Goghs which undoubtedly came to Britain were gifts to friends. Perhaps the most intriguing of these recipients was Alexander Reid, a Glasgow dealer who worked for Goupil in Paris in 1886–7. He quickly became friends with the Van Gogh brothers, and lodged with them for a few months in their Montmartre apartment. Van Gogh painted portraits of Reid, one of which came to Britain in 1929 and was eventually sold to Glasgow Art Gallery in 1974 (cat.2) and another

which he gave to his Scottish friend. It has always been assumed that the version presented to Reid was lost, and that a further portrait of Reid, now in Oklahoma, was a third painting retained by Van Gogh. However, it has now been established that the Oklahoma portrait (cat.1) was the one presented to Reid, probably in the winter of 1886–7. Van Gogh also gave Reid *Basket of Apples* (cat.3). To Alexander Reid's eternal regret, his father apparently sold the portrait and *Basket of Apples* to a Parisian dealer for £10 in the early 1890s.

A third Van Gogh came to Britain shortly afterwards. Another *Basket of Apples* (fig.3) was presented to the artist Lucien Pissarro, son of the Impressionist Camille Pissarro. Vincent and Lucien had met in Paris in the late spring of 1887 and quickly became friends. In the early autumn Van Gogh dedicated *Basket of Apples* 'à l'ami Lucien Pissaro', misspelling his surname. In return Lucien gave him a group of his own wood engravings, which are now in the Van Gogh Museum in Amsterdam. It was at around this time that Lucien sketched Vincent, probably with his brother Theo (cat.4).[5]

In November 1890 Lucien left Paris to settle in the London area, first at Epping and later at Bedford Park. Evidence has emerged to show that he brought *Basket of Apples* with him to Britain. In 1906 Lucien was short of money and approached his friend, the great Impressionist Claude Monet, asking for a loan of 2,500 francs (£100) and offering to provide the Van Gogh as security. Monet advanced the sum, but insisted that it was unnecessary to send the painting.[6] Later that year Lucien Pissarro sold *Basket of Apples* through a Parisian dealer.

Another of Van Gogh's British friends almost acquired some of his works. The Scottish art student Archibald Hartrick met Van Gogh while he was in Paris in 1887. He later recalled that Vincent had offered him 'a bundle of lithographs by himself of Dutch peasant women working in the fields, and among them a proof of that terrible litho he called *Sorrow* [F1665] done from the woman he lived with in Amsterdam: naked, pregnant and starving.' Hartrick politely declined the gift. In 1891 Hartrick saw four Van Gogh paintings for sale with a small Parisian dealer, probably Père Tanguy, where Vincent had bought paint and stored his canvasses. The pictures were available for two francs each (ten pence). The Scottish artist almost bought a still life of green apples in a basket, but decided not to as he would have had to carry the picture and his hotel was some distance away.[7] It is a curious coincidence that two of the three identified Van Goghs which had come to Britain by 1891 were still lifes of apples and, but for Hartrick's unfortunate decision, there would have been a third.

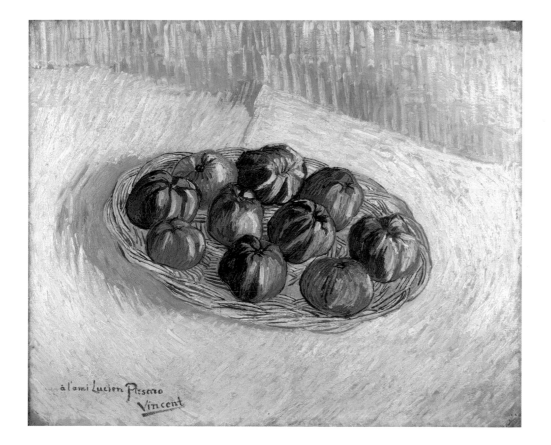

Fig.2 *opposite* · Letter from Theo van Gogh to Sulley & Lawrie, 3 October 1888

Fig.3 *left* · *Basket of Apples* [F378]
Kröller-Müller Museum, Otterlo

Fig.4 *above* · *Bouquet of Flowers* [F236]
Schmit Gallery, Paris

EARLY BRITISH PURCHASES

The first Briton to purchase a Van Gogh was William Robinson, the British consul in Amsterdam, who originally came from Bournemouth. In May 1893 he bought *Two Crabs* (cat.5) from Johanna (Jo) van Gogh-Bonger, Vincent 's sister-in-law, paying 200 guilders (£17). Robinson also owned a Van Gogh drawing, *Peasant in a Cart Coupled to an Old White Horse*.[8] He sold both works in 1906. Although now a forgotten figure, Robinson formed a large collection of nineteenth-century Dutch art which he amassed during his time in Amsterdam.

A few months after Robinson's purchase the London publisher Fisher Unwin visited Paris, in the summer of 1893. Accompanied by the artist Joseph Pennell, they visited Père Tanguy's shop, where Van Gogh had left some of his work. According to Joseph's wife, Elizabeth Pennell, Unwin bought three Van Goghs, although only one of these was described, a flower still life, which cost 24 francs (£1).[9] For years, Van Gogh's flowers hung at the top of the staircase outside the door to Unwin's apartment in the Adelphi, off the Strand. It was publicly exhibited five times between 1909–13, and must have had quite an impact on British art lovers of the period. The still life has not been firmly identified, but the most likely candidate is *Bouquet of Flowers* now in the Schmit Gallery, Paris (fig.4).[10] Unwin still had the painting

in 1916, but probably sold it shortly afterwards. The identity and fate of his two unidentified Van Goghs remains a mystery, but they may have been sold at an earlier time.

The other very early British collectors were the playwright Alfred Sutro and his artist wife Esther, who bought *Interior of a Restaurant* (fig.5). This was acquired in March 1896, while they were living for a short time in Paris. It was bought for 300 francs (£12) from Ambroise Vollard, the dealer who handled work for Jo van Gogh-Bonger, Theo's widow. Alfred Sutro later recalled that he had acquired the painting on the advice of the artist Edouard Vuillard, whose own work at the time comprised mainly interior genre scenes. This may explain why *Interior of a Restaurant* caught Vuillard's eye. The Sutro painting was kept until Esther's death in 1934.[11] Therefore, by 1896 three British collectors had bought Van Gogh works. At some point the London-based Gérard Slot purchased two drawings, *Peasant Digging* (cat.10) and *The Thatched Hut* [F875]. These were both bought from the London branch of Amsterdam's Van Wisselingh Gallery. Slot sold them in 1913, and they were acquired by the London-based Frank Wilson.

In the early twentieth century the Manchester-born Herbert Coleman, whose parents were German, and who worked for the family shipping firm in Britain, Kolp, Coleman & Co, became fasci-

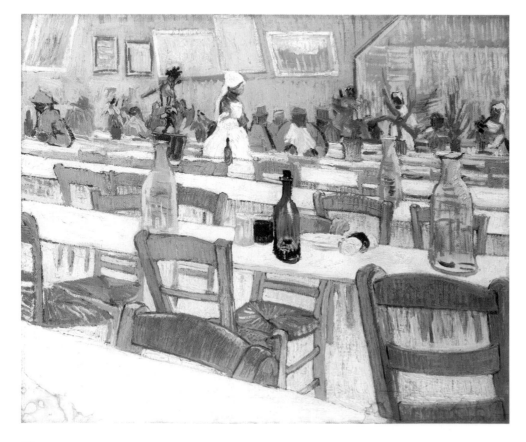

Fig.5 *left · Interior of a Restaurant* [F549]
Private Collection

Fig.6 *right · Stairway at Auvers* [F795]
Saint Louis Art Museum

nated by modern art, and was a friend of Matisse. At some point after 1909 Coleman bought Van Gogh's *Stairway at Auvers* (fig.6), from Parisian dealer Bernheim-Jeune. In May 1914 he put up part of his collection for sale at auction, although the Van Gogh failed to sell. The estimate was 12,300 francs (£492), an indication of how Van Gogh prices had risen by the eve of the First World War. In 1922 *Stairway at Auvers* was seen at Coleman's home by the collector and academic Michael Sadler, who a year later bought five Van Goghs. Sadler described the Coleman painting in a note: 'Over the mantelpiece, a masterpiece of Vincent van Gogh's, brightly coloured, blues, a little red and yellow … Never realised before the affinity between Van Gogh and the decoration of a medieval missal. He is really a modern medievalist.'[12] Coleman kept *Stairway at Auvers* until the early 1930s.

However, the most important early collector, in terms of what he acquired, was Frank Stoop, a Dutch-born stockbroker who had worked in London since the early 1890s. In January 1910 he bought Van Gogh's painting *Farms near Auvers* (cat.6). In January 1911 Stoop was visiting Amsterdam, and the C. M. van Gogh Gallery (established by one of Vincent's uncles) arranged for him to meet Jo van Gogh-Bonger. Subsequently, two oil paintings, two watercolours and seven drawings were sent to Stoop on approval. He returned the paintings

and watercolours, but kept three drawings, for 3,000 guilders (£250).[13] These were *Thatched Roofs* (cat.7), *A Corner of the Garden at St Paul's Hospital at St-Rémy* (cat.8) and *The Oise at Auvers* (cat.9). Stoop amassed an important collection of modern art, including examples by Cézanne, Matisse and Picasso, which he eventually bequeathed to the Tate Gallery in 1933.[14]

GROUND-BREAKING EXHIBITIONS

It was in the early 1900s that Van Gogh's work really began to be discovered by committed British art lovers. The earliest traced reference to his name in an English publication was in the *Burlington Magazine*, a respected publication devoted to art history, which mentioned him twice in 1904. On the second occasion, the name was misspelt as 'von Gogh'.[15] Four years later the first Van Gogh was exhibited in Britain. *Le Tisseur* (*The Weaver*), a watercolour, was shown in January 1908 at the eighth exhibition of the International Society of Sculptors, Painters & Gravers, at London's New Gallery. It was part of a mixed show of over 400 modern works, largely British, and the Van Gogh loan received scant attention. A Van Gogh painting lent by Unwin and possibly one from Sutro were shown at the New Gallery the following year.[16]

The moment when Van Gogh really arrived in Britain was on 8 November 1910, with the opening of *Manet and the Post-Impressionists*, at London's Grafton Galleries. The show, organised by the critic Roger Fry, comprised over 150 works, dominated by Cézanne, Gauguin and Van Gogh, and with good representations of Manet, Matisse, Seurat and Picasso. In the rush to produce the catalogue, Van Gogh's year of birth was wrongly printed in the first edition as 1833 (rather than 1853) and a Gauguin painting, *Le Gardeur d'Oies*, was incorrectly attributed to Van Gogh. The catalogue lists twenty Van Gogh paintings, of which twelve were lent by Jo van Gogh-Bonger, seven came from dealers in Paris and Berlin, and one from a Berlin collector. Other Van Goghs were added shortly before the opening and are unrecorded in the catalogue, including loans from the Berlin museum director and champion of avant-garde art Hugo von Tschudi, and further works from Jo van Gogh-Bonger. These probably pushed up the number of Van Goghs to nearly thirty.[17] Among the paintings were masterpieces which in the late twentieth century would fetch record sums. These included a version of *Sunflowers* (fig.7), which sold for nearly £25 million in 1987, and the *Portrait of Dr Gachet* [F753], which went for £49 million three years later to Tokyo collector Ryoei Saito. To give an idea of 1910 values, the dozen paintings which Jo van Gogh-Bonger

originally sent to the London show were insured for a total of £10,000.[18]

The exhibition was highly controversial, with the shocked British public recoiling from the horrors of modern art and the press whipping up a storm.[19] *Morning Post* critic Robert Ross wrote that 'the emotions of these painters (one of whom, Van Gogh, was a lunatic) are of no interest except to the student of pathology and the specialist in abnormality'. The *Graphic* ran their account under the headline 'Is it art?' H.M. Bateman drew one of his inimitable cartoons in the *Bystander*, which included a parody of a Van Gogh self-portrait with 'a misplaced ear'. The feature in the *Sketch* was headlined: 'Giving amusement to all London: Paintings by Post-Impressionists'. The *Illustrated London News* had a series of cartoon figures, centred around a trio of conversing art lovers who 'explain what to them is unexplainable'. The report in the *Nineteenth Century* journal was entitled 'Post illusionism and the art of the insane'. Desmond MacCarthy, the exhibition secretary, was understandably concerned as to how lenders would react to the press coverage. On 29 November 1910 he wrote to Jo van Gogh-Bonger, 'I am afraid that you must have been disgusted with many of the press notices although there have been quite a number of intelligent ones.' Ten days later he apologised over

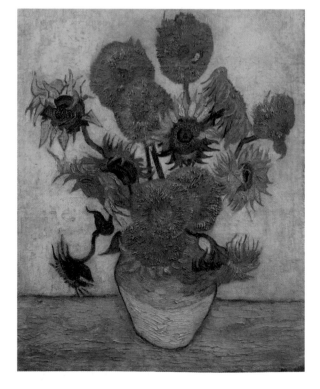

Fig.7 · *Sunflowers* [F457]
Sompo Japan Museum of Art, Tokyo

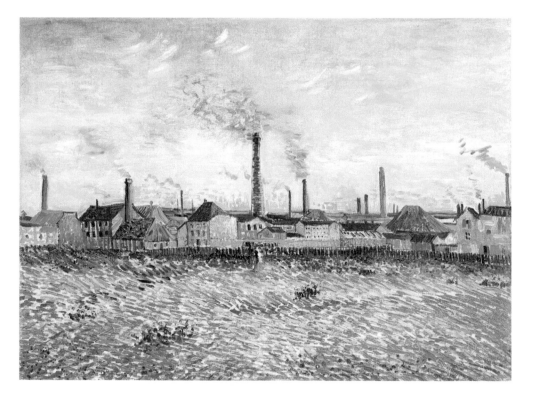

Fig.8 · *Factories at Asnières* [F317]
Saint Louis Art Museum

reviews which concentrated on Van Gogh's illness and alleged madness. 'It is just the vulgar love of sensationalism,' he explained. MacCarthy added: 'The longer I live with these pictures the more certain I become that Van Gogh is the great man of the movement. I admire him so much. He moves me.'[20]

Despite the outbursts, some critics had a more open mind. The writer for the *Star*, Alexander Finberg, admitted that, although initially Post-Impressionism might have looked as if it were the work of 'practical jokers and madmen', it should be taken seriously: 'These pictures at the Grafton Galleries may very possibly be the masterpieces the National Art Collections Fund will be raising subscriptions to purchase and present to the National Gallery in 20 years' time. Future generations may love and honour the names of Cézanne, Gauguin and Van Gogh in the way we now reverence the names of Rembrandt, Titian and Raphael.'[21] Hugh Blaker, the artist and dealer who later encouraged Gwendoline Davies to buy *Rain – Auvers* (cat.11), loved Van Gogh's work, but was even more pessimistic about how long it would take to become acceptable. In a letter to the *Saturday Review*, he predicted that Van Gogh 'will not percolate into official craniums until about the year 2000 when the help of the National Art Collections Fund may be invoked to prevent the few remaining examples from leaving the country.'[22]

At this stage, however, there was no question of Van Gogh entering the portals of a public collection. Three years later, the National Gallery trustee Lord Redesdale wrote a memorandum in which he proclaimed: 'I should as soon expect to hear of a Mormon service being conducted in St Paul's Cathedral as to see an exhibition of the works of the modern French Art-rebels in the sacred precincts of Trafalgar Square.'[23]

At the *Manet and Post-Impressionists* exhibition, only one of the nearly thirty Van Goghs was sold. This sale was only recently identified, from a letter in the Van Gogh Museum archives.[24] *Factories at Asnières* (fig.8) was bought by Gustav Robinow, a German resident of Richmond Hill, Surrey. A year later it passed to Paul Robinow, a major Hamburg collector of modern art and presumably a relative.

After *Manet and the Post-Impressionists*, small numbers of Van Goghs were shown in the United Kingdom up until the outbreak of the First World War in a series of exhibitions, many of which were held outside London. The nine exhibitions were: *Post-Impressionist Painters* at Dublin's United Arts Club (January 1911), *Modern Art* at Liverpool's Liberty Buildings (March 1911), the annual exhibition of the International Society at London's Grafton Galleries (April 1912), the rehang of the *Second Post-Impressionist* show at London's Grafton Galleries (January 1913), the *Post-Impressionist* exhibition at Liverpool's Sandon Studios Society (February 1913), the *Post-Impressionist* exhibition at the Leeds Art Club (June 1913), the *Post-Impressionist and Futurist* exhibition at London's Doré Galleries (October 1913), the annual show of the Society of Scottish Artists in Edinburgh (November 1913), and *French Art 1800–85* at London's Grosvenor House (August 1914).[25]

The first books in English on the artist also began to appear. The earliest was *The Letters of a Post Impressionist, being the familiar Correspondence of Vincent van Gogh*, published in 1912. With an introduction by Anthony Ludovici, it comprised letters translated from the original 1906 German edition. *Personal Recollections of Vincent van Gogh*, with memories by the artist's sister Elizabeth (Lies) du Quesne, was translated into English in 1913.

At this point, on the eve of the First World War, by far the largest numbers of Van Goghs were not in Britain, but in collections in the Netherlands, Germany and France. Beyond these three countries, there were twelve Van Gogh paintings in Switzerland, eight each in Austria and Russia, and four each in America and Scandinavia.[26] Although seven paintings had come to Britain, three had already left, leaving the four owned by Unwin, Sutro, Stoop and Coleman. There were also five drawings, three belonging to Stoop and two to Wilson.[27]

THE TWENTIES

Understandably, the First World War interrupted British interest in Van Gogh and it was not until the early 1920s that the collecting of his work really took off in Britain. Among the first post-war purchases was *Rain – Auvers* (cat.11), which was acquired in 1920 for 100,000 francs (£1,900). The buyer was Gwendoline Davies, who along with her sister Margaret had quickly amassed the finest collection of modern French pictures in Britain (Samuel Courtauld soon took over that position in the mid-1920s). The Davies sisters were an extraordinary duo, turning their rural Welsh home at Gregynog Hall into what was effectively an arts centre, with studios, printing press, pottery and music facilities. They bequeathed their collection, which included major works by Millet, Monet and Renoir, to the National Museum of Wales in Cardiff in 1952 and 1963.[28]

As discussed in Frances Fowle's essay, Scotland soon became a centre of Van Gogh collecting. It was Alexander Reid who had formed an early link with the Van Gogh brothers and who eventually, in 1921, made his first sale of a Van Gogh painting, more than three decades after the death of the artist. *Le Moulin de Blûte-fin, Montmartre* (fig.15) was sold to the Glasgow collector William McInnes. A new group of Van Gogh collectors was also emerging in Dundee. The furniture retailer Matthew Justice acquired *Bouquet of Flowers* (fig.4) by 1924, and this may have been the still life which Unwin had bought in Paris in 1893.[29]

He also bought *Orchard in Blossom* (cat.14). William Boyd, owner of James Keiller & Son in Dundee, bought three Van Goghs in the 1920s, all of which came from Continental dealers. These were *Field with Ploughman* (cat.13) and *Orchard in Blossom* (cat.14), both from the Bernheim-Jeune Gallery in Paris, and *Trees* (fig.22), from the Paul Vallotton Gallery in Lausanne, owned by the brother of artist Félix Vallotton. In addition, John Tattersall, a minor art dealer, bought Van Gogh's *View of a River with Rowing Boats* (cat.12), probably in 1925, from London's Independent Gallery. In 1935 he sold the painting and it went to a fellow Dundee collector, Royan Middleton.

Van Goghs now began to appear regularly for sale at London galleries, so British collectors no longer had to buy from European dealers. Although one painting had sold at *Manet and the Post-Impressionists* in 1910, after this the next commercial gallery to show a Van Gogh was Goupil, in 1920.[30] By coincidence, this was the same gallery at which Vincent had worked in London in 1873–5. Forty-five years after his dismissal, the firm began to handle the occasional work of their now famous ex-employee.

In 1923 Alexander Reid, in collaboration with Ernest Lefevre, began to offer Van Goghs for sale in London. In June, their London show included two works, although neither sold.[31] Sales went better at a subsequent exhibition, in October, which included three Van Goghs. Two were bought by Elizabeth Workman: *Bridge at Trinquetaille* [F426] and *The Hospital at Arles* (fig.21). The third, *Oleanders* (cat.18), was originally bought by Michael Sadler, but he later sold it back to the gallery and it then also went to Elizabeth Workman, who was the wife of wealthy shipbroker Robert Workman. The Workmans assembled an important (but now largely forgotten) collection of Impressionist and Post-Impressionist art.

The first Van Gogh work acquired by a British public collection was the etched *Portrait of Dr Gachet* (cat.16), which went to the British Museum in July 1923. It was presented by Paul Gachet, son of Dr Paul Gachet, the friend who had cared for Van Gogh in Auvers. Efforts were also made to buy some drawings from Jo van Gogh-Bonger. In October 1923 the museum's keeper of prints and drawings, Campbell Dodgson, wrote to her, saying that he wanted Van Gogh to be properly represented. He pointed out that he had been 'looking out for an opportunity of securing drawings, but those offered … by dealers have not been good enough, and moreover much too dear … Our grant for purchases is not at all large.'[32] Although Dodgson was presumably hoping for an attractive offer, it never materialised.

Fig.9 · Portrait of Joseph Roulin [F436]
Museum of Modern Art, New York

ONE-MAN SHOW

Van Gogh's first one-man show opened at London's Leicester Galleries at the beginning of December 1923. The gallery's owner Oliver Brown later recalled how it came about. A friend, Mr Simmons, of the theatrical costumiers B.J. Simmons, had been on holiday in the Netherlands and had visited Jo van Gogh-Bonger. Mr Simmons asked her why Van Gogh's work had not been shown in depth in Britain. 'Nobody has ever asked me,' she replied. Brown then met Jo's son Vincent Willem in Amsterdam and viewed the collection. 'The walls in every room were crowded with his famous uncle's pictures … Even in the bathroom upstairs I noticed several canvases propped between the bath and the wall.'[33] The Leicester Galleries showed forty works – twenty-eight paintings and twelve drawings, more than had been included in the first Post-Impressionist show in 1910. All were from Jo van Gogh-Bonger, except for *Restaurant at Arles* [F549], lent by the Sutros. Press reviews were mixed, although noticeably more positive than in 1910. Three drawings and five paintings were sold, a reasonable result.[34] Prices ranged from £91 for the drawing *Orchard* [F1516] to £1,363 for the masterpiece, *Sunflowers* (fig.1).

Michael Sadler, Master of University College, Oxford, wrote the introduction to the Leicester Galleries catalogue, praising Van Gogh

as 'one of the three master painters whose work has had a seminal power in recent European art', alongside Cézanne and Gauguin. He went on to compare their influence in art to that of Karl Marx and John Ruskin in economics.[35] Sadler owned a fine collection of modern art, including works by Gauguin. He bought the only three Van Gogh drawings which sold at the 1923 show – *Orchard near Arles* [F1516], *Cypresses* [F1525] and *Olive Trees with the Alpilles* [F1544]. He also purchased the painting *Olive Trees* (cat.19). The previous month, he had bought *Oleanders* (cat.18) which had been shown at a Lefevre exhibition and originally purchased by Workman. This meant Sadler had acquired five works, in as many weeks, overtaking Stoop as the major British collector of Van Gogh. He was keen to share his enthusiasm, and in May 1924 he organised a Van Gogh exhibition at the Oxford Arts Club, an important event not previously recorded in the literature. It comprised eleven Van Goghs lent by British collectors, with all his own works along with those of Stoop, Coleman and Murray.[36]

Another buyer at the 1923 exhibition at the Leicester Galleries was recorded in the De la Faille catalogue as 'Mrs Flemming', who acquired *Head of a Peasant Woman* (cat.21). She can be identified as Evelyn Fleming, then the mistress of the artist Augustus John. The final private purchaser was Elizabeth Carstairs, wife of the dealer Charles Carstairs of the Knoedler Gallery, who bought *Terrace and Observation Deck at the Moulin de Blûte-fin, Montmartre* (cat.20). According to Brown, this latter purchase was made 'on the advice of Augustus John'.[37] John therefore played a crucial role in encouraging interest in Van Gogh.

VAN GOGH GOES TO MILLBANK

It was in 1923 that Van Gogh's paintings finally entered the Tate (at this time it was still known as the National Gallery, Millbank). The gallery at Millbank, opened in 1897 with money from Sir Henry Tate, had originally been set up to collect British art, but in 1917 its mandate was extended to include modern foreign art. The first Van Gogh that had been considered was *Garden Court, Arles*, which was offered in November 1922 by the Lefevre Gallery, priced at £2,625, but it was turned down.[38] Although not previously identified, this was almost certainly *Courtyard of the Hospital at Arles* [F519, now in the Oskar Reinhart Collection in Winterthur, Switzerland].

Although Charles Aitken, the Millbank director, was lukewarm about Post-Impressionism, his young assistant, H. Stanley (Jim) Ede, more than made up for this with his personal enthusiasm. In October 1923 Ede visited Amsterdam and had tea with Jo van Gogh-Bonger. He left full of excitement, thanking her a few hours later in a letter written from his hotel: 'My heart is full of things which I came to Holland to see. In England I could only read of Van Gogh & so I saved my money

& had three days in Holland where I knew I should learn much … I shall do all I can to get those pictures for the National Gallery.'[39] On his return to London, Ede wrote again to Jo van Gogh-Bonger, with an idea: 'I have been fantastically wondering how I could arrange to buy the Books [*Parisian Novels*, F358] & finally give it to the National Gallery, but as I have only 3300 gulden [£275] a year & a wife & child to keep I have put it by as an absurd dream!'[40] Nothing ever came of Ede's suggestions.

It was the vastly greater wealth of Samuel Courtauld, whose name is irrevocably associated with the art-history institute he founded in London, that successfully brought Van Gogh's paintings into the national collection. His fortune came from Courtaulds Ltd, then the world's largest manufacturer of rayon textiles. In June 1923 he had offered an extremely generous donation of £50,000 to set up a fund to buy Impressionist and Post-Impressionist pictures for the Millbank gallery. 'In my own mind the central men of the movement are Monet, Renoir, Degas, Cézanne, Monet, Van Gogh and Gauguin,' he wrote.[41] Along with Courtauld, the other trustees of his fund were Charles Aitken (Millbank director), Charles Holmes (director of the main National Gallery), Lord Henry Bentinck (Millbank trustee) and Sadler. The fund would eventually buy twenty-three pictures, including four Van Goghs.

The first Van Gogh bought with the fund was *A Wheatfield, with Cypresses* (cat.17), which was acquired in October 1923 from the Independent Gallery, run by Percy Moore Turner, one of Courtauld's close advisers.[42] The price was £3,300. Just a month later there was a unique opportunity to view Van Gogh's work in London, at the Leicester Galleries, and the Courtauld Fund trustees were offered first choice from the exhibits, four days before the opening.[43]

Two Van Gogh acquisitions were immediately made with money from the Courtauld Fund: *Portrait of Joseph Roulin* for £909 (fig.9) and *Van Gogh's Chair* for £696 (fig.10). It is now almost forgotten that the Millbank gallery once owned the magnificent portrait of the Arles postman Joseph Roulin. Although it was formally acquired and illustrated in the press, under the terms of the Courtauld Fund works could be sold, and it was quickly decided to trade it in for an even more powerful work. Within a month of the December 1923 acquisition of the Roulin portrait, Courtauld was having second thoughts about the painting on the grounds of 'there being other versions and the background not being entirely satisfactory'.[44] Ede later recalled that the Courtauld Fund trustees felt the postman's beard was 'too funny'.[45] The Roulin portrait was therefore returned, and in February 1924 it was sold to the Lucerne dealer Thannhauser. After a long period in a private Swiss collection, the painting was acquired in 1989

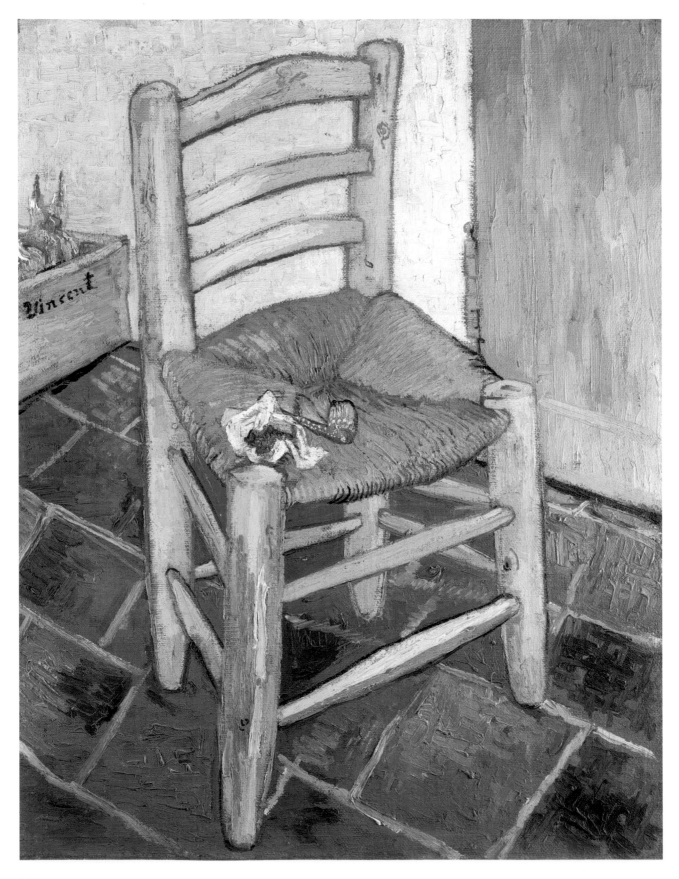

Fig.10 *left*
Van Gogh's Chair [F498]
The National Gallery, London

Fig.11 *opposite*
Self-portrait [F320]
Musée d'Orsay, Paris

26

by New York's Museum of Modern Art, with press reports suggesting it might have been valued at around £17 million.[46]

When the *Portrait of Joseph Roulin* was returned, the Millbank gallery attempted to acquire *Sunflowers* which was also in the Leicester Galleries show (fig.1). This request was initially rejected. Then on 24 January 1924 Jo van Gogh-Bonger wrote an emotional letter, in her slightly stilted English: 'For two days I have tried to harden my heart against your appeal; I felt as if I could not bear to separate from the picture, I had looked on every day for more than thirty years. But at the end the appeal proved irresistible. I know, that no picture would represent Vincent in your famous Gallery in a more worthy manner than the "Sunflowers" and that he himself, le Peintre des Tournesols, would have liked it to be there … It is a sacrifice for the sake of Vincent's glory.'[47] The £909 paid for the Roulin portrait was set against the £1,308 owed for *Sunflowers*. Today *Sunflowers* is Van Gogh's most iconic image, and the National Gallery painting is arguably the finest of the several versions of this composition.

Documents in the Tate archive also reveal that there was nearly another sell-off after the Roulin portrait. According to a note of 26 March 1926, Courtauld telephoned Ede to say he thought 'we ought not to have too many Van Goghs' and he was reluctant to proceed with the acquisition of *Long Grass with Butterflies* (cat.22) 'unless we will part with the Chair'. Courtauld added that he knew a buyer who would 'pay a profit' on the £696 spent on *Van Gogh's Chair*.[48] Ede's note suggests that the prospective buyer may have been the art historian Victor Rienaecker, a Corot specialist. Later that year Rienaecker purchased a Van Gogh drawing for his private collection, *The Roofs of Paris and Notre Dame* [F1389]. In the end, *Van Gogh's Chair* was not sold and the Millbank gallery did proceed with the purchase of a fourth Van Gogh. *Long Grass with Butterflies* was bought at the end of March 1926 for £2,100 (cat.22).

New research suggests that the Millbank gallery had also wanted the 1887 self-portrait which was in the 1923 Leicester Galleries exhibition (fig.11). The price was £1,091 and the gallery sought funding from an unnamed 'American lady'.[49] She never made a donation, and after passing through a French collection, the self-portrait was acquired by the Louvre in 1947 and is now in the Musée d'Orsay.

Among the works rejected from the Leicester Galleries show was *Wheatfield with Crows* [F779], often assumed to be Van Gogh's final painting, which the Millbank director Aitken dismissed with the words 'sky unsatisfactory'. He also criticised as 'dull' the *Head of a Peasant Woman* (cat.21), a fine Nuenen work eventually acquired by the National Gallery of Scotland.[50] At this point there was little British interest in Van Gogh's earlier Dutch paintings, and nearly all the works bought by the early British collectors were from his French period (1886–90). Nevertheless, as a result of the Courtauld Fund money, the Tate succeeded in acquiring four major works by Van Gogh. Immediately after the 1923 Leicester Galleries exhibition, the Millbank gallery organised a small Van Gogh display. Running from January to May 1924, it comprised the new acquisitions, plus three short-term loans from Jo van Gogh-Bonger's works which had been at the Leicester Galleries – *Vincent's House in Arles* [F464, now in the Van Gogh Museum, Amsterdam], *Vincent's Bedroom in Arles* [F482, now in the Van Gogh Museum, Amsterdam] and the self-portrait (fig.11). Two years later, the permanent acquisitions were moved to more suitable galleries. There had been limited space at Millbank for foreign art, and Sir Joseph Duveen funded an expansion project, with a new wing. This opened in June 1926, and was celebrated with a loan exhibition of modern art, which included five Van Goghs lent by British collectors – Coleman [F795], Sutro [F549], Workman [F593], Wilson [F875] and Murray [F325, later to be dismissed as a fake]. The gallery was renamed the Tate in 1934.

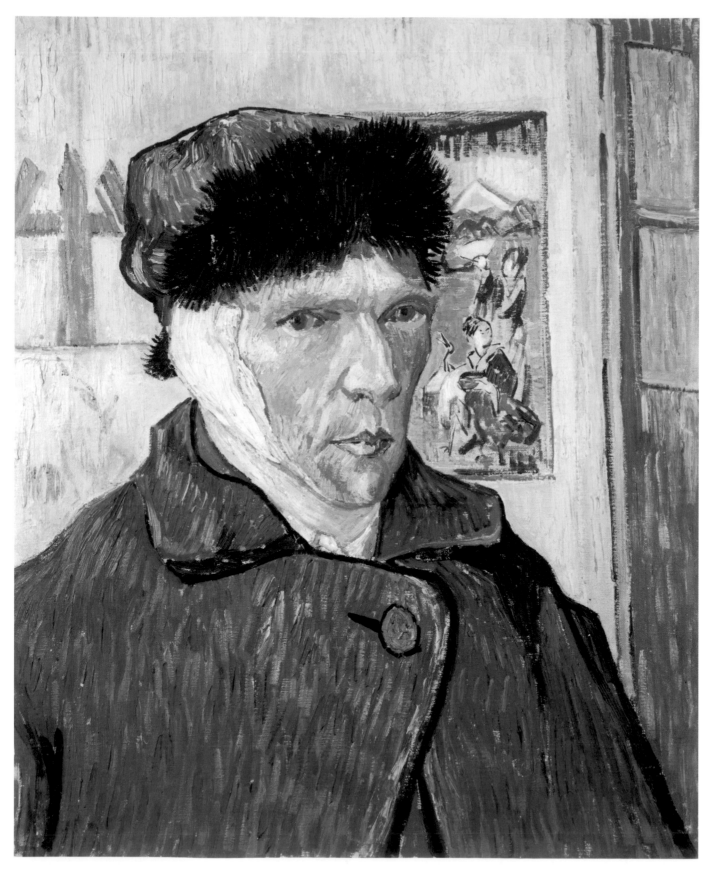

Fig.12
*Self-portrait with
a Bandaged Ear*
[F527]
The Samuel Courtauld
Trust, Courtauld Institute
of Art Gallery, London

Meanwhile, Samuel Courtauld was building up his own personal collection of Impressionists and Post-Impressionists. In May 1924 he visited Jo van Gogh-Bonger in Amsterdam, although it was not until three years later that he bought his own Van Gogh, acquiring the drawing *Tile Factory* (cat.27) and the painting of *Peach Blossom in the Crau* (cat.26). The following year he paid £10,000 for *Self-portrait with a Bandaged Ear* (fig.12), from the Rosenberg Gallery in Paris. Ownership of Courtauld's celebrated paintings and drawings was subsequently transferred to the Courtauld Institute trusts in 1932 and 1948. A public gallery was opened in 1958, initially in Woburn Square, and then at Somerset House in 1990.

Thanks to the success of the 1923 exhibition, the Leicester Galleries decided to hold a second one-man show in November 1926. This comprised forty-eight paintings and drawings (five more than in the published catalogue). The gallery's owner Oliver Brown was pleased with the public reaction, writing to V.W. van Gogh on 16 December 1926: 'Opinion has changed a great deal in London during the last three years, and everyone admires the Van Goghs with enthusiasm, whereas on the former occasion, they were either puzzled or hostile.'[51] Financially the second show proved a success, and sixteen works were sold, including a few to foreign buyers. The first fourteen works brought in a total of 57,500 guilders (£4,792) for the Van Gogh family.[52] Two works on paper entered the collection of the Whitworth Art Gallery, at the University of Manchester, the first public acquisitions by a gallery outside London. The drawing *Hayricks* (cat.24) was bought directly by the Whitworth and the watercolour *The Fortifications of Paris with Houses* (cat.23) was donated by a trustee, Sir Thomas Barlow, whose wealth came from the textile industry.[53] Other works at the show went to private collectors, including Courtauld, the Earl of Sandwich, Charles Beechman, Birger Jonzen and the Beattys.

Chester and Edith Beatty would later emerge as the most important Van Gogh collectors by the 1930s. The American-born mining tycoon, with business interests in southern Africa, had moved to London after the First World War, eventually becoming a British subject in 1933. The couple lived in Baroda House in Kensington Palace Gardens, one of London's grandest residences. Both collected, and in 1928 Chester gave his wife £100,000 to buy paintings. This was a huge sum, twice that which Courtauld had given to the Millbank gallery and which had resulted in twenty-one acquisitions. Edith Beatty acquired the couple's first four Van Goghs. *Sheaves of Wheat* [F771] probably from the 1926 Leicester Galleries exhibition, followed over the next nine years by *Portrait of Patience Escalier* (fig.15), *Sunflowers*

(fig.7) and *Trunk of a Yew* [F573]. Chester Beatty bought *Rocks with Oak Tree* [F466] in 1936. However, *Sunflowers* was the most important purchase, representing a similar composition to that already in the Millbank gallery. In November 1910 the painting had been bought by Berlin collector Paul von Mendelssohn-Bartholdy, who that month lent it to the Post-Impressionist show in London. He kept it until 1934, when it was acquired by the Paris dealer Paul Rosenberg, who then sold it to Edith Beatty. She insured it for £10,200, presumably reflecting the price she had paid.[54] *Sunflowers* hung in the second drawing room of Baroda House, above a sofa (fig.13). It was later displayed in another of the Beatty properties, 19 Eldon Road, Kensington; after the Beattys sold the house it was to become the home of the art critic Brian Sewell. *Sunflowers* was also lent to the National Gallery in 1956–9 and 1983–7, where on the second occasion it hung with the gallery's own version (fig.1), which had come from Millbank. In 1987 *Sunflowers* was sold by the estate of Helen Beatty, the daughter-in-law of Chester and Edith. It fetched £24,750,000, then the highest price for a work of art sold at auction, when it was acquired by the Japanese insurance company, Yasuda (now Sompo).

Another notable collector from this period was the artist Sir Matthew Smith, who acquired *Cottage* [F92] in the late 1930s. He bought it for £160 from the Reid & Lefevre Gallery with the proceeds of the sale of one of his own paintings. Smith kept the Van Gogh in his modest flat at Chelsea Cloisters in Sloane Avenue, where it hung unframed above the bed. Smith's own paintings were strongly influenced by the Post-Impressionists, above all Van Gogh. Smith had long been a great admirer of the Dutch artist. In 1928, after being given Van Gogh's published letters, he responded: 'To me it is an inspired book and a Bible … If any modern should be canonised as a saint I think that Vincent should be one of the very first on the list.'[55] Smith visited Arles in 1930 and 1932, to see where Van Gogh had painted. In 1949 Smith and the sculptor Henry Moore, who were friends, had a £5 bet on whether a painting by Van Gogh or Gauguin would fetch the higher sum in three years' time. Smith put his money on Gauguin, despite his enthusiasm for Van Gogh, and it was indeed a Gauguin which sold for a record sum, so Moore paid up.[56] In the 1950s, on a further visit to the south of France, he made several sketches based on Van Gogh's *Sunflowers*, as a homage. On his death in 1959, Smith left *Cottage* to his model and companion, Mary Keene.

An intriguing story surrounds another Van Gogh which came to Britain in the early years. It depicts a similar Nuenen scene to Smith's picture, and both were painted in June-July 1885. *Cottage in Brabant* (fig.14) emerged in 1969, in the possession of Dr Luigi Grosso, an Italian journalist working for the BBC in London. He had bought the

picture in September 1968 from a Hampstead antique shop for £45, unrecognised as a Van Gogh. The Van Gogh world is plagued by people who claim to have discovered an unknown work, and it is very rare for a genuine painting to turn up – something that now occurs perhaps once in a decade. In this case, however, the work was eventually authenticated. *Cottage in Brabant* had been sold earlier in 1968 in a farm auction, for just £4. The sale, at Billington Farm, just outside Stafford, was organised by Bagshaws of Uttoxeter, with most of the lots consisting of agricultural equipment, which was being sold on the retirement of farmer Charles Holme. Further research now suggests that the painting had been inherited from Charles' father John, who died in 1952, and for many years it hung in the room used as a nursery. John Holme, also a farmer, is said to have received the picture in the late 1920s in settlement of a debt for grain and straw. The previous owner was apparently a doctor from the Rowley Park area of Stafford, a few miles away, who owed money for supplies for his horse. Assuming that family tradition is correct, *Cottage in Brabant* presumably reached Stafford fairly early in the twentieth century, and the identity of the artist was at some point lost.[57] Since its rediscovery, the painting has passed through five auctions, selling most recently in 2001, when it fetched £1,165,000.

INTO THE PUBLIC REALM

Rising prices and the wind-up of the Courtauld Fund in 1927 made it much more difficult for British public collections to acquire further Van Goghs. *Oleanders* (cat.18), which had been owned by Sadler and then Workman, was in 1928 offered for sale by the Reid & Lefevre Gallery to the Millbank gallery.[58] It is not recorded why the acquisition was not pursued. The following year, the British Museum acquired a second Van Gogh print, the lithograph of *Gardener by an Apple Tree* (cat.28), donated by Henry Van den Bergh, who purchased it for £25 and immediately presented it through the National Art Collections Fund.

In 1930, during a third Van Gogh exhibition at the Leicester Galleries, the Millbank gallery was interested in acquiring *Cypresses* [F621] or, if this was not available, *Arles, with Irises in the Foreground* [F409], both from the Van Gogh family collection and now in the Van Gogh Museum, Amsterdam. An unnamed 'well-known benefactor' was willing to put up the money for the acquisition, but none of the works at the Leicester Galleries were for sale and V.W. van Gogh was unwilling to make an exception.[59] In 1933 the Millbank gallery, then renamed the Tate and under the directorship of James Manson, received the generous bequest of seventeen modern works from

Fig.13 *left*
Photograph of Beatty room with *Sunflowers* on the wall, Chester Beatty Library, Dublin

Fig.14 *right*
Cottage in Brabant [F1669]
Private Collection

Stoop, who had died earlier that year. These included Van Gogh's painting *Farms near Auvers* (cat.6) and his three drawings, *Thatched Roofs* (cat.7), *A Corner of the Garden at St Paul's Hospital, St-Rémy* (cat.8) and *The Oise at Auvers* (cat.9).

The following year the Tate considered the purchase of *Portrait of Joseph Roulin* [F433], a different version of the 'postman' which had been returned in 1924. The Tate applied to the National Art Collections Fund for a grant, but it was turned down on the grounds that the £3,850 price was too high and £1,500 would be a more reasonable sum.[60] The portrait is now at the Detroit Institute of Arts. A proposed bequest from Charles Wakefield-Mori, the British-born curator of the Monte Carlo Museum, was considered in 1936, and it appears to have included a Van Gogh, although ultimately the collection never came to London and the painting remains untraced.[61]

Meanwhile, Scottish public galleries were trying to acquire their first Van Goghs. In Edinburgh, the National Gallery of Scotland bought *Olive Trees* (cat.19) for £1,600 in 1934. That same year Glasgow Art Gallery considered buying the *Portrait of Patience Escalier* (fig.15), for around £10,000, but it went to Edith Beatty.[62] The Glasgow gallery was also offered an opportunity to buy the *Portrait of Alexander Reid* (cat.2) owned by McNeill Reid, but decided against the purchase.

There were several major exhibitions in Britain at which it was possible to discover Van Gogh's work, following the major one-man shows at the Leicester Galleries in 1923 and 1926. The Royal Academy's large survey exhibition *Dutch Art 1450–1900* in January 1929 included nineteen Van Gogh paintings, a sign of his growing recognition. In May 1930 the Leicester Galleries held its third Van Gogh exhibition, with thirty-one paintings from the family collection, none of which was for sale. There was a large retrospective at Manchester Art Gallery in October 1932, the first major show outside London. This comprised seventy-nine works (forty-five paintings and thirty-four drawings), making it the most important Van Gogh exhibition to have been held in Britain. All the loans came from V.W. van Gogh's collection in the Netherlands, except for the *Portrait of Alexander Reid* (cat.2) and the Tate's *Van Gogh's Chair* (fig.10).[63] Individual works also appeared regularly from the mid 1920s at a number of London dealers, particularly at Reid & Lefevre and the Leicester Galleries, and to a lesser extent at Arthur Tooth and Wildenstein's London branch.

An increasing number of publications on Van Gogh came out in English. The most important works were the artist's correspondence: the two-volume *Letters of Vincent van Gogh to his Brother* published in 1927, the *Further Letters of Vincent van Gogh* published in 1929, *Letters to an*

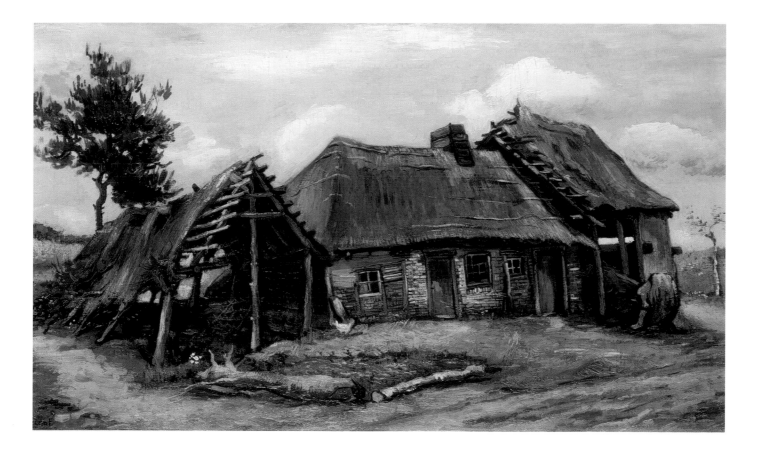

Artist: From Vincent van Gogh to Anton Ridder van Rappard published in 1936 and *Vincent van Gogh Letters to Emile Bernard* published in 1938. There were also foreign language biographies translated into English by Julius Meier-Graefe (1922), Louis Piérard (1925), Paul Colin (1926) and Walter Pach (1936). In popular terms, the most influential book was undoubtedly the fictionalised account *Lust for Life*, by American writer Irving Stone, first published in Britain in 1934.

FAKES

Van Gogh's oeuvre has been plagued by fakes, a problem which began to emerge as soon as prices started to rise in the early 1900s. *Still Life with Daisies and Poppies* (cat.15), had been bought by 1923 by Sir James Murray, an Aberdeen-based businessman. It was sold with a large part of his collection in 1927, when it became the first Van Gogh painting to be auctioned in Britain, fetching 1200 guineas (£1,260) at Christie's, shortly before it was exposed as a fake.[64] The buyer was Sir Laurence Philipps, who later became Lord Milford. It soon emerged that the painting had earlier come from the Otto Wacker Gallery in Berlin. In 1928 Wacker was unmasked for having sold more than thirty fake Van Goghs.

A second Wacker fake was owned by a British collector, Sir Robert Abdy, who lived in London and Paris. He had acquired a self-portrait [F521] from the Hugo Perls Gallery in Berlin and had already sold it to the Thannhauser Gallery in Munich by 1927, shortly before it was exposed in the Wacker scandal. Another early fake, although not one handled by Wacker, belonged to the lawyer Julian Lousada – whose son Anthony would many years later serve as chairman of the Tate Gallery, in 1967–9. By 1928 Julian Lousada owned *Still Life with Book, Bowl and Candle*, prominently signed 'Vincent', but not authentic.[65]

GERMANY AND THE RISE OF FASCISM

In the very early years of the twentieth century it had been the Germans who had been the most enthusiastic collectors of Van Gogh. But the impact of the First World War and subsequent economic problems led to sales, particularly to Swiss and American buyers. Many of the German collectors were Jewish, and some of these fled abroad after 1933 when Hitler became Chancellor. As a result of this exodus, quite a number of Van Goghs came to Britain during the 1930s. The distinguished Berlin artist Curt Herrmann owned two Van Goghs, *A Group of Houses* [F794] and *Field with Green Wheat* [F807]. He died in 1929, and the works passed to his son Frederick, an architect, who brought both paintings to London when he fled Germany in 1937. *Restaurant de la Sirène at Asnières* (cat.29) had been owned by Valerie Alport, an amateur artist from Hamburg, who took the picture to

Oxford when she escaped with her son Erich in 1937. The painting *Orchard in Blossom* [F406] was taken out of Germany by Albert and Marie Stern, although it may not have reached Marie and her daughter Eva in Manchester until immediately after the war. Dr W. Regendanz owned a Van Gogh watercolour, *Ramparts of Paris* [F1402], which came when he moved from Berlin to Wales. Another work came to Britain after the Anschluss, the German take-over of Austria in 1938. Later that year the Viennese dealer and collector Lea Bondi-Jaray fled to London, bringing with her the drawing *Backyard with Two Figures* [F939a]. In another case an important Van Gogh drawing was auctioned in a forced sale in Berlin in 1935, but subsequently restituted to an owner in Britain, more than sixty years later. *Olive Trees with the Alpilles* [F1544], once owned by Sadler, was returned in 1999 to Leicester-based Greta Silberberg, daughter-in-law of the original Breslau owner. It was then sold and has now been promised to New York's Museum of Modern Art.

At the same time that collectors were fleeing this oppression, Van Gogh's work was increasingly viewed as 'degenerate' by the Nazi authorities, and a number of paintings were sold off by German museums.[66] Despite early German enthusiasm for Van Gogh's work, there are today only fourteen paintings in its public galleries, compared with sixteen in Britain.

BALANCE SHEET

The best comparative data on the location of Van Gogh's works comes from the three editions of the De la Faille catalogue. The first, in 1928, recorded eleven paintings and thirteen drawings in British private and public collections (excluding those owned by dealers), a total of twenty-four works. Our research has shown that the number was somewhat larger, since De la Faille's data for Britain was incomplete. The 1939 edition of the catalogue, which excluded drawings, listed sixteen paintings, a slight rise. New research has identified sixty-five paintings and twenty-five drawings that had been owned by British collectors and public galleries at some point before 1939. Of the total of ninety works, around thirty had already left the country, leaving approximately sixty at the outbreak of the Second World War.[67] In terms of the individuals, a number of major collectors stand out: Beatty (five paintings), Sadler (two paintings and three drawings), Courtauld (two paintings and one drawing), Workman (three paintings), Boyd (three paintings), Unwin (up to three paintings) and Stoop (one painting and three drawings).

By the 1970 edition of De la Faille, the number of works in Britain was recorded as fifty-one, represented by thirty-three paintings and eighteen drawings. In terms of world rank, the Netherlands, the

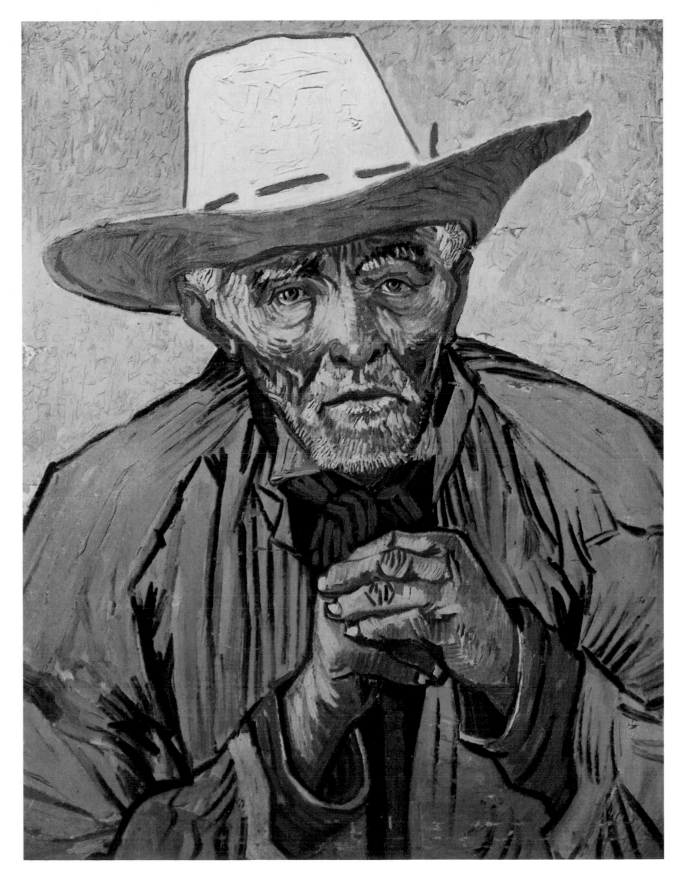

Fig.15 · *Portrait of*
Patience Escalier
[F444]
Private Collection

United States and Switzerland each had many more works. The Dutch figure is swollen by the massive collections of the Van Gogh Museum and Kröller-Müller Museum. The American number reflects the growing wealth and ambition of US collectors. Swiss collectors had the resources and have long been enthusiasts for Post-Impressionism. In the 1970 De la Faille catalogue, Britain (fifty-one works) trailed only very slightly behind France (fifty-seven works) and Germany (fifty-three works). Britain had therefore caught up with France and Germany, which (with the Netherlands) originally had the greatest concentration of Van Gogh collectors.[68]

Tracking the ownership of Van Goghs also makes it possible to examine the rise in prices. Works remained inexpensive in the decade after the artist's death in 1890. At £1, Unwin's flower still life was the cheapest work bought by a British collector, and the highest sum paid in the 1890s was £17 for *Two Crabs* (cat.5). But after the turn of the century, prices jumped ahead, with *Farms near Auvers* (cat.6) costing £400 in 1910. Following the First World War, prices rose again. Courtauld bought two of the most expensive paintings acquired by British collectors, paying £9,000 in 1927 for *Peach Blossom in the Crau* (cat.26) and £10,000 for *Self-portrait with Bandaged Ear* (fig.12) the following year. Beatty also paid around £10,200 for *Sunflowers* (fig.7)

in 1935. However, paintings could be acquired for considerably less, and in 1929 V.W. van Gogh very generously sold the *Portrait of Alexander Reid* (cat.2) to the sitter's son for just £100, a fairly nominal sum for such an important picture. Works on paper rarely went for more than a few hundred pounds. Henry Wellcome paid just under £6 for the etched *Portrait of Dr Gachet* [F1664] in 1927.

Some works sold twice, providing revealing comparisons. *Olive Trees* (cat.19) was bought by Sadler for £363 in 1923, but sold for £1,600 in 1934. *Head of a Peasant Woman* (cat.21) was acquired for £300 in 1923 by Fleming, but fetched £4,000 in 1951. *Portrait of Alexander Reid* (cat.1) had been sold for the special price of £100 in 1929, but Glasgow Art Gallery paid £166,250 for it in 1974. However, despite these increases, the really massive rises did not arrive until the 1980s. The two versions of *Sunflowers* tell the story of what happened to the outright masterpieces. The Millbank gallery paid £1,363 in 1924 for their painting (fig.1), but even by 1948 its insurance value had only risen to £7,500.[69] Another version of *Sunflowers* (fig.7) was bought by Beatty in 1935 and insured soon afterwards for £10,200. By 1983 it was valued at £4.2 million.[70] Just four years later the painting sold at Christie's for a record £24,750,000. Theoretically, if the former Beatty *Sunflowers* came onto the market today, it might well break the £100 million barrier.

Fig.16 · *Harvest Landscape* [F1483]
Private Collection

THE PUBLIC'S VAN GOGHS

By 1939 there were six Van Gogh paintings and seven works on paper in British public collections.[71] To update the record, thirteen Van Goghs have been added since the Second World War. Eight paintings have been acquired: *Le Moulin de Blûte-fin, Montmartre* (fig.17) was bequeathed by McInnes to Glasgow Art Gallery in 1944; *Rain – Auvers* (cat.11) was a bequest from Gwendoline Davies to the National Museums and Galleries of Wales in 1952; *Head of a Peasant Woman* (cat.21) and *Orchard in Blossom* (cat.14) were donated by Maitland in 1960 to the National Gallery of Scotland; *Peasant Woman Digging* [F95a] was bought by the University of Birmingham's Barber Institute from Gillian Solomons in 1961; *Restaurant de la Sirène at Asnières* (cat.29) was bequeathed by Erich Alport to Oxford's Ashmolean Museum in 1972; *Portrait of Alexander Reid* (cat.2) was bought by Glasgow Art Gallery in 1974 from the grandson of the sitter; and *Autumn Landscape* [F119] was purchased by Cambridge's Fitzwilliam Museum in 1980 from the executors of Lady Epstein, widow of the sculptor Sir Jacob Epstein. Two drawings were acquired by public collections after the Second World War: *Landscape near Montmajour* [F1424] was donated to the British Museum in 1968 by French collector César Mange de Hauke; and *Sorrow* [F929a] was given to Walsall Museum and Art Gallery in 1972 by Lady Epstein. In addition, the three Courtauld works went into the public sphere with the opening of the Courtauld Institute Gallery in 1958. These comprised two paintings, *Peach Blossom in the Crau* (cat.26) and *Self-portrait with a Bandaged Ear* (fig.12), and the drawing *Tile Factory* (cat.27). The Tate's five Van Gogh paintings were transferred on long-term loan to the National Gallery at various points in the post-war period. This was formalised by a 1997 agreement that 1900 should be regarded as the cut-off date between the two collections. The Tate's three drawings went on long-term loan to the British Museum in 2002.

British public collections therefore now have a total of twenty-six Van Goghs. Although a reasonable number, the most recent acquisition was as long ago as 1980, and the rise in prices means that there are likely to be few opportunities to add works of 'museum quality'. The problem was illustrated when the magnificent watercolour *Harvest Landscape* (fig.16) was auctioned in 1997, selling for £8.8 million, a record price for a work on paper at auction. Although it had been in the Kessler collection since 1930, and is undoubtedly a masterpiece, no British public collection attempted to buy the work when an export licence was temporarily deferred. The watercolour is now in an American private collection. It is also striking that only five Van Goghs have ever been purchased by British public collections, excluding the four acquisitions paid for by the Courtauld Fund and

effectively donated by Samuel Courtauld. The purchases were *Hayricks* in 1926 (£200), *Olive Trees* in 1934 (£1,600), *Peasant Woman Digging* in 1961 (around £10,000), the *Portrait of Alexander Reid* in 1974 (£166,250) and *Autumn Landscape* in 1980 (just under £70,000).[72] Compared with today's prices, these now seem to be bargains. All the other twenty-one Van Goghs in public collections were donated or bequeathed.

Overall, the history of British collecting of Van Gogh reflects the key role played by a number of enlightened collectors, individuals of avant-garde tastes. Their interest helped pave the way for a wider acceptance of the artist's work in Britain, particularly from the early 1920s. This, in turn, very soon led to interest from public collections, in the Tate's case backed by the financial support of the Courtauld Fund. However, most of the Van Goghs in our museums and galleries were donated by collectors – a reminder of the generosity of the 'pioneers' who had the foresight to acquire these works in the early years.

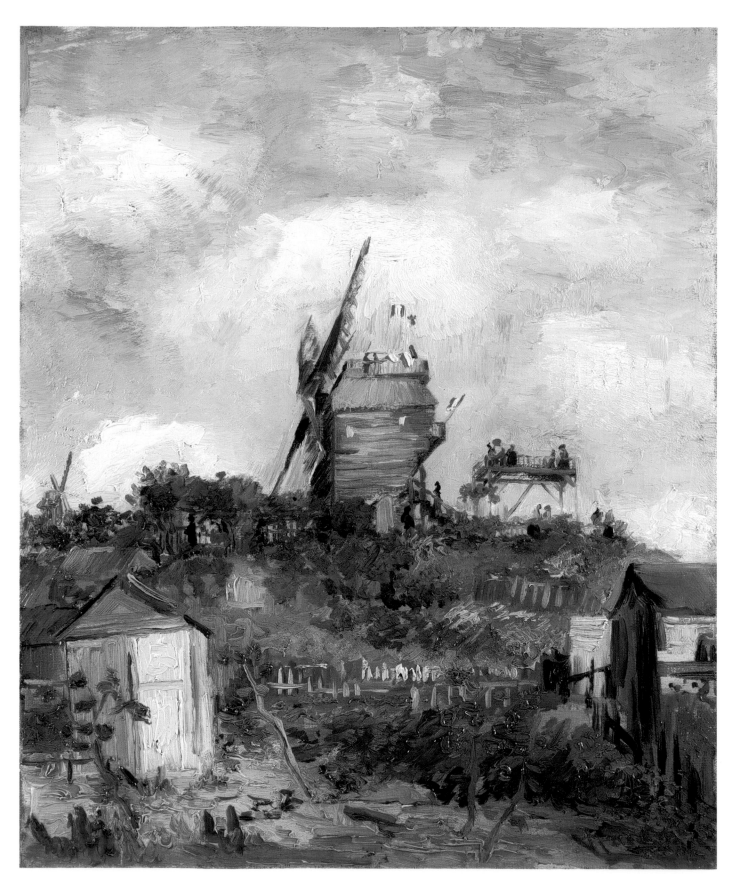

VAN GOGH IN SCOTLAND

In 1948 a one-man exhibition of nearly 200 works by Vincent van Gogh was held in Glasgow. Such was the public's enthusiasm that they queued round the block to obtain admission, and the supply of catalogues soon ran out. Few of those waiting in line to feast their eyes on the work of this notorious and eccentric genius were aware of the close connections that had existed between Glasgow and the Van Gogh brothers at the end of the nineteenth century; all they knew was that Van Gogh's art was something to be experienced.

Despite the fact that Van Gogh allegedly sold only one picture during his lifetime, the Scots were swift to admire his art. Indeed Scottish collectors accounted for a fair percentage of pictures by this artist that were bought in Britain before the Second World War.[1] By contrast, relatively few Scots invested in other Post-Impressionist artists such as Gauguin and Cézanne. The Dundee collector William Boyd, for example, owned three works by Van Gogh, as well as pictures by Bonnard, Vuillard, Marchand and Friesz, but not a single example of Gauguin, Cézanne and Seurat. What were the reasons for this? Were Van Gogh's pictures more freely available than those of other artists, or did the Scots have a special affinity for his fluid handling and expressive use of colour?

The Glasgow art dealer Alexander Reid (fig.18) provided the principal link between Scotland and Van Gogh: first, through his personal contacts with the Van Gogh brothers; and second, through the Reid gallery's promotion of Van Gogh's work after the First World War. In the spring of 1888 Reid presented his father, James Reid, director of the Glasgow firm Kay & Reid, with two paintings by Van Gogh. The first was *Still Life, Basket of Apples* (cat.3), the second a portrait of Reid himself. The Scottish artist A.S. Hartrick, who had known Reid in Paris, recalled:

> Reid got into serious trouble with his father for acquiring or investing in some of Van Gogh's work, but I cannot believe he gave much money for them, or I should have heard about it from the painter! It was the contact with such atrocities, as they seemed, that aroused the ire of the parent: for, in the view of the elder picture dealer, Reid was destroying his taste for what was saleable.[2]

In fact, the pictures were gifts from the artist, with whom Reid had been sharing an apartment in Paris. Neither he nor his father was particularly taken by Van Gogh's work and James Reid sold both paintings without hesitation to a French dealer for £10.

Reid had moved to Paris in 1886 to work for the prestigious firm of art dealers, Boussod & Valadon. He was appointed to work alongside Theo van Gogh in the modern paintings section of the gallery at 19 Boulevard

Fig.17 · *Le Moulin de Blûte-fin* [F 274]
Glasgow Museums: Kelvingrove Art Gallery and Museum

Fig.18 · *Alexander Reid (far left) in France around 1890 with (from left to right) Arthur Heseltine, Roderic O'Conor, James Guthrie, Mme Heseltine, and John Lavery*

Montmartre. Shortly after he joined the firm, Theo invited him to share lodgings with him and his brother Vincent at 54 rue Lepic. At first Vincent was strangely drawn to Reid, who was not only a similar age (Vincent was born on 30 March 1853 and Reid on 25 March 1854) but resembled him closely. Indeed, contemporaries remarked that they were so alike they could have been taken for twins and two portraits of Reid, originally in the Van Gogh family collection were catalogued by De la Faille in 1928 as self-portraits (cat.nos 1, 2).[3]

Reid enjoyed Vincent's company and on his day off from work he would accompany the artist on occasional painting expeditions. In the evenings he would pose for informal portraits or discuss Vincent's plans to introduce the British public to avant-garde French art.[4] However, after six months of living in relative harmony, the friendship came to an abrupt end when Vincent tried to involve Reid in a suicide pact. The circumstances of this unfortunate event were recounted by the artist Robert Macaulay Stevenson, one of Reid's close friends:

> One day when, his hopes all shattered, [Reid] confided in Vincent van Gogh his troubles, Vincent gallantly suggested suicide – together. A. Reid, like a shrewd Scot, at once replied, 'Topping, but I have sisters in Scotland and don't want to put them to needless trouble and worry – so if we wait till nightfall it will be all right.' Thus taken by the sentiments Vincent 'fell to it' … Reid went out to 'make arrangements' which resulted in him spending his last francs and getting as far away as Paris permitted.[5]

In the early spring of 1887 Reid moved into new lodgings at 6 Place d'Anvers and, although he was still working for Boussod & Valadon, set himself up as an *agent en chambre*, buying and selling works of art on the side. He acquired a number of Impressionist pictures during his stay in Paris, including Manet's *Le Bon Bock* (Philadelphia Museum of Art) but, as he later admitted, he was never convinced of Van Gogh's ability as an artist. And when he returned to Glasgow in 1889 and set up his own art gallery, La Société des Beaux-Arts, he focused on the Impressionists, completely disregarding the work of younger artists such as Van Gogh.

Indeed, despite Reid's intimate association with the Van Gogh brothers, he made no attempt to market Van Gogh's work in Scotland before the First World War. This is hardly surprising, since by 1914 relatively few British collectors had begun to take an interest in Impressionism, and 'Post-Impressionism' – the name given by the artist and critic Roger Fry to the work of Van Gogh, Gauguin and Cézanne – was still largely misunderstood.

It was not until 1913, after Post-Impressionist and Futurist pictures had been shown in London and Leeds, that works by Van Gogh and his contemporaries began to travel as far north as Glasgow and Edinburgh. It was the artist (and future director of the National Gallery of Scotland) Stanley Cursiter who masterminded the loan of works from the second Post-Impressionist and Futurist exhibitions of 1912 to the Glasgow Institute and the Royal Scottish Academy.[6] In addition, a selection of paintings by Gauguin, Cézanne and Van Gogh were lent to the annual exhibition of the Society of Scottish Artists (SSA) at the Royal Scottish Academy by individual collectors and dealers, including the Leeds academic and innovative collector Michael Sadler and the Paris dealer Bernheim-Jeune.

The SSA Exhibition opened at the Royal Scottish Academy in November 1913 and included two late works by Van Gogh: *Le Ravin*[7] and *Evening: The End of the Day* (after Millet), 1889 (fig.19). The former was on sale at £200; the latter, catalogued as 'L'Homme à la Veste', was lent by Bernheim-Jeune. That year, *The Scots Pictorial* ran a series of articles on modern art, including one on Post-Impressionism, which was published in September 1913. It was Van Gogh's mental condition rather than his skill as an artist which was the focus of most of the critical debate at this time.[8] The critic for the *The Scots Pictorial* described Van Gogh as 'a burning spirit to whom art was more than life. He was indeed a madman as we reckon madmen, but it was the madness of fevered genius. Every stroke of paint which he laid on his canvas felt to him like a strip of his soul torn away.'[9]

In November 1913, Michael Sadler was invited to Glasgow to give a lecture at Glasgow School of Art on Post-Impressionist art. The aim of his talk was to show that the Post-Impressionists were essentially rooted in tradition and he drew comparisons between Cézanne and Wordsworth, between Gauguin and Conrad and between Van Gogh and Ruskin.[10] Sadler was determined to see the Post-Impressionists as

a continuation of, rather than a reaction against artistic tradition, and he later described Van Gogh as 'a modern medievalist', comparing his work with 'the decoration of a medieval missal'.[11] However, even though he had already bought several works by Gauguin and Cézanne at this date, Sadler had not yet developed an interest in Van Gogh.

Van Gogh was still regarded with suspicion by most dealers and, despite his close links with the artist, Alex Reid was no exception. Indeed, it was not until his son, A.J. McNeill Reid, joined the firm after the war that the Reid Gallery began to handle Van Gogh's work. The first picture by Van Gogh to enter a Scottish collection was the *Moulin de Blûte-fin* (fig.17) which was sold by Reid to the Glasgow collector William McInnes (fig.20) in July 1921 for £550.[12] By comparison with most Scots, McInnes was extremely advanced in his tastes and had acquired works by Degas, Monet and Sisley just after the war. He was an employee in the Glasgow shipping firm of Gow, Harrison & Co., whose partners included Leonard Gow and Ion Harrison, both enthusiastic collectors. As T.J. Honeyman, director of Glasgow Art Gallery, later recalled, 'Whenever I looked in at the office in Gordon Street, I seemed always to be interrupting talks on Art, not shipping.'[13]

McInnes collected the work of the Scottish Colourists and was an early and important patron of Leslie Hunter, who may have encouraged his enthusiasm for Van Gogh. He began collecting Peploe's still lifes just after the First World War, during which period work by Hunter and Peploe was regularly exhibited not only in Glasgow, but also in Edinburgh and Dundee.[14] It was almost certainly his familiarity with the loose handling and brilliant palette of both these artists that made him so receptive to the work of Van Gogh. And it was not long before he progressed to even more avant-garde artists such as Matisse, Braque and Picasso.

McInnes's early interest in Van Gogh prompted McNeill Reid to ask Bernheim-Jeune to send further works on approval, but none appears to have been sold. At the same time, the price of Van Gogh's paintings was rising and a number of fakes were being introduced onto the market. For example, in 1923 the Aberdeen collector Sir James Murray acquired a still life entitled *Still Life with Daisies and Poppies* (cat.15), which later turned out to be a fake. Later that year the first one-man exhibition of Van Gogh pictures was held at the Leicester Galleries in London. Two of the paintings now in the National Gallery of Scotland were included in the show: *Head of a Peasant Woman* (cat.21), which was bought by Evelyn Fleming (the mistress of Augustus John) and *Olive Trees* (cat.19), acquired by Michael Sadler, who also wrote the preface to the exhibition catalogue.

Fig.19 · *Evening: The End of the Day* [F649]
Menard Art Museum, Japan

Fig.20 · *William McInnes* by Leslie Hunter
Glasgow Museums and Art Gallery

As a result of the exhibition at the Leicester Galleries, McNeill Reid began to renew his interest in Van Gogh. He realised that it would be more economical and less risky to invest in Post-Impressionist art on a half-share basis, and it was around this period that he set up an informal partnership with the London dealer Ernest Lefevre and the French dealer Etienne Bignou. In October and November 1923 Reid collaborated with the Lefevre Gallery to hold his first joint exhibition of Post-Impressionist art. The exhibition focused on the work of Renoir, but also included works by Gauguin and Toulouse-Lautrec and three works by Van Gogh. These were *The Hospital at Arles* (fig.21), the spectacularly beautiful *Oleanders*, 1888 (cat.18),[15] and the more sombre *Bridge at Trinquetaille*, June 1888 [F426, Private Collection].[16] All three pictures were eventually bought by Mrs Elizabeth Russe Workman.[17]

Elizabeth Workman came from Rhu in Dunbartonshire and she and her husband bought regularly from Reid's Glasgow gallery from 1903 onwards, acquiring works by Peploe, Hornel, Clausen and Courbet before the First World War. Robert Workman formed the biggest collection in Britain of William McTaggart and in 1919 alone he bought five works by this artist. Just as McInnes developed a taste for Van Gogh through his familiarity with the work of Hunter and Peploe, it was almost certainly through a love of the later works of McTaggart that the Workmans learned to appreciate the loose

handling and expressive qualities of Van Gogh's paintings. Robert Workman, a shipbroker, may have held the purse strings but, according to McNeill Reid, 'It was … Mrs Workman who had the taste.' Her first purchase in 1916 was an important work by Degas and her collection included Degas's *Portrait of Diego Martelli* and Gauguin's *Martinique Landscape*, both now in the National Gallery of Scotland. During the 1920s she went on to invest in Vuillard, Toulouse-Lautrec, Matisse, Picasso, Braque and Dufy before her husband lost his fortune and they were forced to sell the collection in 1931.[18]

Enthusiasm for Van Gogh in the West of Scotland was only equalled by a group of collectors from Dundee, a city which had rapidly expanded in the second half of the nineteenth century on the back of industries such as jute and jam. Among the most significant post-war collectors in Dundee was William Boyd of West Ferry who, like Elizabeth Workman, owned three pictures by Van Gogh. Boyd had acquired his first Van Gogh, *Field with Ploughman* (cat.13) by 1925 when he lent it to the inaugural exhibition of Kirkcaldy Art Gallery. He went on to acquire two more works: *Orchard in Blossom* (cat.14), painted by Van Gogh shortly after his arrival in Arles in the spring of 1888 and *Trees* (fig.22), painted at Auvers in July 1890.

Boyd was a director of James Keiller & Son, the Dundee-based marmalade manufacturers. He may have been especially receptive to Van Gogh's work since he had already built up a considerable collec-

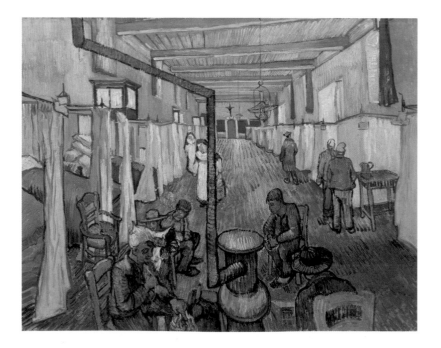

Fig.21 · *The Hospital at Arles* [F646]
Oskar Reinhart Collection, Winterthur

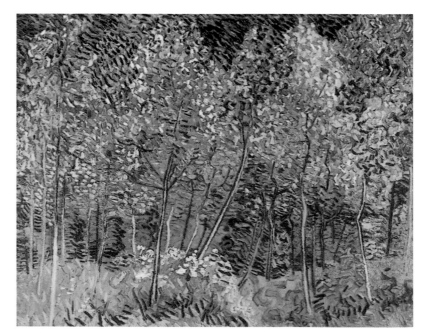

Fig.22 · *Trees* [F817]
Private Collection

tion of earlier nineteenth-century Dutch art. He began collecting before the war and by 1912 he had acquired a number of works by artists of the Hague School, including Josef Israels, Anton Mauve (Van Gogh's cousin), William Maris and Johannes Bosboom.[19] Like William McInnes, he also invested in the work of Peploe and Hunter from an early date, but his first love was McTaggart. According to McNeill Reid, he 'had nothing else in his dining room',[20] and, even when he began to replace his Scottish collection with examples of modern French art, he retained his McTaggarts. Like the Workmans, he almost certainly developed a taste for Van Gogh through an early acquaintance with McTaggart's highly expressive late works, as well as through the loose handling and prismatic colours of Peploe and Hunter.

Although Boyd invested in the work of Harpignies before the war it was really only in the 1920s that he began to take an interest in French painting. In 1921 he renovated his house, Claremont, in West Ferry, transforming the large, plain 1870s house, which was 'Frenchified to accommodate the collection … with whitish grey and gold leaf rococo interior work'.[21] In 1923 he bought two Impressionist works – Sisley's *Church at Moret* (Hunterian Art Gallery) and Monet's *Etretat* (unidentified) – from Reid. But he bought the bulk of his French paintings, including works by Van Gogh, through the Dundee agent, Matthew Justice.[22]

Justice owned a furniture and interior design business, Thomas Justice & Sons based in Dundee and London. He was a close friend of John Tattersall, an art dealer who had worked briefly as Reid's partner in Glasgow during the First World War. Tattersall in turn was acquainted with Leslie Hunter and William McInnes. The artist E.A. Taylor recalled meeting all three in Paris, just before the war:

Just about the war time (a little before it) [Hunter] turned up at the Café du Dome with two friends and took me aside telling me they were very important people (one I think was a dealer or collector from Dundee. I forget the names) and that they had paid his fare over, etc., and he was their guest.[23]

In 1919 Reid held a one-man exhibition of the work of Vuillard, which kindled both Tattersall's and Justice's enthusiasm for modern French art and it was at this stage that Justice developed the idea of becoming an agent or dealer, displaying and marketing works by avant-garde artists in his shop. According to McNeill Reid:

He [Justice] and Tattersall went off to Bernheim-Jeune, got quite a few pictures on sale, bought a few more, and did a good deal of business with Boyd. They both kept quite a few themselves, although neither of them were [sic] in a position to buy anything very expensive. Justice had one Van Gogh Flowers, Tattersall had a Van Gogh river scene of the Paris period and they both had some Vuillards, Bonnards, Marchands, Friesz, Segonzacs, and other more modern paintings.[24]

Justice's Van Gogh, *Bouquet of Flowers* (fig.4), was one of a series of Monticelli-inspired still lifes painted in the summer of 1886 and close in conception to the *Vase with Asters and Phlox* in the Van Gogh Museum [F234].[25] Tattersall's painting was a *View of a River with Rowing Boats* (cat.12), also from Van Gogh's Paris period. Boyd was in a better position financially to make a serious investment in modern French art and Justice and Tattersall persuaded him to part with some of his older pictures and replace them with between forty and fifty works by Van Gogh, Matisse, Dunoyer de Segonzac, Vuillard, Bonnard, Marchand and others.[26] Many of these pictures, including at least one work by Van Gogh, were exhibited in November 1922 at the twenty-fourth exhibition of the Dundee Art Society at the Victoria Art Galleries. The exhibition was hailed as 'one of the most notable in artistic merit ever held under the auspices of the Society' and critics commented on 'the number of pictures by Continental artists of the most advanced type … which have been lent from local collections'.[27]

Van Gogh was also included alongside Vuillard and Bonnard in a loan exhibition of French paintings at the Victoria Art Galleries in October 1924. Once again the pictures on show were 'brought together entirely from collections in Dundee',[28] presumably Boyd, Tattersall and Justice. The individual lenders were seldom named, but we know that in 1928 John Tattersall exhibited his Van Gogh at Kirkcaldy Art Gallery.[29] He also lent works by Boudin, Bonnard and Othon Friesz and Matthew Justice sent pictures by Marchand, Bonnard and Vuillard.[30]

Justice acted as Leslie Hunter's agent and it may have been Hunter who encouraged his interest in Van Gogh. Hunter certainly encouraged William McInnes to invest in Van Gogh, Cézanne and Matisse during the 1920s. Justice's first love, however, was Vuillard, and he acquired several examples of his work just after the First World War, exhibiting them in his furniture showroom.

Boyd ceased collecting around 1929 and died in 1941.[31] In the late 1920s several works by Van Gogh were shown in Scotland, including the famous *Self-portrait with a Bandaged Ear* (fig.12), which Samuel Courtauld lent to the Glasgow Institute in 1929. In the same year three works were exhibited at the Royal Scottish Academy in Edinburgh, including Boyd's *Orchard in Blossom* (cat.14). The following year the portrait of *Alexander Reid* (cat.2), recently acquired by his son, was included in an exhibition of French Paintings at Reid & Lefevre in Glasgow. Another major Scottish collector, David Cargill (who made his fortune from the Burmah Oil company) turned his attention to Van Gogh and in 1930 acquired *Vase with Zinnias* [F592] from Reid & Lefevre for £5,000. However, although Cargill went on to build up an important collection of Impressionist and Post-Impressionist art, this was the only painting by Van Gogh that he acquired. Cargill's half brother,

William, also bought a single example of Van Gogh, *Moulin de la Galette* 1886 (destroyed), remarkably close in date and subject to the painting acquired by McInnes in 1921.[32]

In 1932 a major exhibition of forty-five pictures and thirty-four drawings by Van Gogh was held in Manchester and Stanley Cursiter, director of the National Gallery of Scotland, tried, unsuccessfully, to arrange for the show to travel to Edinburgh. However, his appreciation of Van Gogh had been stimulated by the Manchester exhibition and when the Leicester Galleries staged their own exhibition in London in 1934 he made the first acquisition of a Van Gogh painting for a public Scottish gallery. *Olive Trees* (cat.19), a brilliant and highly expressive work, was an appropriate purchase for the National Gallery of Scotland – not only because it was a fine example of Van Gogh's St-Rémy period, but because it had previously been in the collection of Michael Sadler who, in 1925, had sold Gauguin's *Vision of the Sermon* to the Gallery.

Cursiter communicated his enthusiasm for Van Gogh to another important collector of this period, Alexander Maitland QC (fig.23). Maitland's father, Thomas Maitland, was a Dundee merchant, but Maitland made his home in Edinburgh. In 1906 he married Rosalind Sellar, a young musician who, with his enthusiastic participation, transformed his lawyer's town house at 6 Heriot Row into a musical salon and art gallery. The couple bought their first Post-Impressionist

work, Gauguin's *Three Tahitians* (now in the National Gallery of Scotland), in 1936. The following year they bought Boyd's Van Gogh, *Orchard in Blossom* (cat.14) for £2,500 from the Dundee dealer John Robertson (of Bruce & Robertson), but not before a period of careful deliberation. Maitland was concerned that his purchase should be authenticated and, with Robertson's permission, arranged for the National Gallery of Scotland to send the picture to Holland for closer inspection by Dr Martin de Wild, a paintings conservator in The Hague. According to Cursiter, Robertson had received a second offer for the picture from a dealer and was anxious to close the sale one way or another.[33] Maitland and Cursiter had evidently been on the lookout for pictures by Van Gogh for some time, and earlier that year De Wild had informed Cursiter about two paintings for sale from the collection of the German collector Hugo Moser.[34] These were the *Rispal Restaurant at Asnières* [F355, now in the Shanwee Mission, Kansas, Henry W. Bloch Collection] – painted with a light, cheerful palette and staccato, almost pointillist strokes – and the later, more intense *Green Wheat Field* [F718, now on loan to the Kunsthaus, Zürich], executed at St-Rémy in June 1889. The pictures were shipped off to the USA with Moser's widow before Cursiter or Maitland even had a chance to see them in reproduction. As De Wild commented in his letter to Cursiter, by 1937 there appeared to be 'a great scarcity' of works by Van Gogh on the open market.[35]

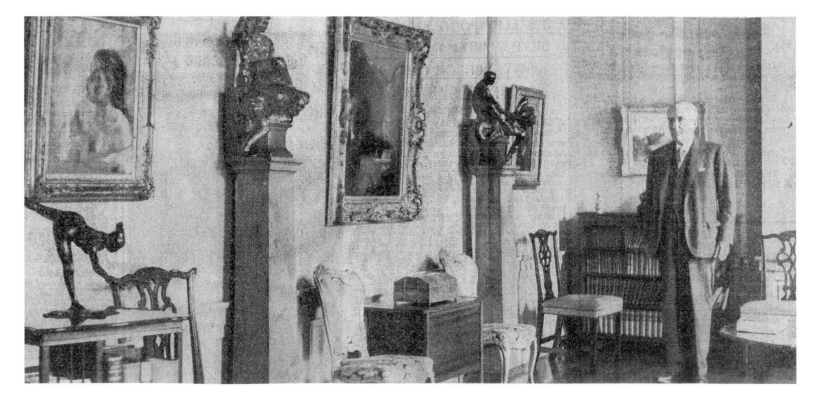

In 1947 Maitland was made a trustee of the National Gallery of Scotland and from that date on his purchases were deliberately chosen to complement or enhance the Gallery's collection. Since the Gallery already owned an example of Van Gogh's later St-Rémy period and he himself owned a picture from the Arles period, he made his next purchase (in 1951) an early, dark-toned work from Van Gogh's Brabant period. This was *Head of a Peasant Woman* (cat.21), previously owned by Evelyn Fleming, which he acquired from Reid & Lefevre in May 1951 for £4,000, an indication of the gradual rise in the market value for Van Gogh's art.

Apart from Maitland the only other Scottish collector to invest in Van Gogh during the 1930s and 40s was another Dundonian, Royan Middleton, who built up an important collection of Post-Impressionist art, including works by the Scottish Colourists. His earliest purchase was the *View of a River with Rowing Boats* (cat.12), previously in Tattersall's collection, and in 1943 he acquired *Coin de Parc*, now called *Lane in Voyer-d'Argenson Park at Asnières* (fig.24) from the London dealers Arthur Tooth & Co. It is not known what price Middleton paid for his two pictures, but he bought mainly during the pre-war economic slump. After the war the market value for Van Gogh's work rose steadily, reaching a peak in the 1980s and culminating in the sale of the *Portrait of Dr Gachet* for $82.5 million in 1990. Had he realised what an investment Van Gogh's art would prove, Reid might have thought twice before selling his two pictures a century earlier for only £5 each.

In 1948 Glasgow staged Scotland's first, phenomenally successful, exhibition of Van Gogh's work. A critic for *The Scotsman* remarked that Van Gogh's popularity was due to the fact that his was 'an art that the ordinary man could understand'.[36] Was it Van Gogh's accessibility that appealed to the Scots mercantile collectors, many of whom were from quite 'ordinary' backgrounds? Or did his paintings hold a special appeal for the Scots since many had already developed a taste for the fluid handling and prismatic colours of artists such as William McTaggart and the Scottish Colourists, who themselves had been influenced by the Dutch artist? Was it Van Gogh's Dutch heritage that appealed to a northern, fiercely Protestant nation such as Scotland – or were they simply fascinated by his madness and eccentricity? Whatever the reason we should be thankful that his work had such an early appeal for the Scots – at a time when his work was still affordable – and that, through the beneficence of individuals such as William McInnes and Alexander Maitland, we are still able to see his paintings in Scotland today.

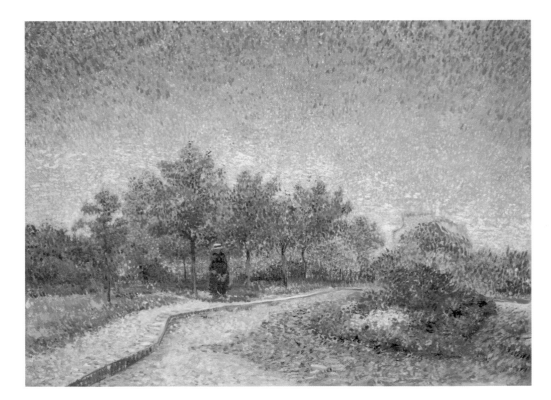

Fig.23 *Left*
Sir Alexander Maitland in his house in Heriot Row, from article published in the *Daily Mail* in 1960, at the time the collection was given to the National Gallery of Scotland. Works by Degas and Courbet's *River in a Mountain Gorge* can be seen on the left.

Fig.24 *Right*
Lane in Voyer-d'Argenson Park at Asnières [F276]
Yale University Art Gallery, New Haven

VAN GOGH AND REID

The first Van Goghs that came to Britain were gifts from Vincent to friends and artists. The Glasgow dealer Alexander Reid was the recipient of two such gifts and provides the closest link between Van Gogh and Britain. Reid lived in Paris for three years from 1886–9 and worked alongside Theo van Gogh at the firm of Boussod & Valadon. For the first six months he shared an apartment with the Van Gogh brothers at 54 rue Lepic. Vincent was immediately drawn to Reid since, according to the artist A. S. Hartrick, the two men were so similar physically that they could have been taken for twins. Van Gogh painted the Glasgow dealer twice, and when he eventually returned to Scotland Reid took with him two Van Gogh paintings – a portrait and a still life, *Basket of Apples*. His father, James Reid, soon sold both pictures on to a French dealer for £5 each. Van Gogh gave a second still life of apples to the artist Lucien Pissarro. He was fascinated by Pissarro's experiments with Neo-Impressionism and the two became firm friends. Pissarro sketched Van Gogh and gave him a group of his own wood engravings as a token of their friendship. Shortly after Van Gogh's death Pissarro left Paris to settle in the London area, first at Epping and later at Bedford Park. He sold the still life in 1906, but kept the drawing until his death in 1944.

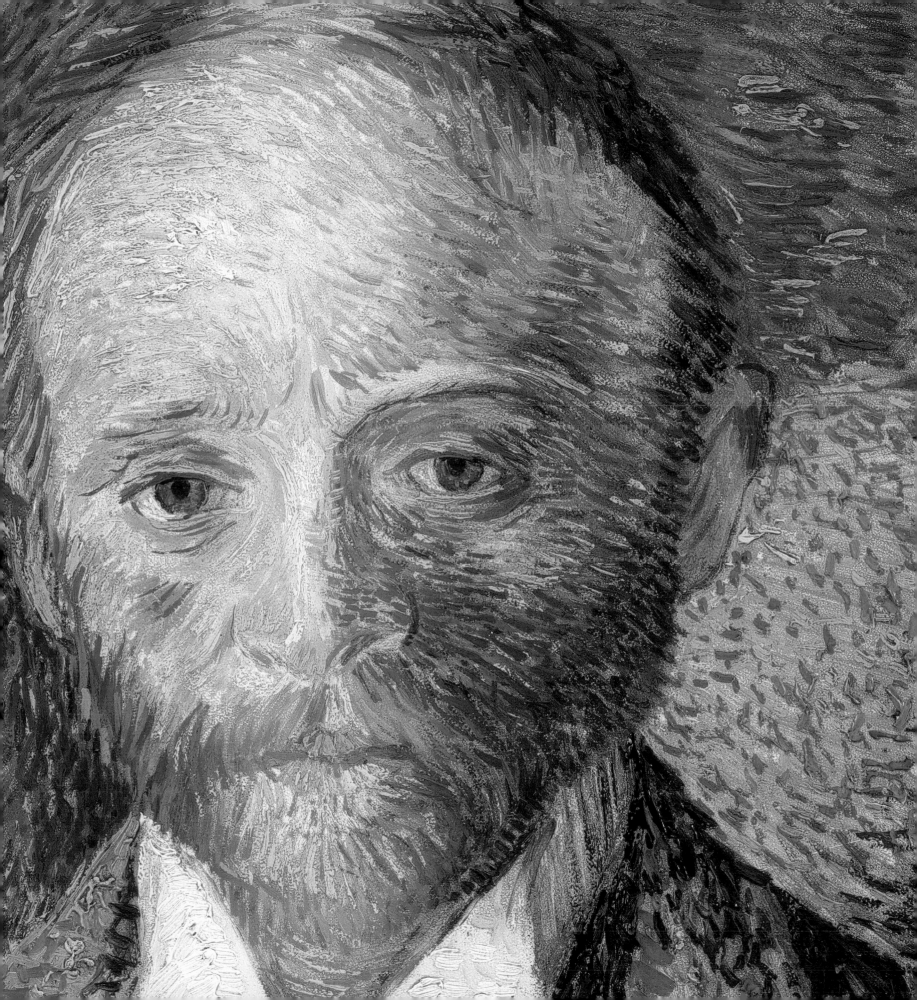

1

PORTRAIT OF ALEXANDER REID

ACQUIRED BY ALEXANDER REID IN 1886-7

ALEXANDER REID

Alexander Reid was born in Glasgow on 25 March 1854. He was the son of the art dealer James Reid (1828–1907), director of the Glasgow firm of Kay & Reid. He spent three years in Paris (1886–9), working for much of this period alongside Theo van Gogh at Boussod & Valadon. By the autumn of 1886 he had met Vincent van Gogh and they shared an apartment for six months. On returning to Glasgow, Reid set up his own gallery specialising in modern French art, especially Degas. He was also an important patron of Scottish artists such as Joseph Crawhall, E.A. Hornel, S.J. Peploe and G. Leslie Hunter. After the First World War, in partnership with his son, A.J. McNeill Reid (1893–1972), he held regular exhibitions of Impressionist and Post-Impressionist art in Glasgow, selling his first work by Van Gogh in 1921. In 1926 he went into partnership with the Lefevre Gallery in London. He died in Killearn on 11 January 1928.

This is the 'lost' portrait, which Van Gogh presented to the sitter, the Scottish art dealer Alexander Reid. Until now the picture in Oklahoma was believed to have belonged to the Van Gogh family until well into the twentieth century, and the version given to his friend Reid was assumed to have been lost.[1] The Oklahoma portrait was exhibited very briefly in the 1950s, but otherwise remained in a private collection until 2000, when it was donated to the Fred Jones Jr Museum of Art. Until then it had never been reproduced in colour, and so it has remained a relatively unknown work. The portrait was painted when Reid was thirty-three. In the summer of 1886 he had moved to Paris, then the capital of the art world, and was working for the firm of Boussod & Valadon, whose Montmartre branch was managed by Vincent's brother, Theo van Gogh. Vincent was then living in Paris with his brother at 54 rue Lepic, and both the Van Goghs became friends with Reid, who lodged with them until early 1887. This portrait was executed in their apartment, probably shortly before Reid moved out to other accommodation. The painting represents the only depiction of the interior of Theo's home. Reid sits in an armchair, bending slightly forward, caught in a pensive moment. He is smartly dressed, perhaps in his gallery clothes. Behind is a sofa, and the green objects at the back might be print portfolios; Vincent and Theo were avid collectors. Hanging on the rear wall are three pictures. The one in the middle is almost certainly a Nuenen peasant woman by Van Gogh, although it cannot be identified with a surviving work. On either side are paintings by the French-based American artist Frank Boggs, a friend of the Van Gogh brothers – *Honfleur Harbour* on the left and *Coal Barges on the Thames* on the right. Both the Boggs water scenes were inscribed in friendship to Vincent and are now in the Van Gogh Museum. Reid brought the portrait back to Glasgow, probably in 1888, but his father James seems to have sold it along with *Still Life, Basket of Apples* (cat.3). Van Gogh painted a second, slightly later, portrait of his friend (cat.2) and there are three drawings in a Paris sketchbook, which could well be of Reid.[2]

Painted in Paris in 1886–7
Oil on board, 46 × 32 cm
Fred Jones Jr Museum of Art,
The University of Oklahoma,
Norman
F270 / JH1207

PROVENANCE

Alexander Reid, Paris and Glasgow, 1886–7; James Gardner Reid, Glasgow, early 1890s; Jos. Hessel Gallery, Paris, early 1890s; Wildenstein Gallery, New York, 1953; Myrtil Frank Gallery, New York; David B. Findlay Gallery, New York, 1957; Aaron Max Weitzenhoffer, Oklahoma City, 1957; Clara Rosenthal Weitzenhoffer, Oklahoma City, 1960; Fred Jones Jr Museum of Art, Norman, 2000 (Weitzenhoffer bequest)

REFERENCES

Theo van Gogh's letter to Anna van Gogh, 28 February 1887 (Van Gogh Museum archive); (references in De la Faille to exhibitions in Berlin in 1914 and Munich in 1928 are incorrect); A.S. Hartrick, 1939, pp.50–1; T.J. Honeyman, 'Van Gogh: A link with Glasgow', *Scottish Art Review*, no.2, 1948, pp.16–21; letter from V.W. van Gogh to Jacob-Baert de la Faille, 21 April 1954 (Van Gogh Museum archive); *Van Gogh*, Wildenstein Gallery, New York, 1955, no.24; *Vincent van Gogh*, Municipal Art Gallery, Los Angeles, 1957, no.8; [Glasgow?] *Evening Times*, 22 May 1963; letters from V.W. van Gogh to McNeill Reid, 13 February and 4 March 1965 and McNeill Reid to V.W. van Gogh, 5 February and 17 March 1965 (Van Gogh Museum archive); *A Man of Influence: Alex Reid 1854–1928*, Scottish Arts Council, Edinburgh, 1967; Feilchenfeldt 1988, p.86; Fowle, 2000, pp.90–1; Bailey 2006, pp.116–9

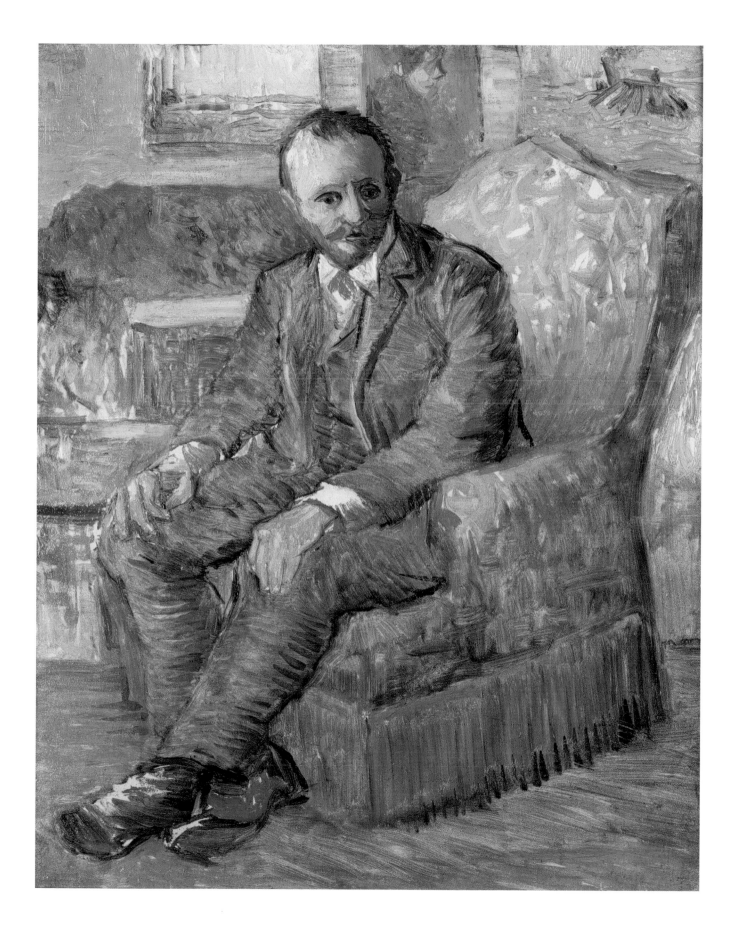

PORTRAIT OF ALEXANDER REID

ACQUIRED BY A.J. McNEILL REID IN 1929

A.J. McNEILL REID

Alexander James McNeill Reid was born in Glasgow on 30 March 1893. He was the son of dealer Alexander Reid (1854–1928) and godson of the artist James McNeill Whistler. After the First World War he joined the family business, encouraging his father to turn his attention to Post-Impressionist art, including Van Gogh. In 1925 Reid senior retired from the business and McNeill Reid was joined by Duncan MacDonald, previously director of Aitken Dott's in Edinburgh. In 1926 the Reid Gallery amalgamated with the Lefevre Gallery in London, with McNeill Reid, Ernest Lefevre, MacDonald and Etienne Bignou as the founding directors. McNeill Reid continued to run the Glasgow gallery and held a number of important exhibitions of Impressionist and Post-Impressionist art during the 1920s. The Glasgow gallery closed in 1932 and McNeill Reid carried on as director of the London branch until 1947, when he retired to Gattonside, near Melrose. He died in 1972.

This painting, originally in the Van Gogh family collection, was once assumed to be a self-portrait of Vincent. It was only in 1928, after the publication of the De la Faille catalogue of Van Gogh's work, that art dealer McNeill Reid recognised the 'self-portrait' as a portrait of his father, Alexander Reid. The confusion is understandable. Scottish artist Archibald Hartrick, a mutual friend of Van Gogh and Reid, once recalled: 'The likeness [between them] was so marked that they might have been twins. I have often hesitated, until I got close, as to which of them I was meeting. They even dressed somewhat similarly, though I doubt if Vincent ever possessed anything like the Harris tweeds Reid usually wore.'[3] Although Hartrick may have been exaggerating, both men were nearly the same age and each had red hair, a moustache and a short beard. The *Portrait of Alexander Reid* was painted in the spring or summer of 1887, presumably in Theo's apartment. It was done in Van Gogh's Neo-Impressionist style, with rhythmic striations and dots, and using the complementary colours of red and green. Stylistically, it is rather different from the portrait of Reid seated (cat.1), which dates from the winter of 1886–7. The green behind Reid's left shoulder in the Glasgow painting is likely to be the back of an armchair, possibly the same one which appears in the earlier portrait. In July 1929 Theo's son, V.W. van Gogh, sold the *Portrait of Alexander Reid* to McNeill Reid for £100 – making it one of the last works to be sold by the family. The price was extremely low for the time, so V.W. van Gogh presumably wanted to do McNeill Reid a good turn. Reid was delighted and gave V.W. van Gogh a Chinese ceramic bowl. In 1934 Reid considered selling the portrait to Glasgow Art Gallery. In 1965 V.W. van Gogh inquired about buying back the Reid portrait, presumably for the planned Amsterdam museum, but this never happened. Shortly before his death in 1972, McNeill Reid offered to sell the picture to the National Gallery of Scotland, but the sale never proceeded. The portrait then passed to McNeill Reid's son Graham, and it continued to hang in the sitting room of the family home. In 1974 Glasgow Art Gallery bought the picture from Graham Reid for £166,250, with the aid of a grant of £57,500 from the National Art Collections Fund. It has since become one of Glasgow's most celebrated paintings.

Painted in Paris in 1887
Oil on board, 42 × 34 cm
Glasgow Museums: Kelvingrove Art Gallery and Museum
F343 / JH1250

PROVENANCE

Theo van Gogh, Paris, 1887; Jo van Gogh-Bonger, Amsterdam, 1891; V.W. van Gogh, Laren, 1925; **Alexander James McNeill Reid, Glasgow and Edinburgh, 1929**; Graham H. Reid, Guildford, 1972; Alex Reid & Lefevre Gallery, London, 1974; Glasgow Art Gallery and Museum, 1974 (with assistance from the National Art Collections Fund)

REFERENCES

Letter from McNeill Reid to V.W. van Gogh, 23 July 1929 (Van Gogh Museum archive); *Renoir and the Post-Impressionists*, Alex Reid & Lefevre Gallery, London, 1930, no.14; *XIXth and XXth Century French Paintings*, Alex Reid & Lefevre Gallery, Glasgow, 1930, no.20; *Vincent van Gogh*, Manchester Art Gallery, 1932, no.16; *Annual Exhibition*, Royal Scottish Academy, Edinburgh, 1934, no.352; *19th Century French Masters*, Alex Reid & Lefevre Gallery, London, 1937, no.46; *French and British Contemporary Art*, National Art Gallery of South Australia, Adelaide, Lower Town Hall, Melbourne and David Jones' Art Gallery, Sydney, 1939, no.133; letter from V.W. van Gogh to McNeill Reid, 13 February 1965 (Van Gogh Museum archive); diary note of V.W. van Gogh, 13 July 1974 (Van Gogh Museum archive); letter from Lord Crawford to NACF, undated (1974) (Tate archive); Feilchenfeldt 1988, p.89; Korn 2001; Korn 2002, pp.122–3 and p.136; Hamilton in Glasgow 2002, pp.106–7, 185 and 205–6

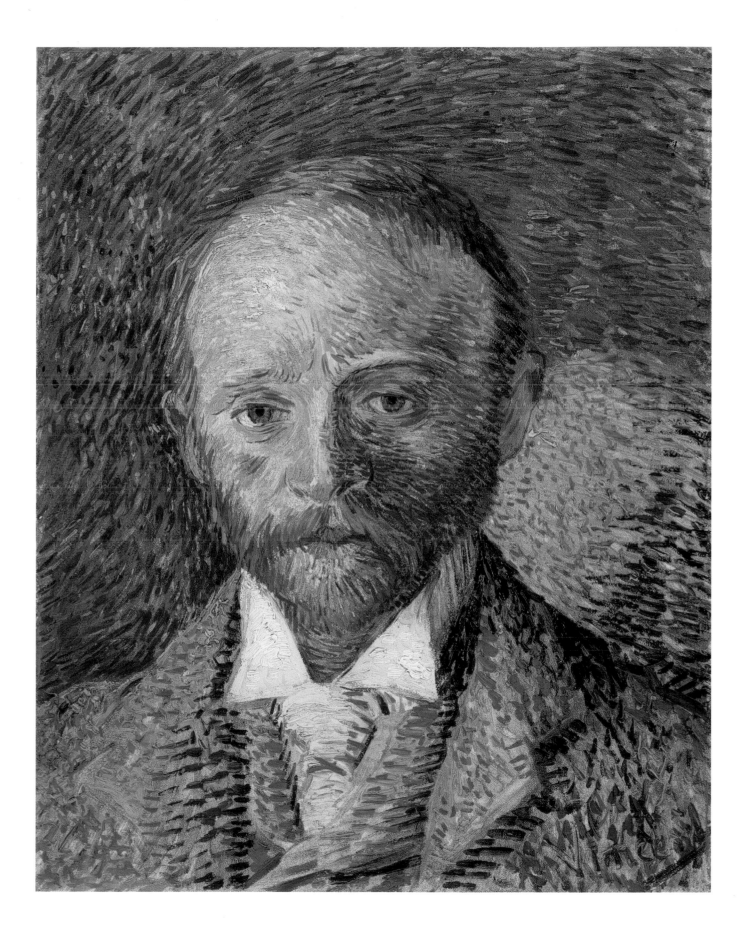

STILL LIFE, BASKET OF APPLES
ACQUIRED BY ALEXANDER REID IN 1887

Painted in Paris in 1887
Oil on canvas, 47 × 55 cm
Saint Louis Art Museum, Gift of
Sidney M. Schoenberg Sr, (43: 197)
F379 / JH1341

PROVENANCE

Alexander Reid, Paris and Glasgow, 1887; James Gardner Reid, Glasgow, early 1890s; Jos. Hessel Gallery, Paris, early 1890s; Félix Vallotton, Paris, 1897; Paul Vallotton Gallery, Lausanne, 1925; Wildenstein Gallery, London and New York, by 1935; Millicent Rogers, Taos, New Mexico and New York, 1943; Joan Whitney Payson, New York, by 1954; Knoedler Gallery, New York; Mr & Mrs Sydney M. Shoenberg Sr, Saint Louis; Saint Louis Art Museum, 1972 (gift of Sydney M. Shoenberg Sr)

Van Gogh painted several still lifes of fruit in the early autumn of 1887. This version, given to the Glasgow dealer Alexander Reid, depicts ten apples in a wicker basket, set against a striking yellow background and casting a contrasting purple shadow on the table. Van Gogh often signed a work prominently, as here, when it was intended as a gift. The story behind the painting was recounted by Reid to his son McNeill Reid and published in 1930: 'The friends [Van Gogh and Reid] had set out one Sunday morning for Ville-d'Avray, but in the rue Rodier Vincent stood at gaze before a basket of apples and refused to budge. He had no money, so Reid bought it for him and proposed to send it home. But he would not hear of this; he carried it back, painted the apples, and in the evening insisted that the picture was Reid's property.'[4] Reid returned to Glasgow for a visit in March 1888. It may well have been then that he took the still life, along with the portrait (cat.1), and stored them in the family house. Alexander later blamed his father, the dealer James Reid, for selling both Van Goghs while he was away again, but the circumstances remain obscure. The story was that the portrait and still life were sold for £10, to an unnamed French dealer, presumably in the early 1890s. The dealer was probably Jos. Hessel, who was one of the first to handle Van Gogh's work. It now appears that in 1897 Hessel exchanged the *Still Life, Basket of Apples* with the Swiss-French artist Félix Vallotton.[5] Using the same apples, Van Gogh also did another still life, this time with a cool, bluish background, and presented the work to his artist friend Lucien Pissarro (fig.3). Both still lifes eventually came to Britain. Lucien Pissarro brought his version to London when he moved there from Paris in 1890, and kept it until 1906.

REFERENCES

Letter from Vincent to Theo, *c*.2 April 1888, Complete Letters, 1958, vol.II, p.539; D.S. MacColl, 'Vincent van Gogh', *Artwork*, summer 1930, pp.135–6; *French and British Contemporary Art*, National Art Gallery of South Australia, Adelaide, Lower Town Hall, Melbourne and David Jones' Art Gallery, Sydney, 1939, no.132 (kept in Australia until early 1940s because of war); unpublished letter from McNeill Reid to *Apollo*, 20 July 1963 (National Library of Scotland); letters from McNeill Reid to V.W. van Gogh, 5 February and 5 March/April 1965 (Van Gogh Museum archive); McNeill Reid's notes, 1960s (National Library of Scotland, Edinburgh); Douglas Cooper, *Alex Reid & Lefevre 1926–1976*, Lefevre Gallery, London, 1976, p.6; *Félix Vallotton*, Yale University Art Gallery, 1992, p.287; Korn 2001; Korn 2002, pp.122 and 136

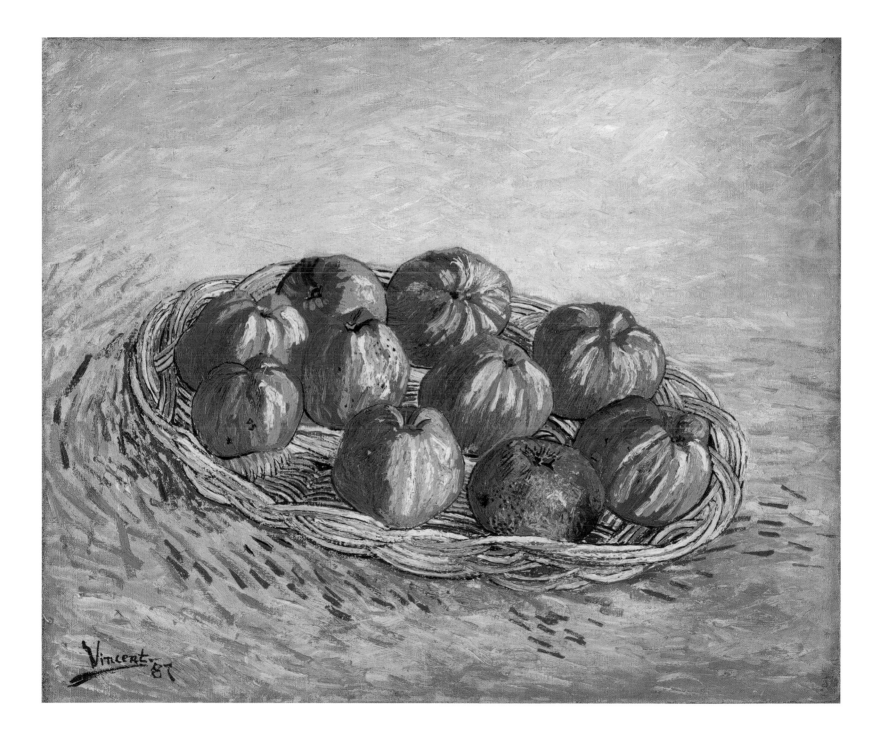

4

LUCIEN PISSARRO
VINCENT IN CONVERSATION

Drawn in Paris in 1887
Black chalk on paper, 18 × 23 cm
Ashmolean Museum, Oxford

REFERENCES
Martin Bailey, 'Theo van Gogh
identified', *Apollo*, June 1994,
pp.44–6

Lucien Pissarro (1863–1944), the son of the Impressionist artist Camille Pissarro, met Van Gogh in Paris in the late spring of 1887. Lucien, then twenty-four, was an artist and illustrator. The two men quickly became friends. It was sometime between the late spring and early autumn that Lucien sketched Vincent, sitting with his arms folded. There are relatively few depictions of Van Gogh by other artists, and this work is, therefore, particularly important. There has been considerable debate over the identity of his companion in the drawing, although it could be argued that it is his brother Theo. The nose of the figure is close to that depicted in other drawings of Theo (and the Van Goghs' father, Theodorus). The more smartly dressed figure, in a top hat, would also seem appropriate for Theo, rather than one of Vincent's artist friends. In the early autumn of 1887 Van Gogh dedicated a painting to Lucien, giving him *Basket of Apples* (fig.3), which he dedicated to 'l'ami Lucien Pissaro', misspelling his surname. In return Lucien gave him a group of his own wood engravings, which are now in the Van Gogh Museum. Lucien was one of the mourners at Vincent's funeral on 30 July 1890. In November 1890 he left Paris, to move to the London area, initially to Epping and then to Bedford Park. He kept this drawing until his death in 1944, when it was bequeathed to the Ashmolean Museum.

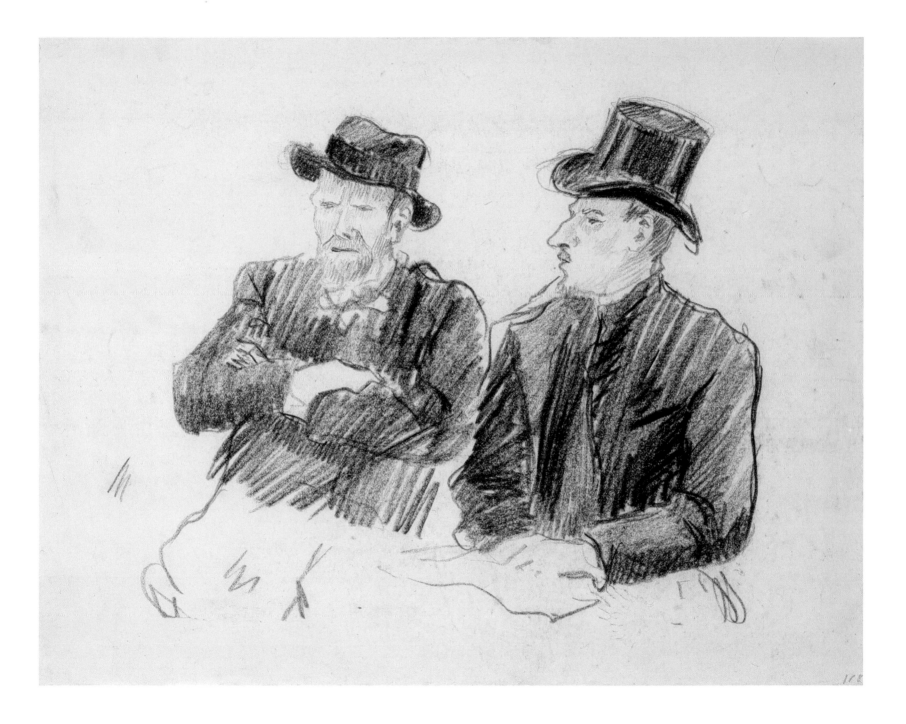

By 1896, only six years after the artist's tragic suicide, eight pictures appear to have been acquired by British collectors, including the London publisher, Fisher Unwin – who probably acquired three works from the artist's colourman Père Tanguy – and the playwright Alfred Sutro. Some of these 'pioneer collectors' had Dutch connections, including William Robinson, the British consul in Amsterdam, who bought *Two Crabs* for £17 in 1893. In the first two decades of the twentieth century Van Gogh's work began to appear in British exhibitions and publications. Public awareness was raised in 1910 when thirty Van Gogh paintings were on view at Roger Fry's groundbreaking show, *Manet and the Post-Impressionists*, held at the Grafton Galleries in London. The press reaction was extreme. Van Gogh was described by one critic as 'a lunatic' and the pictures were judged to be 'of no interest except to the student of pathology and the specialist in abnormality'. Nevertheless, Frank Stoop, a Dutch-born stockbroker, became the first British collector to take a serious interest in Van Gogh. He bought four pictures in 1910 and 1911 which he eventually bequeathed to the Tate Gallery. The Manchester-born collector Herbert Coleman also took an early interest in Van Gogh. He bought *Stairway at Auvers* [F795] from Bernheim-Jeune in Paris and went on to build up a major collection of Post-Impressionist art.

5 TWO CRABS

WILLIAM ROBINSON

William Robinson was born in 1834. He was British consul for North Holland, based in Amsterdam (1882–1906) but with another residence in Bournemouth. During his stay in Amsterdam he built up an important collection of Dutch nineteenth-century art. He died in 1908 in Christchurch, Hampshire.

Two Crabs was probably painted in the middle of January 1889, less than three weeks after Van Gogh had mutilated his ear. He had left hospital and returned to the Yellow House on 7 January, telling Theo that he was about to begin 'one or two still lifes so as to get back into the habit of painting'. Ten days later he said he had 'three finished studies in the studio'.[6] The idea for the subject may have been inspired by a print of two large crabs by the Japanese artist Hokusai, published in a journal that Van Gogh had read the previous September,[7] but he almost certainly bought real crabs from the market in Arles. The painting may well depict only one crab, shown in two positions. What is striking is the use of the powerful complementary reds and greens. The crabs are in warm red-and-yellow tones, set against the much cooler background. The result is a vivid depiction of the creature, emphasising its tough claws. *Two Crabs* was the first Van Gogh painting to be bought by a British collector. It was acquired by William Robinson in May 1893 from Jo van Gogh-Bonger, the widow of Vincent's brother Theo. The price was 200 guilders (£17). Robinson also owned a Van Gogh drawing, *Peasant in a Cart Coupled to an Old White Horse* [possibly F1677]. Robinson was then the British consul in Amsterdam, although he also had a home in Bournemouth. He assembled an important group of late nineteenth-century Dutch art while based in the Netherlands, much of which was dispersed at auction in Amsterdam in 1906. *Two Crabs* fetched only 100 guilders (£8), half of what he had paid thirteen years earlier. The painting has remained in private ownership and, except for short exhibitions in Paris in 1925 and 1960, had never seen by the public before it was auctioned in 2004.

Painted in Arles in 1889
Oil on canvas, 47 × 61 cm
Private Collection, on loan to
The National Gallery, London
F606 / JH1662

PROVENANCE

Theo van Gogh, Paris, 1889; Jo van Gogh-Bonger, Amsterdam, 1891; Miss Schleier, The Hague, 1893; **William Cherry Robinson, Bournemouth and Amsterdam, 1893**; Frederik Muller (auction), Amsterdam, 13 November 1906, lot 33; Bernheim-Jeune Gallery, Paris, 1906; Marquise de Ganay, Paris, by 1925; Bloch family, 1946; Léon Bloch, Paris, by 1960; Sotheby's, London, 21 June 2004, lot 5; Private Collection (on loan to National Gallery, London, from 2004)

REFERENCES

Account Book, p.180; Korn 2001; Korn 2002, pp.123–4 and p.136.

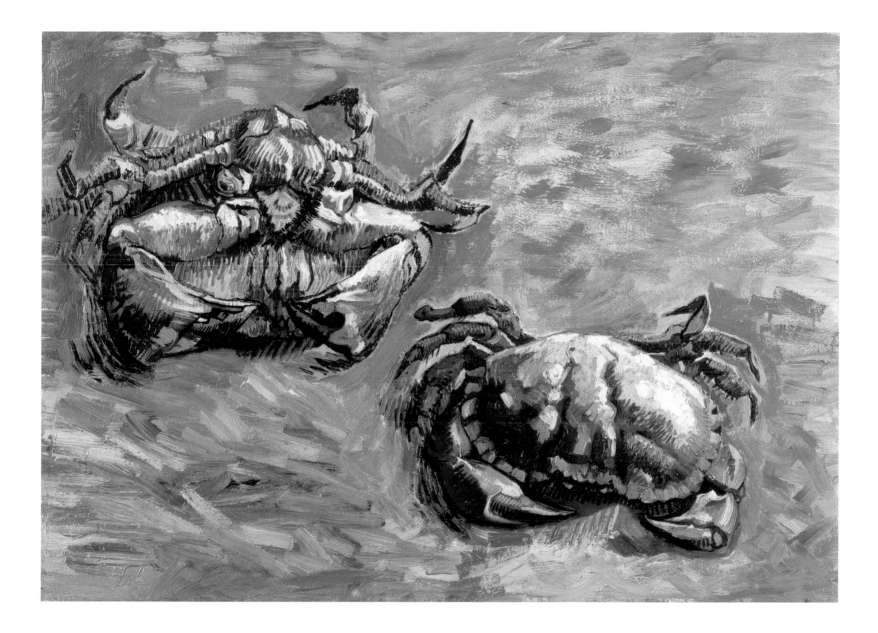

6 FARMS NEAR AUVERS
ACQUIRED BY FRANK STOOP IN 1910

FRANK STOOP

Frank Stoop was born in Dordrecht in 1863. The Stoop family had made its fortune through various enterprises, including shipping, brewing, sugar-refining and salt-making. Frank Stoop moved to London in the early 1890s, to work for the family stockbroking firm, Stoop & Co. and lived with his wife Bertha Keller, née Van Hoorn (1865–1928), at 9 Hans Place, Chelsea. It was she who encouraged him to collect modern art. Stoop formed an important collection during the 1920s, including works by Van Gogh, Cézanne, Picasso, Matisse and Modigliani, which he bequeathed to the Tate. He died on 7 November 1933.

Farms near Auvers was painted between late May and July 1890, within the last few weeks of the artist's life. On 20 May, the day of his arrival at Auvers, Van Gogh wrote to his sister Wil saying that 'there are moss-covered thatched roofs which are superb, and which I am certainly going to do something with.'[8] However, the indications of ripening corn in the painting suggest that this work might have been done slightly later, perhaps in July. The format is large, a 'double square' canvas, and the powerful swirling lines of the brushwork give it great vitality. The site is Valhermeil, a hamlet just to the west of Auvers. The old thatched farmhouses dominate the composition. Four stylised sunflowers decorate the left half of the foreground, and were probably added later in the studio. Behind the cottages, a patchwork of fields rises up. Only a narrow band of sky is at the top, where the canvas was left blank (it is not clear whether this was intended or if the painting remained unfinished). Van Gogh was to describe the Auvers countryside as an 'immense plain with wheatfields against the hills, boundless as a sea, delicate yellow, delicate soft green … '[9] It was in these wheatfields that he was to shoot himself on 27 July 1890, dying two days later. *Farms near Auvers* was bought by the first major British collector of Van Gogh, Frank Stoop, a Dutch-born London stockbroker. This was his first Van Gogh, purchased in January 1910 from the Cassirer Gallery in Berlin, for 8,000 marks (£400). The price illustrates the rise in the market value of Van Gogh's work in the early 1900s. The purchase just pre-dated the *Manet and the Post-Impressionists* exhibition, which took place in November 1910 and introduced the Dutch artist to a wider British audience. Stoop went on to buy three Van Gogh works on paper in March 1911 (cats.7–9).

Painted in Auvers in 1890
Oil on canvas, 50 × 100 cm
Tate, London, bequeathed by Frank Stoop in 1933 (on long-term loan to The National Gallery)
F793 / JH2114

PROVENANCE

Theo van Gogh, Paris, 1890; Jo van Gogh-Bonger, Amsterdam, 1891; Bernheim-Jeune Gallery, Paris, 1907; Alfred Walter von Heymel, Bremen, 1910; Paul Cassirer Gallery, Berlin, 1910; **Cornelis Frank (Frederick) Stoop, London, 1910**; Tate Gallery, London, 1933 (Stoop Bequest); National Gallery, London, 1997 (long-term loan from Tate) .

REFERENCES

Vincent van Gogh, Oxford Arts Club, 1924, no.3; *Dutch Art*, Royal Academy, London, 1929, no.467; J.B. Manson, 'Mr Frank Stoop's Modern Pictures', *Apollo*, September 1929, pp.127–33; *Vincent van Gogh en Zijn Tijdgenooten*, Stedelijk Museum, Amsterdam, 1930, no.110; correspondence on 1930 Stedelijk exhibition (Van Gogh Museum archive); John Hope-Johnstone, 'La collection Stoop', *L'Amour de l'Art*, 1932, pp.197–202; Stoop bequest papers (Tate archive); letter from Jim Ede to Ronald Alley, 30 July 1952 (Tate archive); Kenneth Clark, *Another part of the wood*, London, 1974, pp.117–8; Robert Burgerhoff Mulder, 'Frank Stoop's collection', undated paper (Tate archive); Dennis Farr, 'J.B. Manson and the Stoop bequest', *Burlington*, November 1983, pp.689–90; Feilchenfeldt 1988, p.121; Account Book, p.191; Korn 2001; Korn 2002, pp.126–7 and p.136

THATCHED ROOFS

ACQUIRED BY FRANK STOOP IN 1911

Drawn in Nuenen in 1884
Ink, pencil and gouache on paper,
31 × 45 cm
Tate, London, bequeathed by Frank
Stoop in 1933 (on long-term loan to
The British Museum)
F1242 / JH474

PROVENANCE

Theo van Gogh, Paris, 1884; Jo van
Gogh-Bonger, Amsterdam, 1891;
C.M. van Gogh Gallery, Amsterdam,
1911; **Cornelis Frank (Frederick)
Stoop, London, 1911**; Tate Gallery,
London, 1933 (Stoop Bequest); British
Museum, London, 2002 (long-term
loan from Tate)

REFERENCES

Correspondence between J.H. de
Bois and Jo van-Gogh Bonger, 1911
(Van Gogh Museum archive); *Vincent
van Gogh*, Oxford Arts Club, 1924,
no.10; *Vincent van Gogh en Zijn
Tijdgenooten*, Stedelijk Museum,
Amsterdam, 1930, no.112; Heijbroek
and Wouthuysen 1993, pp.32, 179 and
203; Account Book, p.193

Thatched Roofs depicts a group of cottages at Nuenen, the village in the south of the Netherlands where Vincent's father worked as a preacher. Van Gogh stayed there from December 1883 to November 1885, making great strides with his art. This drawing, with its bare winter trees, probably dates from March 1884. At the end of the month Vincent sent three pen-and-ink drawings to his artist friend Anthon van Rappard, including one he called 'Thatched roofs', which is almost certainly the Tate work. Van Gogh explained that he had rather neglected the composition and execution, but had done them in a 'rough sort of way in order to render the effect of light and brown – the atmosphere of the scenery as it was at that moment'.[10] This drawing shows a small group of cottages, some with smoking chimneys. Van Gogh was fond of the thatched-cottage motif, right up to the end of his life. In the foreground are two fields or gardens, separated by a hedge. The sun seems low in the sky, suggesting dawn. The location may well be a hamlet just outside Nuenen. A year after buying the painting *Farms near Auvers* (cat.6), which also featured thatched farmhouses, Frank Stoop had decided to acquire some drawings. In January 1911, on a visit to Amsterdam, he was given an introduction to Jo van Gogh-Bonger by the Amsterdam-based C.M. van Gogh Gallery, set up by Cornelius Marinus van Gogh, an uncle of the artist. Jo sent Stoop a group of eleven works on approval and he subsequently bought two drawings and a gouache in March 1911. These included *Thatched Roofs*, sold by the Amsterdam gallery for 650 guilders (£54). Although Stoop was born in Dordrecht, he had come to London in the early 1890s, with his wife Bertha, to work for the family stockbroking firm, Stoop and Co. Their Chelsea home eventually housed a magnificent collection of modern art, and in addition to his Van Goghs, he had important works by Cézanne, Degas, Matisse and Picasso.

A CORNER OF THE GARDEN OF ST PAUL'S HOSPITAL AT ST-REMY

ACQUIRED BY FRANK STOOP IN 1911

Drawn in St-Rémy in 1889
Ink, pencil and chalk on paper,
62 × 48 cm
Tate, London, bequeathed by Frank
Stoop in 1933 (on long-term loan to
The British Museum)
F1497 / JH1852

PROVENANCE

Theo van Gogh, Paris, 1889; Jo van
Gogh-Bonger, Amsterdam, 1891;
C.M. van Gogh Gallery, Amsterdam,
1911; **Cornelis Frank (Frederick)
Stoop, London, 1911**; Tate Gallery,
London, 1933 (Stoop Bequest); British
Museum, London, 2002 (long-term
loan from Tate)

REFERENCES

Vincent van Gogh, Oxford Arts Club,
1924, no.11; *Vincent van Gogh en Zijn
Tijdgenooten*, Stedelijk Museum,
Amsterdam, 1930, no.115;
Feilchenfeldt 1988, p.135; Heijbroek
and Wouthuysen 1993 pp.32, 179 and
205; Account Book, p.197

This drawing was done in the asylum at St-Rémy, twenty-five kilometres from Arles, where Van Gogh had come after his period in hospital. He arrived on 8 May 1889 and this work dates from soon afterwards, probably late May or early June. During the first month of his stay he was not allowed to go outside the walls of the asylum, and he therefore spent much of the time painting and drawing in the garden, enjoying the springtime weather. Van Gogh quickly used up the paint which he had brought from Arles, and he then turned to drawing, presumably completing this work before his new paint supplies from Theo arrived on 8 June. The Tate work was probably part of a group of 'hasty studies in the garden' which Vincent sent to Theo on about 19 June.[11] *A Corner of the Garden of St Paul's Hospital at St-Rémy* depicts the south-west corner of the asylum garden. The swirling pine trees, which appear to be moving in the wind, are typical of Van Gogh's style of the period. Beyond the trees, with their twisted trunks, is the wall, which kept in the patients. Farther away is the roof of the porter's lodge. In the middle of the garden there is a figure bending over, perhaps a gardener, although he is now not very prominent. Three iris blooms are in the left foreground. The drawing was done in pencil and chalk, and some ink was added with a reed pen, but the black ink has now faded to brown. Frank Stoop paid 1250 guilders (£114) for *A Corner of the Garden of St Paul's Hospital at St-Rémy*, which was one of three Van Gogh works on paper that he bought in March 1911.

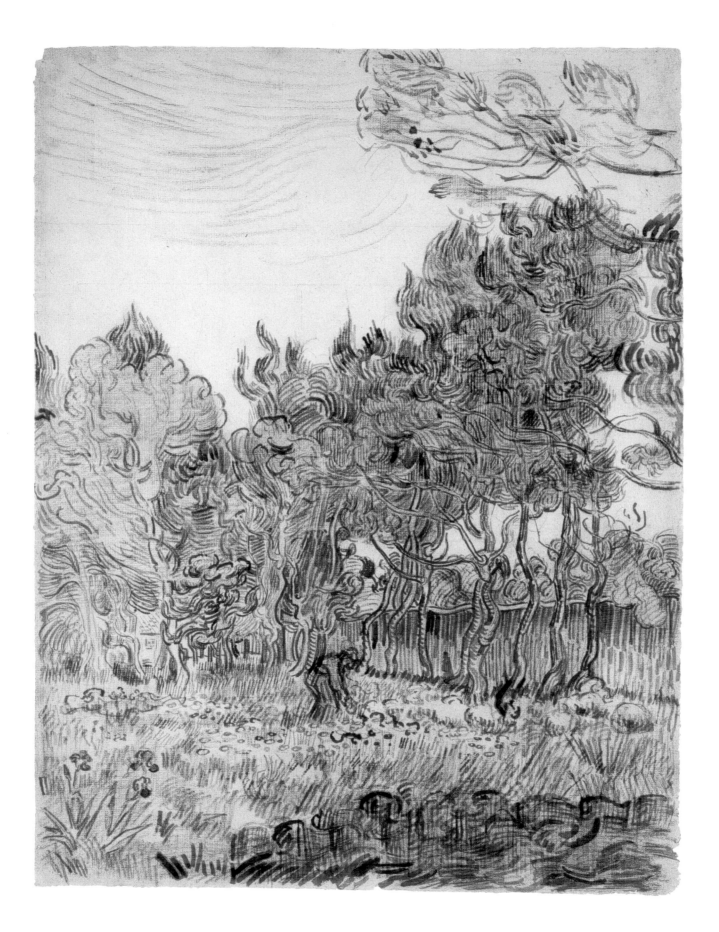

THE OISE AT AUVERS

Painted in Auvers in 1890
Pencil, gouache and diluted oil on paper, 48 × 63 cm
Tate, London, bequeathed by Frank Stoop in 1933 (on long-term loan to The British Museum)
F1639 / JH2023

PROVENANCE

Theo van Gogh, Paris, 1890; Jo van Gogh-Bonger, Amsterdam, 1891; C.M. van Gogh Gallery, Amsterdam, 1911; **Cornelis Frank (Frederick) Stoop, London, 1911**; Tate Gallery, London, 1933 (Stoop Bequest); British Museum, London, 2002 (long-term loan from Tate)

REFERENCES

Vincent van Gogh, Oxford Arts Club, 1924, no.4; *Vincent van Gogh en Zijn Tijdgenooten*, Stedelijk Museum, Amsterdam, 1930, no.120; Feilchenfeldt 1988, p.138; Heijbroek and Wouthuysen 1993, pp.32, 179 and 206; Account Book, p.197

This powerful landscape shows the view from just outside Auvers looking across the River Oise towards the village of Méry. It was probably done in early June 1890, within a few weeks of Van Gogh's arrival in Auvers on 20 May, while he was discovering the area. He painted the work from an embankment above the railway line, and the swirls in the lower-right corner may well be smoke from a passing train. The composition then continues with a diagonal track (rue Rajon) which runs into the centre of Auvers, followed by a series of fenced meadows (one with seven cows). Three figures are included, two with a wheelbarrow in the centre foreground and one working in a field at the right. Beyond the meadows is the poplar-lined River Oise. There are two factories on the far side of the river, one on the left and the other in the centre, partially hidden by tall trees. The wrought-iron bridge at the right was only six months old when Van Gogh arrived, but has since been replaced. The scene, on a large sheet, was first sketched in pencil, and objects such as the cows, trees and factories were then delineated with ink. Gouache was added after this, and it has recently been found that diluted oil paint was also used. The drawing is on pink paper and much of the sky was left empty, other than the swirls of pink paint, which have now turned almost white. The pink ground also shows through in the meadows. The factory roofs were described as vermilion in De la Faille's 1928 catalogue, but have since faded. Frank Stoop bought *The Oise at Auvers* in March 1911 for 1600 guilders (£133). On his death in 1933, Stoop bequeathed seventeen French works to the Tate Gallery, along with all four of his Van Goghs.

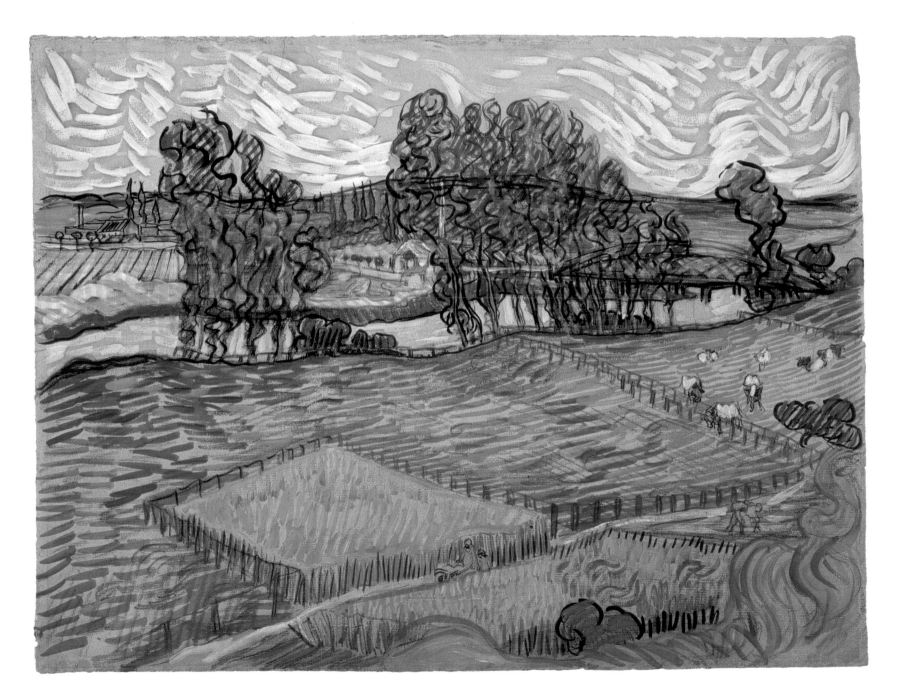

10

PEASANT DIGGING

Drawn in Etten in 1881
Black chalk on paper, 32 × 22 cm
P. and N. de Boer Foundation,
Amsterdam
F860 / JH38
[Edinburgh only]

PROVENANCE
C.M. van Gogh Gallery, Amsterdam;
Van Wisselingh Gallery, London;
Gérard H. Slot, London;
Unidentified sale, London, 1913;
Frank Wilson, London, by 1928;
Sotheby's (unidentified sale),
London, 1956; P. and N. de Boer
Foundation, Amsterdam, 1956

REFERENCES
De la Faille 1928, p.10, vol.III

This very early drawing dates from September 1881, and was done
in Etten, where Van Gogh was living with his parents. The village
in Brabant, in the southern Netherlands, was a farming commu-
nity. Van Gogh had only taken up drawing a year earlier and was
entirely self-taught. In this work, the silhouette of the peasant
extends just above the horizon, where two cottages can be seen.
The pose, particularly the back, is clumsy, but Van Gogh returned
time and again to tackle the theme of peasants working in the
fields, gradually improving his style. The peasant digging in this
sketch may well be the man whom Van Gogh described in a letter
in September 1881: 'My drawing has changed, the technique as
well as the results … I have begun to work from a live model
again. Fortunately, I have been able to persuade several persons
here to sit for me, Piet Kaufmann, the gardener, for instance …
So what seemed to be impossible before is now gradually becom-
ing possible, thank God. I have drawn five times over a man with a
spade, a digger, in different positions … I have to observe and
draw everything that belongs to country life … I no longer stand
helpless before nature, as I used to.'[12] This letter also included a
small sketch of a peasant who appears to be the same man as in
Peasant Digging. The first recorded owner of the drawing is Gérard
Slot, who sold the work in 1913, and it was probably then that it
was bought by Frank Wilson. Nothing is known of the two men,
beyond the fact that they lived in London. Both also owned
another early Van Gogh drawing, *The Thatched Hut* [F875]. *Peasant
Digging* may well have remained with Wilson, or his family, until
1956, when it was acquired by the Amsterdam-based P. and N. de
Boer Foundation.

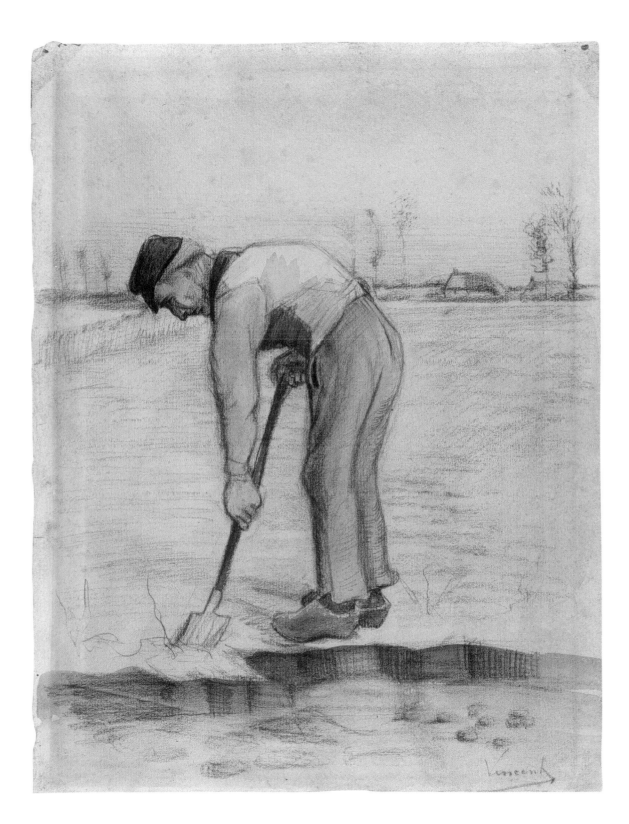

EARLY COLLECTORS

Just after the First World War important collections of Impressionist and Post-Impressionist art were being formed in Britain. Among the earliest and most important collectors were Gwendoline and Margaret Davies, two unmarried teetotal Calvinistic Methodists from mid-Glamorgan, who were the granddaughters of David Davies of Llandinam, one of the richest men in Wales. They inherited a large fortune which came from coalmining and from the development of the docks and railways during the industrial revolution. Just after the First World War Gwendoline Davies bought outstanding works by Monet and Cézanne, as well as a late work by Van Gogh *Rain – Auvers*. During the early 1920s a number of Scottish collectors, many of whom had already developed a taste for the brilliant palette and loose handling of the Scottish Colourists, also took an interest in Van Gogh. These included the Glasgow shipbuilder William McInnes, who bought *Le Moulin de Blûte-fin* (fig.17) in 1921; William Boyd, owner of Keiller's jam factory in Dundee, who acquired *Orchard in Blossom,* now in the National Gallery of Scotland, and two other paintings; and Elizabeth Russe Workman, the Scottish wife of a shipbroker, who bought three Van Goghs in 1923. In England the textile magnate Samuel Courtauld and the educationalist Michael Sadler emerged as the most significant collectors of this period. In June 1923 Courtauld offered £50,000 to set up a special fund for the purchase of Impressionist and Post-Impressionist pictures for the National Gallery, Millbank. These included *Wheatfield, with Cypresses,* the first painting by Van Gogh to enter a public collection in Britain.

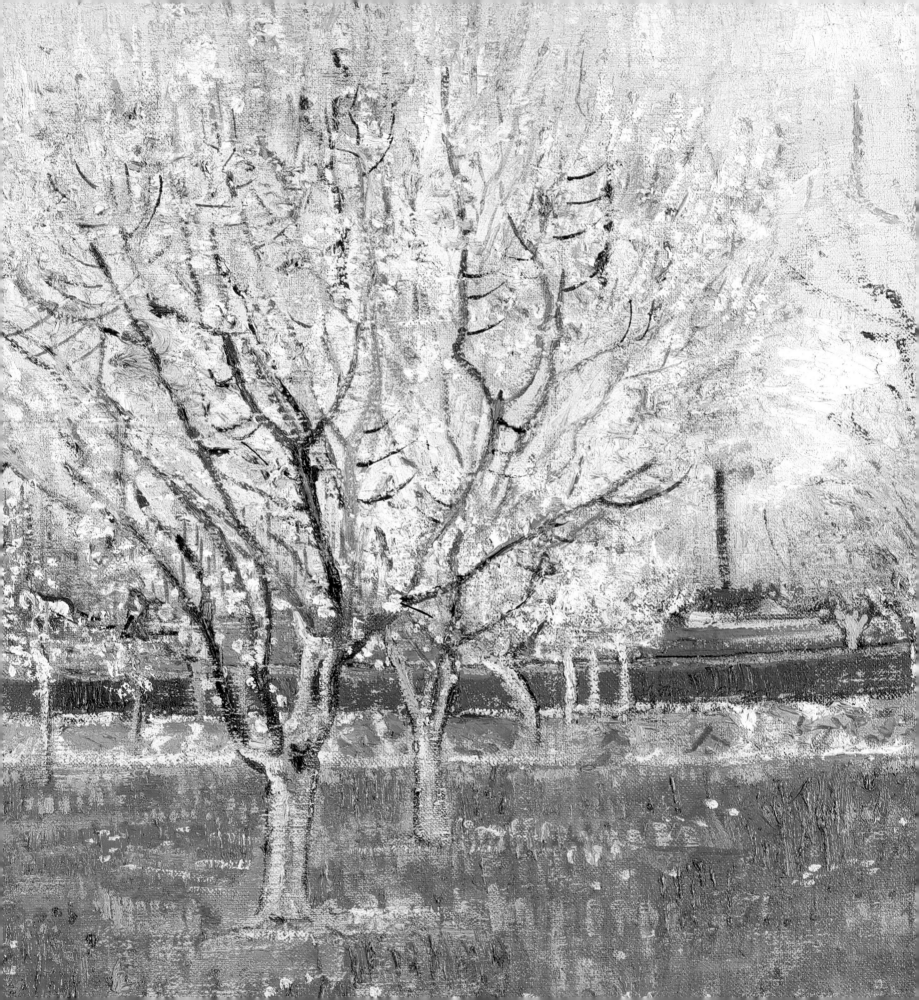

RAIN – AUVERS

ACQUIRED BY GWENDOLINE DAVIES IN 1920

GWENDOLINE DAVIES

Gwendoline Davies was born at Plas Dinam, Montgomeryshire, on 11 February 1882. She and her younger sister Margaret (1884–1963) inherited great wealth from their grandfather, David Davies (1818–90) who made his fortune from coalmining and from the development of the docks and railways during the industrial revolution. Advised by Hugh Blaker, they began collecting art in 1908 and were the principal collectors of Impressionist and Post-Impressionist painting in Britain before the First World War. During the war the two sisters, who never married, ran a canteen for French troops in Troyes. In 1920 they took over Gregynog, a house near Newtown, and set it up partly as a centre for art, craft and music. In 1951 and 1963 they bequeathed their outstanding collection of 264 works to the National Museums & Galleries of Wales. Gwendoline died in Oxford on 3 July 1951.

Rain – Auvers was painted in July 1980, a few weeks before Van Gogh shot himself. The scene represented is the view towards the village from the track which leads up to the wheatfields and the cemetery. On the right side Van Gogh has shown the diagonal track crossing the wheatfields, with several hovering crows. In the middle distance are the roofs of Auvers, tucked into the valley among trees, with the church spire on the left. The streaky rain effect is reminiscent of Japanese prints, particularly the artist Hiroshige in works such as *Shower on the Ohashi Bridge*. It is interesting to note that a few weeks before Gwendoline Davies brought this painting to Wales, it was nearly bought by the avant-garde Japanese collector Koyata Yamamoto, who was in the process of setting up an art museum in the city of Ashiya.[13] Gwendoline Davies and her sister Margaret lived at Gregynog Hall, Newtown, and together they were important collectors, advised by artist and dealer Hugh Blaker. The unmarried sisters inherited great wealth from their grandfather David Davies, who made his fortune from railways and coal; they had a strong social conscience, with a personal mission to patronise the arts, both visual art and music. Gregynog Hall effectively became a privately run arts centre in rural Wales. Gwendoline Davies acquired *Rain – Auvers* in April 1920 for 100,000 francs (£2,000) from Bernheim-Jeune in Paris, a gallery which the Davies sisters had got to know during their stay in France during the First World War. The painting hung in the music room at Gregynog. It was the last major artwork purchased by Gwendoline Davies, but by this time she and her sister had assembled what was then the finest collection in Britain of the Impressionists and Post-Impressionists, including works by Renoir, Manet, Pissarro, Monet and Cézanne. Gwendoline died in 1951, bequeathing her collection to the National Museums & Galleries of Wales. Her younger sister Margaret died in 1963, also leaving her art to the Cardiff gallery.

Painted in Auvers in 1890
Oil on canvas, 50 × 100 cm
National Museums & Galleries of Wales, Cardiff
F811 / JH2096

PROVENANCE

Theo van Gogh, Paris, 1890; Jo van Gogh-Bonger, Amsterdam, 1891; Bernheim-Jeune Gallery, Paris, 1909; **Gwendoline Elizabeth Davies, Gregynog, Newton, Wales, 1920**; National Museums & Galleries of Wales, Cardiff, 1952 (Davies Bequest)

REFERENCES

Letter from Bernheim-Jeune to Gwendoline Davies, 12 March 1920 and invoice, 30 April 1920 (National Museums & Galleries of Wales records); John Ingamells, *The Davies Collection of French Art*, National Museum of Wales, Cardiff, 1967, pp.86–8; Feilchenfeldt 1988, p.122–3; Account Book, p.192; Korn 2001; Korn 2002, p.136; Eric Rowan and Carolyn Stewart, *An Elusive Tradition*, Cardiff, 2002, pp.124–53; *Vincent and Theo van Gogh*, Hokkaido Museum of Modern Art, 2002, p.271; ODNB; *Journal of the History of Collecting*, November 2004, pp.173–253; *Colour and Light*, National Museums & Galleries of Wales, Cardiff, 2005, pp.21–9 and 70–2

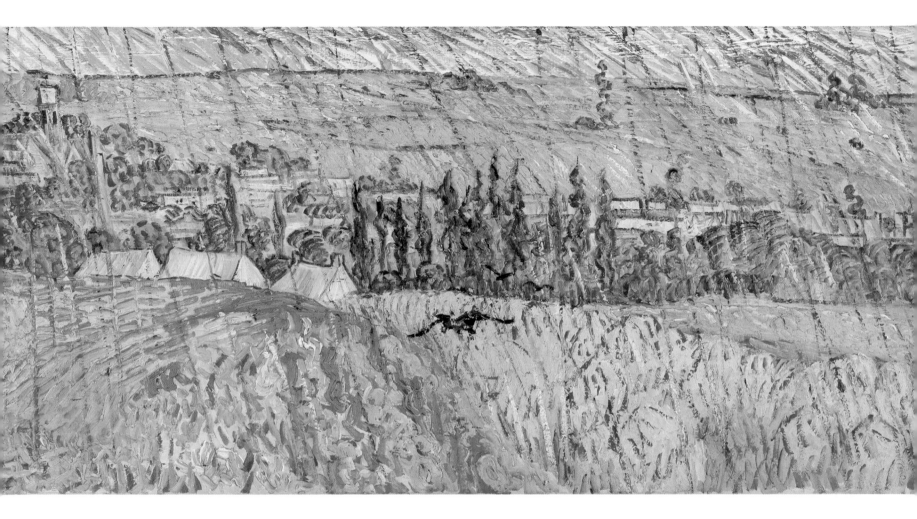

VIEW OF A RIVER WITH ROWING BOATS

ACQUIRED BY JOHN TATTERSALL BY 1928

JOHN TATTERSALL

John Tattersall lived in Dundee. He was an art dealer and collector who worked briefly as Alexander Reid's partner at his Glasgow gallery in 1916. Tattersall was a friend of the Dundee collector/agent Matthew Justice, with whom he formed a close collaboration. He was also acquainted with the artist George Leslie Hunter, who greatly admired Van Gogh, and the collectors William McInnes and William Boyd, both of whom collected Van Gogh. Tattersall's personal collection also included works by Bonnard, Vuillard and Othon Friesz.

The view is of the River Seine near Asnières, a northwestern suburb of Paris, where Van Gogh often painted during the summer of 1887. *View of a River with Rowing Boats* was done just over a year after his arrival in Paris. By this time his palette had lightened and his use of short parallel brushstrokes was influenced by the Neo-Impressionists. Van Gogh stood just downstream from the railway bridge, on the north bank of the river. On the near side of the river is a line of small moored boats, with the nearest painted in orange tones, contrasting with the complementary blue of the river. Just a few buildings on the Paris side are visible across the river, on the left edge, but the bank is mainly lined with trees. The taller trees at the far right are on the tip of the Ile de la Grande Jatte, an area much painted by the Impressionists. Van Gogh's composition is dominated by the large expanse of sky and the triangular block of the water, so that tones of blue dominate the canvas. It is possible that the painting was exhibited in London as early as 1913, in the *Post-Impressionist and Futurist* show at the Doré Gallery. The exhibition catalogue records a picture called 'Boats at Anchor', and in 1928 De la Faille entitled the work acquired by John Tattersall 'Canots amarrés' (Moored Boats). What is certain is that the painting was sold by the Independent Gallery in London, probably in 1925, and bought by Tattersall. Based in Dundee, Tattersall was a minor dealer, and a keen collector of modern art. There were three other early collectors of Van Gogh in Dundee: Matthew Justice, William Boyd (cats.13–14) and Royan Middleton. Tattersall, Justice and Boyd knew each other, creating a most important clique of Van Gogh collectors in the 1920s. In 1935 *View of a River with Rowing Boats* was purchased by Royan Middleton, a publisher of greetings cards, who was also from Dundee. The painting stayed in his family until it was auctioned in 1991.

Painted in Paris in 1887
Oil on canvas, 52 × 65 cm
Private Collection
F300 / JH1275

PROVENANCE

Gaston de Villiers (Gaston Bernheim), Paris; Bernheim-Jeune Gallery, Paris, 1912; Independent Gallery, London, 1925; **John Tattersall, Dundee, by 1928**; Royan Middleton, Dundee and Aberdeen, 1935 (on loan to National Gallery of Scotland, 1938); Sotheby's, London, 3 December 1991, lot 18; Private Collection

REFERENCES

Post-Impressionist and Futurist, Doré Galleries, London, 1913, no.15 (?); *French Painting*, Independent Gallery, London, 1925, no.27; *Scottish and Foreign Artists*, Kirkcaldy Art Gallery and Museum, 1928, no.122; *Dutch Art*, Royal Academy, London, 1929, no.468; *Modern Pictures*, Dundee Corporation Galleries, 1929, no.107; Korn 2001; Korn 2002, p.136

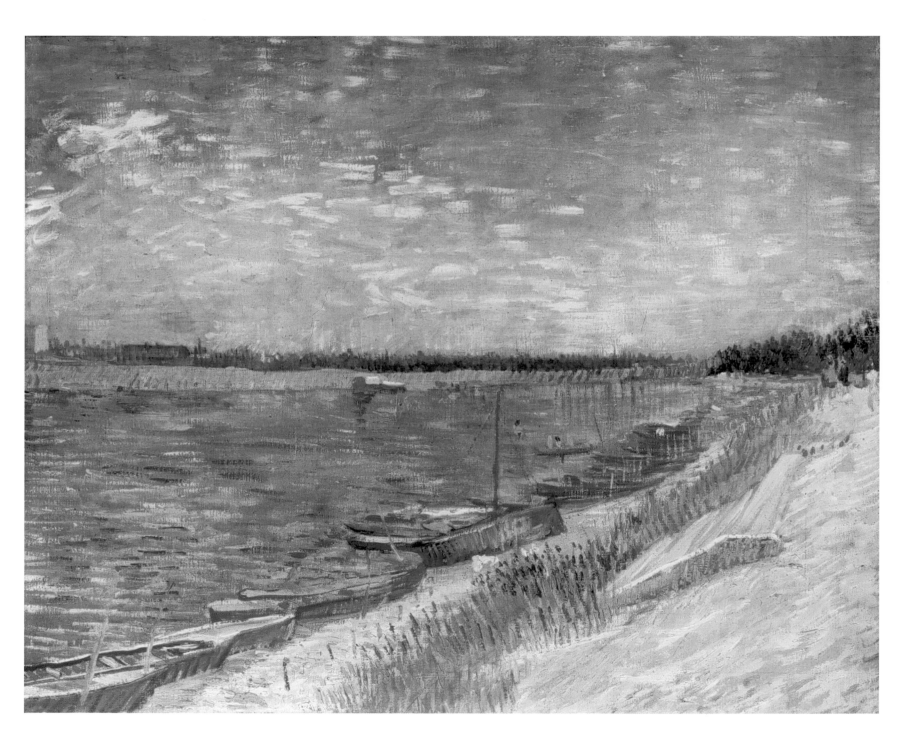

13 FIELD WITH PLOUGHMAN

ACQUIRED BY WILLIAM BOYD BY 1925

WILLIAM BOYD

William Boyd was born in Dundee around 1873. His family owned the Dundee firm of James Keiller & Son, chocolate and jam manufacturers. They sold the business in 1920 and Boyd built Claremont in West Ferry for his retirement. He had a fine collection of modern French paintings, including works by Monet, Sisley, Bonnard, Vuillard, Marchand and Friesz. He also collected pictures by Scottish artists such as McTaggart, Peploe and Hunter. He died in July 1941.

Field with Ploughman was painted in September 1889 in St-Rémy, five months after Van Gogh's arrival at the asylum. The view is very loosely that from his room in the asylum, seen through the barred window. It was based on a painting which he had done a few weeks before, *Enclosed Field with Ploughman* [F625, now Private Collection]. He described this earlier work, on about 30 August 1889, as 'a field of yellow stubble that they are ploughing, the contrast of the violet-tinted ploughed earth with the strips of yellow stubble, background of hills.'[14] The slightly later Boston painting depicts a ploughman and two horses at work, with several ploughed strips, revealing the dark earth between the golden stubble. The large field dominates the composition. The roof of a cottage is visible behind rising ground. The artist departed considerably from reality, removing the high wall which surrounded the asylum and adding two windmills in the distance (the second further away and very small). Beyond this are the hills of Les Alpilles. The picture was bought by William Boyd, probably in the early 1920s, since in October 1925 he lent it to an exhibition in Norwich. Boyd ran the Scottish jam company, James Keiller & Son, which just over a century earlier had 'invented' marmalade. He lived at West Ferry, Dundee, and became an important collector of modern Scottish and French art. He also purchased two other Van Gogh paintings, *Orchard in Blossom (Plum Trees)* (cat.14) and *Trees* [F817]. In 1936 *Field with Ploughman* passed through the Arthur Tooth Gallery in London and was bought by William Coolidge, an American who had studied in Oxford. By coincidence, he too was to make his wealth from oranges, since he helped fund the development of freeze-dried juice. Coolidge bequeathed *Field with Ploughman* to Boston's Museum of Fine Arts in 1993. In 1936 Coolidge had bought a Van Gogh drawing, *Shrub in the Public Garden* [F1465], which he gave a few years later to his British friends Edward and Thalia Gage.

Painted in St-Rémy in 1889
Oil on canvas, 54 × 65 cm
Museum of Fine Arts, Boston
F706 / JH1794
[Edinburgh only]

PROVENANCE

Willemina van Gogh (?), Leiden; Josse and Gaston Bernheim-Jeune, Paris, by 1920; **William Boyd, Dundee, by 1925**; Arthur Tooth Gallery, London, 1936; William Appleton Coolidge, Boston and Topsfield, Massachusetts, 1936; Museum of Fine Arts, Boston, 1993 (Coolidge Bequest)

REFERENCES

Centenary of the Museum, Norwich Castle Museum, 1925, no.64; *Inaugural Fine Art Loan Exhibition*, Kirkcaldy Art Gallery, 1925, no.36; *Autumn Exhibition*, Walker Art Gallery, Liverpool, 1927, no.935; *Annual Exhibition*, Royal Scottish Academy, Edinburgh, 1929, no.354; Feilchenfeldt 1988, p.114; Korn 2001; Korn 2002, pp.134–6

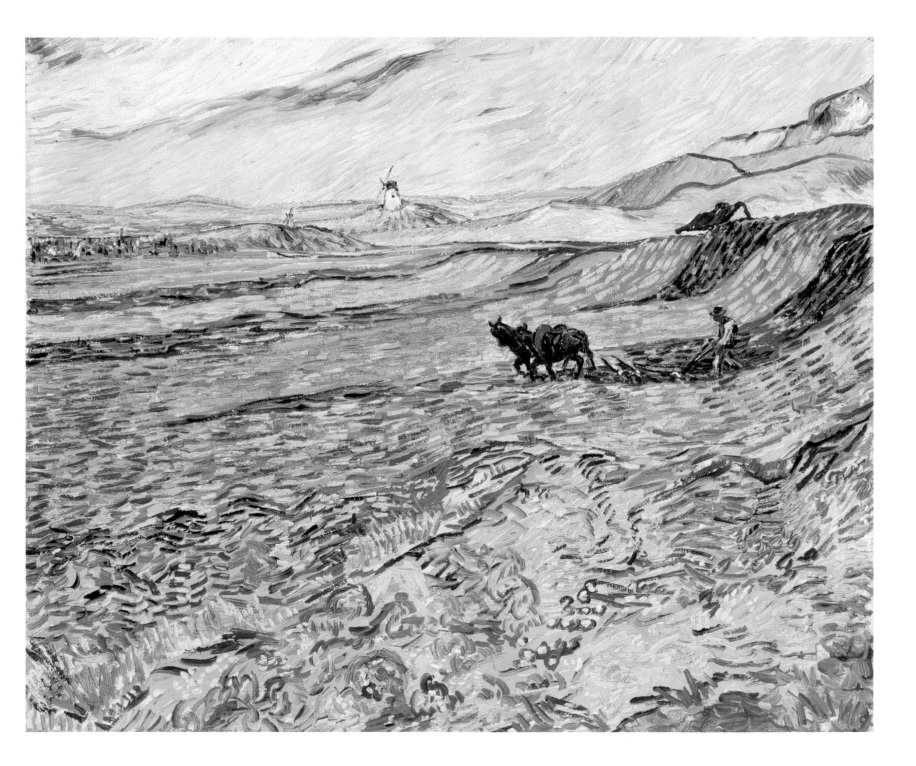

Painted in Arles in 1888
Oil on canvas, 55 × 65 cm
National Gallery of Scotland,
Edinburgh
F553 / JH1387

PROVENANCE

Theo van Gogh, Paris, 1888; Jo van
Gogh-Bonger, Amsterdam, 1891;
Georges Bernheim, Paris; Bernheim-
Jeune Gallery, Paris; **William Boyd,
Dundee, by 1930**; Robertson &
Bruce Gallery, Dundee; Alexander
and Rosalind Gertrude Craig (née
Sellar) Maitland, Edinburgh, 1937;
National Gallery of Scotland, Edin-
burgh, 1960 (Maitland Gift)

REFERENCES

19th and 20th Century French Paintings,
Independent Gallery, London, 1930,
no.21; Robertson & Bruce invoice, 10
June 1937 (NGS records); loan to NGS,
1938; *French Art*, NGS, 1944, no.183;
The Maitland Gift, NGS, 1963, pp.36–7;
Benno Schotz, *Bronze in my Blood*,
Edinburgh, 1981, p.152; letter from
Bernheim-Jeune to NGS, 8 Septem-
ber 1983 (NGS records); Korn 2001;
Korn 2002, pp.134–6

Orchard in Blossom (Plum Trees) was probably painted in April 1888, two months after Van Gogh's move to Arles. It is one of a series of orchard scenes which Van Gogh did during the spring, capturing the blossoming fruit trees of Provence. His orchard scenes bloom with new life, a reflection of his excitement at discovering the Arles countryside. Van Gogh hoped that some of these works would be displayed in groups of three, as a sort of triptych. The Edinburgh picture is thinly painted with much of the ground of the canvas showing through. Beyond the plum orchard, and the line of willow trees, is one of the factory chimneys of the town, an unexpected intrusion in this bucolic scene. The orange roof contrasts with the predominantly green foreground. Barely visible near the horizon, just to the left of the centre, is the tiny figure of a ploughman. The painting is prominently signed at the lower left, suggesting that Van Gogh was pleased with the work. *Orchard in Blossom* was bought by William Boyd, from Paris dealer Bernheim-Jeune, at some point in the 1920s. Glasgow sculptor Benno Schotz later suggested that Boyd might want to endow a Chair of Dentistry at the University of St Andrews, and in 1937 Boyd sold the picture to help raise the necessary funds (although it only provided a relatively small part of the £17,500 endowment). The sale took place through the Dundee dealers Robertson & Bruce. It may also have been at this point that Boyd sold a second Van Gogh landscape, a later Auvers work entitled *Trees* [F817]. *Orchard in Blossom* was bought in 1937 for £2,500 by Alexander Maitland, who donated it to the National Gallery of Scotland in 1960.

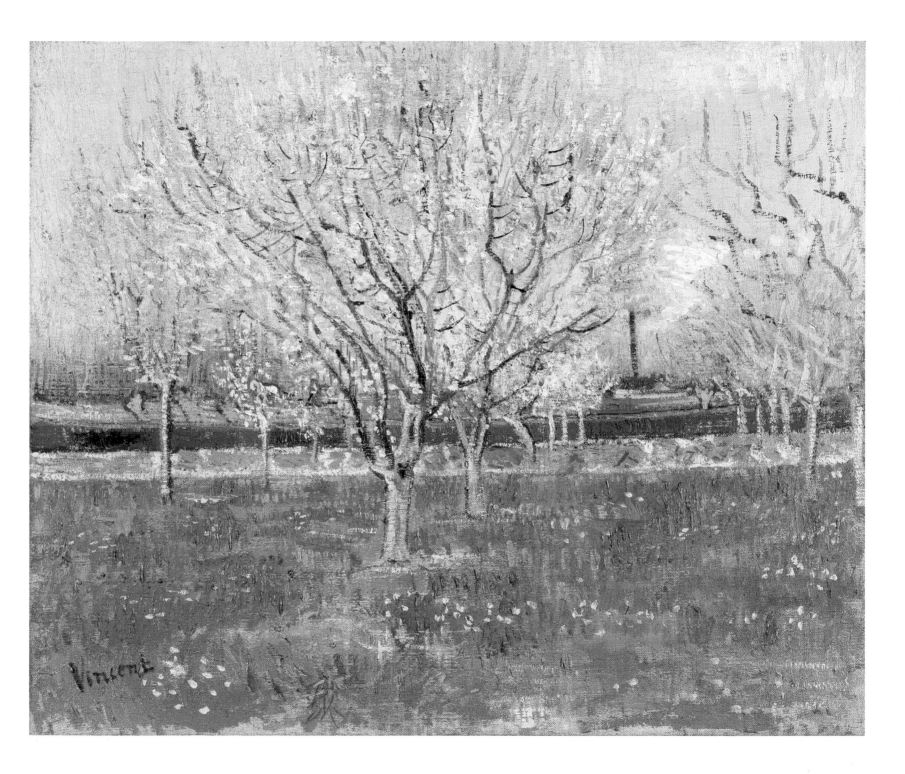

UNKNOWN ARTIST

STILL LIFE WITH DAISIES AND POPPIES

ACQUIRED BY SIR JAMES MURRAY BY 1923

SIR JAMES MURRAY

James Murray was born in Aberdeen on 18 September 1850. He was a dealer in cattle hide and tallow, through the family firm of W. Murray & Son, and Liberal Member of Parliament for East Aberdeenshire (1906–10). He was also chairman of Aberdeen Art Gallery (1901–28). He died in Aberdeen on 12 April 1933.

Still Life with Daisies and Poppies was one of the earliest fakes to be unwittingly bought by a British collector. By 1923 it was owned by Sir James Murray, an Aberdeen-based businessman, who had bought it from London's French Gallery. The work was sold with a large part of his collection in 1927, when it became the first Van Gogh painting to be auctioned in Britain, fetching 1,200 guineas (£1,260) at Christie's. It was bought by Sir Laurence Philipps, who later became Lord Milford. Shortly after the purchase, it was realised that the picture was a fake. It emerged that it had been sold by the Otto Wacker Gallery in Berlin, which became infamous in 1928 over the sale of thirty forgeries. Wacker also sold three 'Van Goghs' that may not have been deliberately forged, but which were slightly earlier works that had been falsely attributed to the Dutch master. *Still Life with Daisies and Poppies* was one of these three, since Murray had owned it in 1923, before Wacker ordered the forgeries. The picture is unsigned, so it is unclear whether it was originally painted to deceive or not. The still life has been hidden away since it was exposed as a fake, only once being briefly exhibited, in Aberystwyth in 1946. It has never before been reproduced in colour. The location of the painting is unrecorded in the Van Gogh literature, but it is at Picton Castle, in Pembrokeshire.

Probably painted in the early twentieth century
Oil on canvas, 41 × 34 cm
Picton Castle Trust, Pembrokeshire
F325 / JH –

PROVENANCE

Otto Wacker Gallery, Berlin; Nico Eisenloeffel Gallery, Amsterdam; Rainer Gallery, London; French Gallery, London; **Sir James Murray, Aberdeen and London, by 1923;** Christie's, London, 29 April 1927, lot 44; Gooden & Fox Gallery, London; Sir Laurence Richard Philipps, later Lord Milford, Dalham Hall, Newmarket, and Picton Castle, Haverfordwest, Pembrokeshire, 1927; Hanning Philipps, Picton Castle, 1962; Picton Castle Trust, 1999

REFERENCES

J.B. Manson, 'Sir James Murray's Collection', *Studio*, February 1922, pp.61–71; *French Art*, Agnew Gallery, Manchester, 1923, no.20; *Vincent van Gogh*, Oxford Arts Club, 1924, no.5; *Murray Collection*, Aberdeen Art Gallery, 1925 (no catalogue); *Opening Exhibition*, Tate, London, 1926, p.7; *Some Masterpieces from Welsh Houses*, (Arts Council), National Library of Wales, Aberystwyth, 1946, no.36; Korn 2001; Korn 2002, p.136; Stefan Koldehoff, 'The Wacker Forgeries', *Van Gogh Museum Journal* 2002, p.146

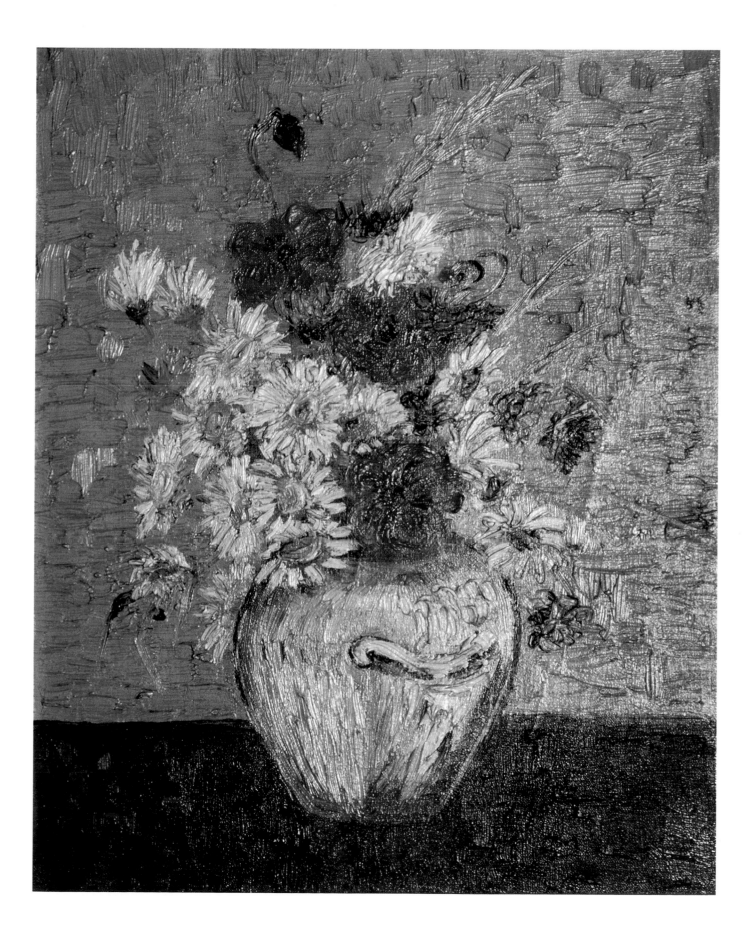

PORTRAIT OF DR GACHET

GIVEN BY PAUL GACHET TO THE BRITISH MUSEUM IN 1923

Etched in Auvers in 1890
Etching, 18 × 15 cm
The British Museum, London
F1664 / JH2028

PROVENANCE
Paul Gachet Jr, Auvers; **British Museum, London, 1923**

REFERENCES
The Graphic Work of Vincent van Gogh, Van Gogh Museum, 1995, no.10.40.

Van Gogh produced only one etching, a portrait of Dr Paul Ferdinand Gachet (1828–1909), the homeopathic doctor he knew in Auvers. He also painted two celebrated portraits of Gachet which he executed a week or so before the print.[15] As well as a medical specialist, Gachet was an amateur artist and an enthusiastic collector of modern art. He also owned a printing press, and this gave Van Gogh his only opportunity to experiment with the etching process. The etching depicts Gachet, aged forty-two, smartly dressed and smoking his pipe. He is deep in thought, with a furrowed brow, and has a melancholic air. The setting is almost certainly his garden, on the outskirts of Auvers, where Van Gogh loved to paint. The date on the etching, 15 May, is incorrect and was most likely added to the plate retrospectively by Gachet. Van Gogh had Sunday lunch with the Gachet household on 15 June 1890, probably the date on which the print was made. Six weeks later he shot himself and it was Gachet who treated him for the two days before he died. Gachet named the print 'L'Homme à la pipe' (Man with a Pipe). Sixty-one impressions have been recorded, and this particular one was printed by Gachet's son, Paul (or possibly by his printer Eugène Delâtre). It was donated by Paul Gachet Jr to the British Museum in July 1923, making it the first work by Van Gogh to enter a British public collection. There are two of the Gachets' collectors' marks at the bottom of the print: on the left, the intertwined initials (P.F.G.), and in the centre, a cat's head. A second copy of the etched *Portrait of Dr Gachet* came to Britain four years later, purchased by Henry Wellcome from Paul Gachet Jr for 700 francs (£6). Wellcome, who owned a successful pharmaceutical company, had an enormous collection of medical material from around the world. His primary interest in the Van Gogh etching was that it was the portrait of a medical specialist. His print was transferred to the library of the Wellcome Institute in 1936. A third copy of the etching (present location unknown) was once owned by Martha Edwards of Gloucester and was exhibited there in 1936.

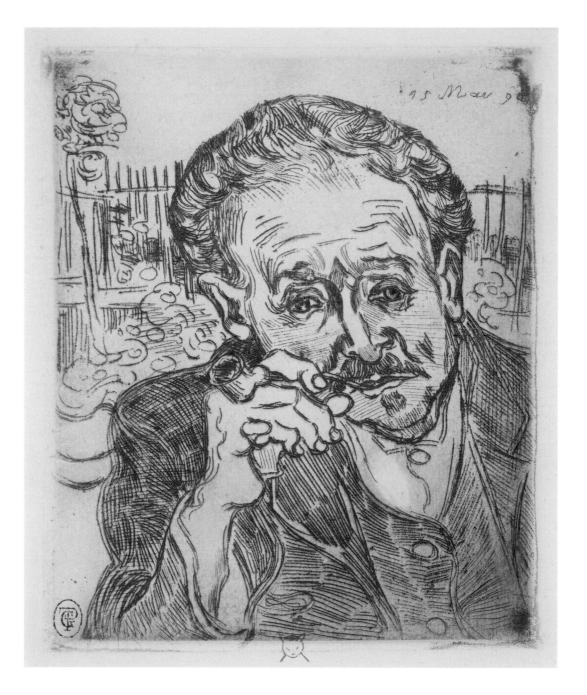

Painted in St-Rémy in 1889
Oil on canvas, 73 × 91 cm
The National Gallery, London
F615 / JH1755

PROVENANCE

Père Julien Tanguy Gallery, Paris, 1890; Octave Mirbeau, Paris, by 1901; Alexandre Rosenberg, Paris; Bernheim-Jeune Gallery, Paris; Dr Gustav Jebsen, Oslo, 1920; Paul Rosenberg Gallery, Paris, 1923; Independent Gallery, London; Courtauld Fund Trustees, London, 1923; **Tate Gallery (formerly National Gallery, Millbank), London, 1923**; National Gallery, London, 1961

REFERENCES

Opening Exhibition, Tate, London, 1926, p.7; National Gallery and Tate trustee minutes; Courtauld Fund papers (Tate archive); letter from Alexandre Rosenberg to Tate, 9 July 1957 (Tate archive); letter from Stephan Madsen to Ronald Alley, 4 November 1957 (Tate archive); Martin Davies, *The French School*, National Gallery, London, 1970, pp.136–7; Frances Spalding, *The Tate: A History*, London, 1998; Feilchenfeldt 2006, p.108

Van Gogh's magnificent St-Rémy landscape depicts a noonday scene, with the billowing clouds echoing the contorted shapes of the hills, Les Alpilles. The site was close to the asylum where Van Gogh had come in May 1889. At the far right, the summit seems to fold into itself – this was not a figment of the artist's imagination, but a slightly exaggerated depiction of the twisted peaks. In the immediate foreground lies a path, lined with poppies and white flowers, and beyond this is the wheatfield, almost ready to be harvested, with olive trees and cypresses. Although cypresses are traditionally associated with death, Van Gogh has brought them alive, turning them into dark, flickering flames. Van Gogh painted three versions of *A Wheatfield, with Cypresses* of which this is his finest. The first was executed outdoors in early July 1889 [F717, now in the Metropolitan Museum of Art, New York], shortly before he fell ill for several weeks. On about 25 June, he wrote to his brother Theo: 'The cypresses are always occupying my thoughts. I should like to make something of them like the canvases of the sunflowers … [The cypress] is beautiful in line and proportion as an Egyptian obelisk.'[16] The National Gallery version was painted in his room, probably in September, after his recovery from a setback in his psychological condition, and is a slightly more stylised and powerful work than that the earlier picture. A final, smaller version [F743, now Private Collection] also dates from September. *A Wheatfield, with Cypresses* is ample evidence that Van Gogh's 'madness' did not prevent him from creating masterpieces, at least in the periods of reasonable health between bouts of illness. The London version was first owned by Parisian critic and writer Octave Mirbeau, but was eventually acquired by the London-based Independent Gallery, run by Percy Moore Turner, a great enthusiast for modern art. In October 1923 Samuel Courtauld bought the landscape for the Tate (then known as the National Gallery, Millbank), for £3,300. It was the first Van Gogh painting to enter a British public collection.

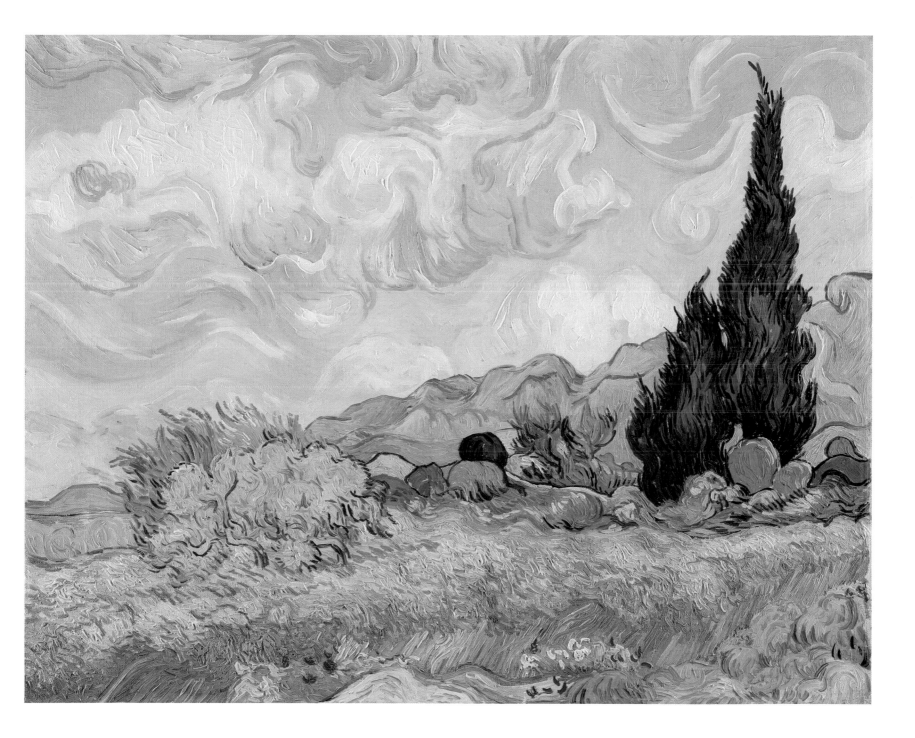

18 OLEANDERS

MICHAEL SADLER

Michael Sadler was born in Barnsley, Yorkshire, on 3 July 1861. He was Professor of the History and Administration of Education at Manchester University and later vice-chancellor of the University of Leeds (1911–23). He then moved to Oxford to become Master of University College (1923–34). He began collecting seriously in 1909, building up an important collection of modern art, including works by Gauguin, Cézanne, Sérusier, Klee, Marc, Munter, Kandinsky and many of the leading English Modernists. He died in Oxford on 14 October 1943.

Oleanders was painted in Arles at the very end of August 1888. It depicts the pink flowers with their spiky leaves in a majolica jug, set against a powerful yellow-green background. The jug rests on a table with two novels near the edge – the upper one is Emile Zola's *La Joie de vivre*, which had been published four years earlier. This still life bristles with energy. Van Gogh had referred to the work in a letter of around 14 August 1888 to his brother Theo, saying that 'one of these days I hope to make a study of oleanders'. It was probably the 'bunch of flowers' which he said he was working on when he wrote a few days later. On about 22 September he told Theo that he was 'thinking of planting two oleanders in tubs' in front of the Yellow House, where he lived. Five days later he described the oleanders in the public garden near his home as growing as if they were 'raving mad': 'The blasted things are flowering so riotously they may well catch *locomotor ataxia* [a form of syphilis]. They are loaded with fresh flowers, and quantities of faded flowers as well, and their green is continuously renewing itself in fresh, strong shoots, apparently inexhaustibly.'[17] The painting was exhibited at London's Lefevre Gallery exhibition in October 1923. *Oleanders* was bought by the educationalist Michael Sadler, who seems to have kept it until 1925.[18] That year it was sold by the Lefevre Gallery to Elizabeth Workman. She was the wife of Robert Workman, a wealthy shipbroker, then based in London. The couple began by collecting the Scottish Colourists and moved into Impressionism and Post-Impressionism, and finally into early twentieth-century art. Mrs Workman also bought two other Van Gogh paintings from the 1923 Leicester Galleries exhibition – *Bridge at Trinquetaille* [F426] and *The Hospital at Arles* (fig. 21). Mrs Workman sold *Oleanders* in 1928 and it was bought back by the Alex Reid & Lefevre Gallery. It was then offered to the Tate, which decided against the acquisition. The painting went to New York collector Mrs William Clark and was eventually acquired by the Metropolitan Museum of Art in New York in 1962.

Painted in Arles in 1888
Oil on canvas, 60 × 74 cm
The Metropolitan Museum of Art, New York. Gift of Mr and Mrs John L. Loeb, 1962 (62.24)
F593 / JH1566

PROVENANCE

Theo van Gogh, Paris, 1888; Jo van Gogh-Bonger, Amsterdam 1891; Paul Cassirer Gallery, Berlin, 1905; Carl Reininghaus, Vienna, 1905; Mrs Josef Redlich, Vienna; Barbazanges Gallery, Paris; Lefevre Gallery, London, 1923; **Sir Michael Ernest Sadler, Oxford, 1923**; Alex Reid & Lefevre Gallery, London, 1925/6; Elizabeth Russe Workman (née Allan), London, 1925/6; Alex Reid & Lefevre Gallery, London, 1928; Knoedler Gallery, New York, 1928; Mrs William Andrews Clark, New York, 1928; Knoedler Gallery, New York, 1947; Mrs Charles Suydam Cutting, New York, 1947; Knoedler Gallery, New York, 1962; Metropolitan Museum of Art, New York, 1962 (gift of Mr and Mrs John L. Loeb)

REFERENCES

Post-Impressionist Masters, Lefevre Gallery, London, 1923, no.20; *Vincent van Gogh*, Oxford Arts Club, 1924, no.1; *Vincent van Gogh*, Bernheim-Jeune Gallery, Paris, 1925, no.25; *Modern Foreign Gallery*, Tate, London, 1926, p.7; letter from Workman to Tate, 6 October 1926 (Tate archive); *French Painting*, Knoedler Gallery, New York, 1928, no.31; trustee minutes, Tate, 15 May 1928; Charles Sterling and Margaretta Salinger, *French Paintings*, Metropolitan Museum of Art, New York, 1967, pp.185–8; Douglas Cooper, *Alex Reid & Lefevre 1926–1976*, London, 1976, p.18; Feilchenfeldt 1988, p.106; Account Book, p.180; Korn 2001; Korn 2002, pp.131 and 136

It was not until 1923 and 1926, when two major one-man exhibitions were held at the Leicester Galleries in London, that the British public really began to take an interest in Van Gogh. The first exhibition in December 1923 included forty works – twenty-eight paintings and twelve drawings – almost all lent by Jo van Gogh-Bonger from the family collection. Several pictures were bought by women. Among them was the brilliant socialite Evelyn Fleming, mistress of Augustus John and mother of Ian Fleming, creator of the James Bond novels. She bought an early Van Gogh *Head of a Woman*, now in the National Gallery of Scotland. Elizabeth Carstairs, the wife of a dealer at the Knoedler Gallery, bought *Terrace at the Moulin de Blûte-fin, Montmartre*, now in Chicago. Around this time further Van Gogh acquisitions were made for the National Gallery at Millbank with money from the Courtauld Fund, including two iconic works: *Van Gogh's Chair* and *Sunflowers*, as well as the outstandingly beautiful *Long Grass with Butterflies*. The Leicester Galleries held a second one-man show in November 1926, comprising forty-eight paintings and drawings. Sixteen works were sold, including two works on paper which went to the Whitworth Art Gallery in Manchester and several to private collectors, including Samuel Courtauld and the mining tycoon Chester Beatty, who, with his wife Edith, was another major collector of Van Gogh. During the 1920s Chester and Edith Beatty bought five works by Van Gogh, including a version of the *Sunflowers* which sold for £24.7 million in 1987.

OLIVE TREES

Painted in St-Rémy in 1889
Oil on canvas, 49 × 63 cm
National Gallery of Scotland,
Edinburgh
F714 / JH1858

PROVENANCE

Theo van Gogh, Paris, 1889;
Jo van Gogh-Bonger, Amsterdam,
1891; Leicester Galleries, London,
1923; **Sir Michael Ernest Sadler,
Oxford, 1923**; Leicester Galleries,
London, 1934; National Gallery of
Scotland, Edinburgh, 1934

REFERENCES

Vincent van Gogh, Leicester Galleries,
London, 1923, no.38; *Vincent van Gogh*,
Oxford Arts Club, 1924, no.2; *19th and
20th century French Painting*, Independent Gallery, London, 1930, no.22;
correspondence between Oliver
Brown and Stanley Cursiter, 1934
(NGS records); Account Book,
pp.186–7; Korn 2002, pp.131 and 136

Olive Trees was painted in the autumn of 1889, just outside the
asylum at St-Rémy. The space beneath the trees takes up half the
picture. The brushstrokes of the earth seem to make it flow like a
river. Depicted in an astonishing range of colours, the earth
appears to twist and turn, imparting a dizzying effect to the scene.
Red poppies scattered in the olive grove give an additional touch
of colour. Behind the grove there are patches of white sky visible,
but blue in the trees and the shadows on the ground make it
difficult to distinguish between sky, trees and earth. Van Gogh
frequently painted olive groves, enjoying their twisted trunks and
dramatic shapes. In a letter of 28 September 1889, he wrote about
the trees in terms which could well apply to this painting: 'They
are old silver, sometimes with more blue in them, sometimes
greenish, bronzed, fading white above a soil which is yellow, pink,
violet-tinted or orange, to a dull red ochre.'[19] This painting was
bought by Michael Sadler in December 1923 from Van Gogh's first
one-man show in Britain at the Leicester Galleries, comprising
works from the collection of Jo van Gogh-Bonger. He paid £363
for *Olive Trees*. At the same sale Sadler bought three drawings:
Orchard near Arles [F1516, for £165], *Cypresses* [F1525, for £275] and
Olive Trees with the Alpilles [F1544, for £275]. That year Sadler had
just moved to Oxford, to become Master of University College.
When he left Oxford in 1934, he sold *Olive Trees* back to the Leicester Galleries. In March 1934 it was bought by the National Gallery
of Scotland for £1,600.

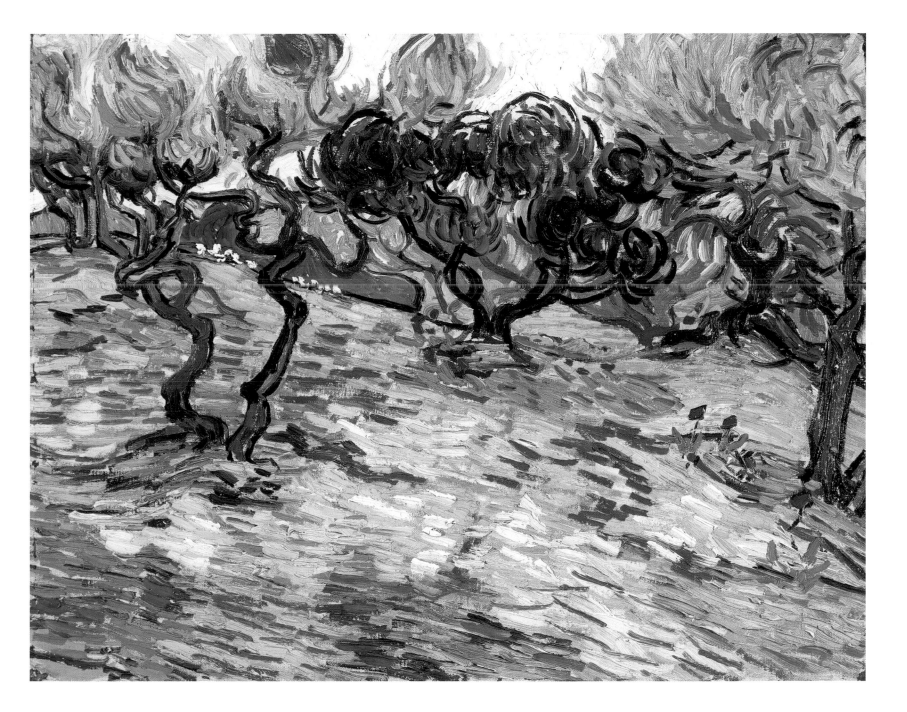

TERRACE AND OBSERVATION DECK AT THE MOULIN DE BLUTE-FIN, MONTMARTRE

ACQUIRED BY ELIZABETH CARSTAIRS IN 1923

ELIZABETH CARSTAIRS

Elizabeth Carstairs was the wife of art dealer Charles Stewart Carstairs, a director of the Knoedler Gallery in London, who held an important exhibition of Impressionist art in June 1923. Mrs Carstairs had contacts with a number of artists including William Orpen and John Singer Sargent. She died in 1949.

This landscape depicts the terrace of the Moulin de Blûte-fin, beneath the windmill. The raised wooden belvedere on the right gave a marvellous panoramic view of the city of Paris. In the painting, the city is simply sketched in with no detail, looking like a sea; no individual buildings can be discerned in the hazy background. A couple is seated on the observation deck, while a woman in a shawl rests on a bench and two others loiter just behind the railings. It is a winter scene, probably dating from 1886–7, although it is difficult to be more precise. There is a naivety about the picture, with its sparse foreground and crooked lampposts, but the resulting composition is striking, drawing the eye up the terrace towards the figures. Van Gogh has deliberately used complementary colours, with most of the composition in cool blues and a smaller area of orange in the wooden viewing platform. Although the scene is sunny, the colouring has a wintery feel, and this is reinforced by the clothing of the visitors. *Terrace and Observation Deck at the Moulin de Blûte-fin, Montmartre* was exhibited in December 1923 at the Leicester Galleries. Director Oliver Brown later recalled that 'a woman collector who lived in London bought a little painting called "On Montmartre" on the advice of Augustus John.'[20] The price was £300. Her name is recorded in the De la Faille catalogue as 'Mrs Carstairs', and she can be identified more specifically as Elizabeth, the wife of Charles Carstairs, a director of the Knoedler Gallery. Elizabeth Carstairs, who moved in artistic circles (and was painted by William Orpen and John Singer Sargent), was a collector in her own right. Brown's comment suggests that the Van Gogh was bought for the Carstairs' private enjoyment. Nevertheless, she sold it the following year and in 1926 it was donated to the Art Institute of Chicago.

Painted in Paris in 1886–7
Oil on canvas mounted on pressboard
44 × 34 cm
The Art Institute of Chicago, Helen Birch Bartlett Memorial Collection (1926.202)
F272 / JH1183

PROVENANCE

Theo van Gogh, Paris, 1886; Jo van Gogh-Bonger, Amsterdam, 1891; Leicester Galleries, London, 1923; **Elizabeth Carstairs (née Stebbins), London, 1923**; Knoedler Gallery, London and Paris, 1924; Frederick Clay Bartlett, Chicago, 1924; Helen Birch-Bartlett, Chicago; Art Institute of Chicago, 1926 (Helen Birch-Bartlett donation)

REFERENCES

Vincent van Gogh, Leicester Galleries, London, 1923, no.18; *Peintres de l'école française*, Knoedler Gallery, Paris, 1924, no.13; Brown 1968, p.85; Account Book, p.168; Korn 2001; Korn 2002, pp.131 and 136

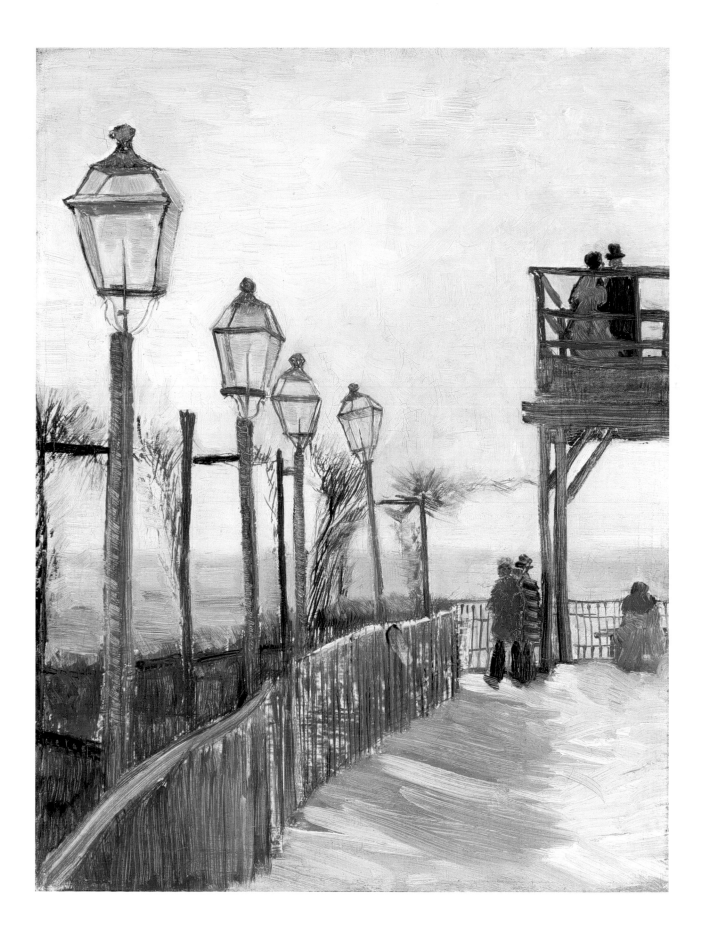

21 HEAD OF A PEASANT WOMAN

ACQUIRED BY EVELYN FLEMING IN 1923

EVELYN FLEMING

Evelyn Fleming was born in 1885. In 1906 she married Valentine Fleming, son of the wealthy Scottish banker Robert Fleming. Evelyn and Valentine's children included the writers Peter and Ian Fleming (the latter the creator of the James Bond novels). Valentine died in action during the First World War and Evelyn inherited his fortune, but only on condition that she should never remarry. She became a celebrated society hostess and around 1921 she met Augustus John, with whom she had a daughter, Amaryllis Fleming (1925–99), later a noted cellist. John painted several portraits of Evelyn. Evelyn died in 1964.

This Nuenen painting dates from the spring of 1885, just over a year after Van Gogh had moved to the Brabant village where his parents lived. There he painted the local peasants and weavers. The woman depicted is Gordina de Groot (1855–1927), who appears in several other of Van Gogh's works, including his early masterpiece *The Potato Eaters* [F82, now in the Van Gogh Museum, Amsterdam]. While the artist was staying in Nuenen there was malicious gossip that he had got one of his models pregnant. Gordina is assumed to have been the subject of this rumour, although there is no real evidence of a relationship with Van Gogh. As in most of his Dutch works, the colours are muted. The background is very dark, as is the woman's clothing, other than the white of the top of the blouse and the bonnet, which frame the face. *Head of a Peasant Woman* is recorded in the De la Faille catalogue as having been bought at the Leicester Galleries exhibition in 1923 by 'Mrs Flemming'. The price was £300. According to an unpublished letter from gallery director Oliver Brown, she was also a friend of Augustus John, who had painted her portrait.[21] This helps us identify the collector as Evelyn (Eve) Fleming, who became Augustus John's mistress around 1921 and was to bear his illegitimate daughter Amaryllis in 1925. (Evelyn's children from an earlier marriage included the writer Ian Fleming.) John painted several portraits of Evelyn, one of which (now in a Private Collection) was exhibited at the Royal Academy in 1922. In 1923 she moved to Cheyne Walk, Chelsea, to a house which had once belonged to the artist J.M.W. Turner. In 1950 Evelyn Fleming retired to the Bahamas and it was probably then that *Head of a Peasant Woman* was sold. The following year the painting was bought for £4,000 by Sir Alexander Maitland, an Edinburgh advocate. He had earlier acquired Van Gogh's *Orchard in Blossom* (cat.14) formerly owned by William Boyd. Both pictures were donated by Maitland to the National Gallery of Scotland in 1960.

Painted in Nuenen in 1885
Oil on canvas on cardboard,
48 × 36 cm
National Gallery of Scotland, Edinburgh
F140 / JH745

PROVENANCE

Theo van Gogh, Paris, 1885; Jo van Gogh-Bonger, Paris, 1891; Leicester Galleries, London, 1923; **Evelyn (Eve) Beatrice Ste Croix Fleming (née Rose), London, 1923**; Alex Reid & Lefevre Gallery, London, 1951; Alexander and Rosalind Gertrude Craig (née Sellar) Maitland, Edinburgh, 1951; National Gallery of Scotland, Edinburgh, 1960 (Maitland Gift)

REFERENCES

Vincent van Gogh, Leicester Galleries, London, 1923, no.15; letter from Oliver Brown to Colin Thompson, 24 April 1961 (NGS records); letter from McNeill Reid to Colin Thompson, 4 May 1961 (NGS records); receipt, Alex Reid & Lefevre Gallery, London, 7 May 1951 (NGS records); letter from V.W. van Gogh to Colin Thompson, 6 May 1961 (NGS records); *The Maitland Gift*, NGS, 1963, pp.34–5; Account Book, p.168; Korn 2001; Korn 2002, pp.131 and 136

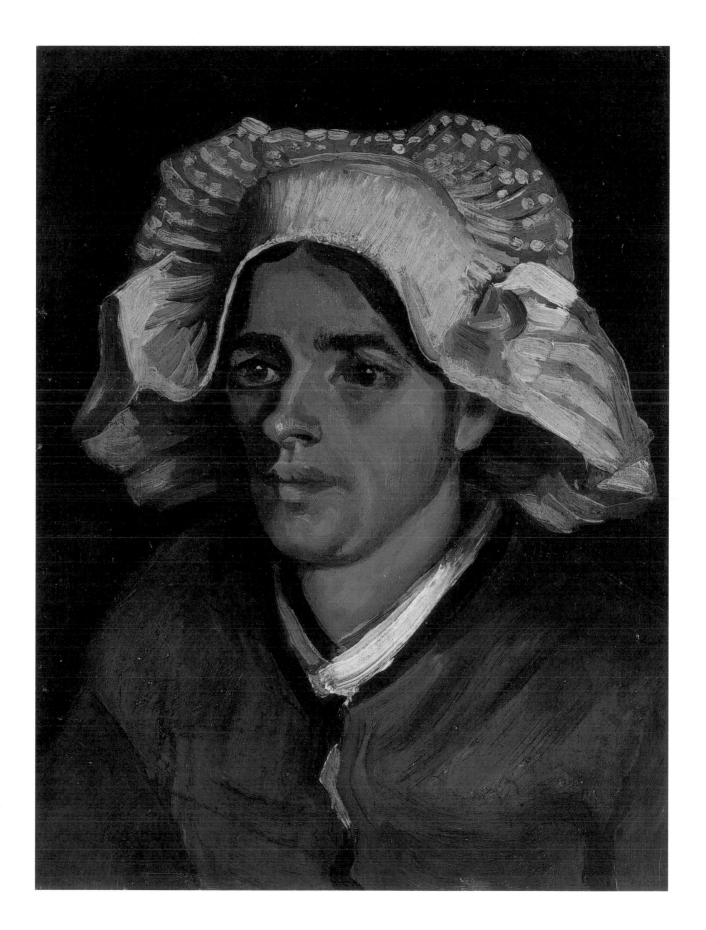

LONG GRASS WITH BUTTERFLIES

Painted in St-Rémy in 1890
Oil on canvas, 65 × 81 cm
The National Gallery, London
F672 / JH1975

PROVENANCE

Theo van Gogh, Paris, 1890; Jo van Gogh-Bonger, Amsterdam, 1891; Paul Rosenberg Gallery, Paris, c.1925; French Gallery, London, 1926; Courtauld Fund Trustees, London, 1926; **Tate Gallery (formerly National Gallery, Millbank), London, 1926**; National Gallery, London, 1961

REFERENCES

Two letters from J.B. de la Faille to V.W. van Gogh, November-December 1925 (Van Gogh Museum archive), possibly referring to F672; receipt, French Gallery, London, 30 March 1926 (Tate archive); *Great Masters of the French XIXth Century*, French Gallery, London, 1926, no.18; National Gallery and Tate trustee minutes; Courtauld Fund papers (Tate archive); letter from Paul Rosenberg to Tate, 9 October 1952 (Tate archive); Martin Davies, *The French School*, National Gallery, London, 1970, pp.138–9; Feilchenfeldt 1988, p.111

Long Grass with Butterflies was painted in early May 1890 in the walled garden (or park) of the asylum at St-Rémy, just a few weeks before Van Gogh discharged himself. On 4 May 1890 Van Gogh wrote to Theo, saying 'my work is going well, I have done two canvases of the fresh grass in the park'. This was very shortly after he had recovered from another bout of illness and, as he explained: 'As soon as I got out into the park, I got back all my lucidity for work; I have more ideas in my head than I could ever carry out, but without it clouding my mind. The brushstrokes come like clockwork.'[22] Van Gogh's unusual composition has a claustrophobic feel, and only just included, in the upper left corner, is a path and to the right a row of tree trunks. But these small details at the top succeed in giving a sense of three-dimensional space to the picture. Several white butterflies flutter above the grass. The painting is predominantly green, but over this Van Gogh has applied a range of colours – ochre, yellow, white and purple – painted with numerous small brushstrokes. *Long Grass with Butterflies* belonged to the Van Gogh family and was probably sold at the end of 1925. After passing through the Paul Rosenberg Gallery in Paris it was sold in March 1926 by the London-based French Gallery, also known as Wallis & Son. Interestingly, Vincent had known the Wallis family, including their two children, while he was working in London as a young art dealer in 1873–5. *Long Grass with Butterflies* was purchased by Samuel Courtauld for £2,100 for the Tate. The acquisition almost fell through, after Courtauld suggested there might be too many Van Goghs in the national collection. In 1961 the painting was transferred from the Tate to the National Gallery.

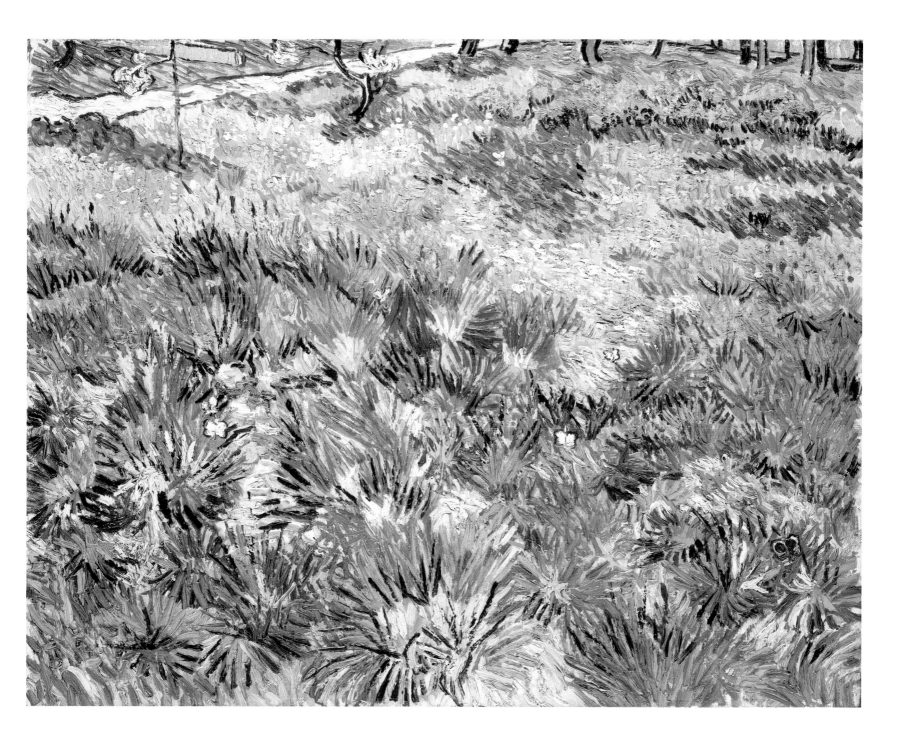

THE FORTIFICATIONS OF PARIS WITH HOUSES
ACQUIRED BY SIR THOMAS BARLOW FOR THE WHITWORTH ART GALLERY IN 1927

SIR THOMAS BARLOW

Thomas Barlow was born in London on 23 February 1883. He moved to Manchester and entered the family textile business Barlow and Jones Ltd, of Bolton and Manchester. He joined the board of District Bank in 1922 and became its chairman in 1947. He was a governor of the Whitworth Art Gallery and later its chairman (1930–58). He had a major collection of Old Masters and Dürer prints. Barlow died in London on 22 November 1964.

This watercolour depicts part of the fortifications which were built around Paris in the 1840s. These had become redundant by the 1880s and their outer tracts were used for strolling. Van Gogh's watercolour was made in the north of the city, probably near the Porte de St-Ouen or Porte de Clichy. Both were two kilometres from Theo's apartment in Montmartre. The watercolour dates from the summer of 1887, just over a year after Van Gogh's arrival in Paris, and the view is from just outside the city. Part of the canal next to the rampart walls is visible on the left and the tall building beyond the ramparts is probably a former military barracks. A woman with a parasol is walking into the scene, and the ghostlike image of a couple, which the artist had attempted to remove, is now visible. *The Fortifications of Paris with Houses* was bought by Manchester-based collector Sir Thomas Barlow, whose wealth came from the family textile business of Barlow and Jones Ltd. The watercolour, which was exhibited at the Leicester Galleries in November 1926, was acquired for £157. Barlow immediately presented it to the Whitworth Institute (later Art Gallery), University of Manchester, of which he was a governor. The Whitworth watercolour was one of four which Van Gogh made of the ramparts, possibly with an eye to using them as compositions for oil paintings. One of the others, entitled *Fortifications of Paris* [F1402] and of a similar view, was owned by W. Regendanz, a German collector who fled to Britain in the 1930s. After the war the Regendanz watercolour was acquired by property developer Charles Clore.

Painted in Paris in 1887
Watercolour, gouache, chalk and pencil on paper, 40 × 54 cm
The Whitworth Art Gallery, University of Manchester
F1403 / JH1281

PROVENANCE

Theo van Gogh, Paris, 1887; Jo van Gogh-Bonger, Amsterdam, 1891; V.W. van Gogh, Laren, 1925; Leicester Galleries, London, 1926; **Sir Thomas Dalmahoy Barlow, Manchester, 1927**; Whitworth Art Gallery, Manchester, 1927 (Barlow Gift)

REFERENCES

Vincent van Gogh, Leicester Galleries, London, 1926, no.38; *Report to the Governors for 1927*, Whitworth Art Gallery, Manchester, 1928, pp.13 and 16; *Paintings from Sir Thomas Barlow's Collection*, Whitworth Art Gallery, Manchester, 1968; *ODNB*

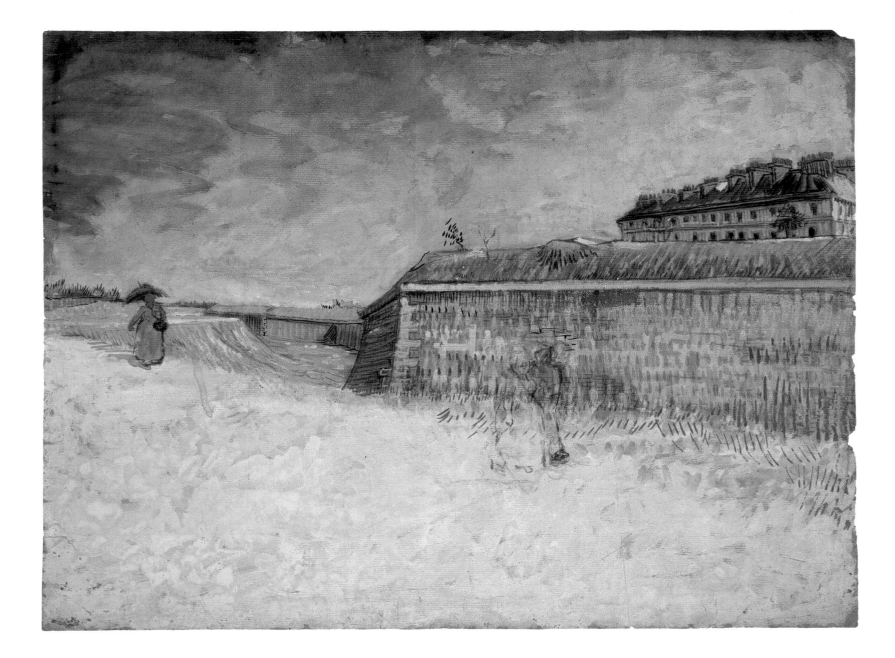

HAYRICKS

Drawn in St-Rémy or Auvers in 1890
Pen, ink, chalk and pencil on paper,
47 × 61 cm
The Whitworth Art Gallery,
University of Manchester
F1643 / JH2119

PROVENANCE

Theo van Gogh, Paris, 1890; Jo van
Gogh-Bonger, Amsterdam, 1891;
V.W. van Gogh, Laren, 1925; Leicester
Galleries, London, 1926; **Whitworth
Art Gallery, Manchester, 1927**

REFERENCES

Vincent van Gogh, Leicester Galleries,
London, 1926, no.25; *Report to the
Governors for 1926*, Whitworth Art
Gallery, Manchester, 1927, pp.12–3
and 25; Feilchenfeldt 1988, p.138

Judging by the crop growing in the field, the drawing may well
depict wheat, rather than hay, as has been traditionally assumed.
The scene is very simple: a track, which dominates the lower right
of the composition, is mainly blank, with relatively few pen
marks. In the background are distant trees. A bird, perhaps a
crow, can be seen above the horizon and another is nearby in the
field. The drawing was made using a reed pen and has faded
considerably since it was drawn.[23] There has been much debate
over when it was done, and it has recently been suggested that it
may date from St-Rémy in the summer of 1889, rather than
Auvers the following year.[24] *Hayricks* was purchased by the
Whitworth Art Gallery from the November 1926 Leicester
Galleries exhibition for £200. Earlier that year the Whitworth had
bought a Gauguin drawing, *Portrait of a Child*, also from the
Leicester Galleries, but this was returned and the £75 paid was put
towards the purchase of *Hayricks*. The Van Gogh acquisition was
encouraged by Sir Thomas Barlow, who at the November 1926
exhibition had bought *The Fortifications of Paris with Houses* and
immediately presented it to the Whitworth (cat.23). Two other
Whitworth governors, Herbert Coleman and Sir Michael Sadler,
were also Van Gogh collectors.

**GEORGE MONTAGU,
9TH EARL OF SANDWICH**

George Montagu was born on 29 December 1874. He became the 9th Earl of Sandwich in 1916 and lived at Hinchingbrooke, Huntingdon. He was Conservative Member of Paliament for South Huntingdonshire (1900–6) and a trustee of the Tate (1934–41). He was encouraged by the artist Paul Maze to collect modern French art. His collection of British paintings was sold at Sotheby's on 10 December 1947. He died on 15 June 1962.

The Outskirts of Paris was painted in 1886, probably towards the end of the year in which Van Gogh had arrived in the French capital. The scene is divided in two by the horizon, with a stormy sky (with three birds). The lamppost dominates the centre of the composition. A track takes up the entire front of the picture, receding towards the horizon. There are a number of people: the man in the foreground, a couple walking away to the right, and more figures in the background. The location of the scene has not been identified, but it is almost certainly outside Paris, looking towards the city. A church is just visible on the horizon, to the right of the lamppost, and further to the right is a windmill. The two large buildings on either side of the painting are probably barracks, similar to those which appear in cat.23. In an unpublished study in 2004, Henry Travers Newton, concluded that it may well be a scene from near the Quai de Clichy, on the Seine, looking south towards Paris. *The Outskirts of Paris* was shown at the 1926 Leicester Galleries exhibition, the second Van Gogh one-man show in Britain, and it was one of the five paintings illustrated in the catalogue. It was bought by George Charles Montagu, 9th Earl of Sandwich, who paid £400 for the painting. From the same show he also acquired a Van Gogh drawing, *Pollard Willows* [F1247]. The Earl of Sandwich was a keen collector of modern art, encouraged by his French artist friend Paul Maze. He acquired works by Renoir, Degas, Cézanne, Gauguin and also early twentieth-century British artists. The earl served as a trustee of the Tate, from 1934–41. He lived at Hinchingbrooke, the family seat near Huntingdon, where there was a collection of portraits and old masters in the mansion. *The Outskirts of Paris* was hung in the cottage, a more modest house on the estate; it was displayed in the dining room. The Earl of Sandwich kept the painting until 1956, six years before his death.

Painted in Paris in 1886
Oil on canvas, 46 × 55 cm
Lent by Mrs Frank G. Wangeman, California
F264 / JH1179

PROVENANCE

Theo van Gogh, Paris, 1886; Jo van Gogh-Bonger, Amsterdam, 1891; V.W. van Gogh, Laren, 1925; Leicester Galleries, London, 1926; **9th Earl of Sandwich (George Charles Montagu), Huntingdon, 1926**; Wildenstein Gallery, New York, 1956; Norman B. Woolworth, Monmouth, Maine, 1958; Parke-Bernet (auction), 31 October 1962, lot 21 (unsold); Mrs Norman B. Woolworth, Monmouth, Maine, 1962; Christie's, London, 1 December 1967, lot 42; Nathan Cummings, New York; Mr and Mrs Frank G. Wangeman, California, 1985; Christie's, New York, 10 November 1987, lot 16 (unsold); Mr and Mrs Frank G. Wangeman, California

REFERENCES

Vincent van Gogh, Leicester Galleries, London, 1926, no.3; Mary Chamot, 'Collection of the Earl of Sandwich', *Country Life*, 23 March 1929, pp.431–3; J.B. Manson, 'The collection of the Earl of Sandwich', *Studio*, May 1929, p.332–5; *Vincent van Gogh*, Stedelijk Museum, Amsterdam, 1930, no.9; correspondence on 1930 Stedelijk exhibition (Van Gogh Museum archive); *Reminiscences of 9th Earl of Sandwich* (typescript), 1961, pp.30–6, Sandwich family papers; *Vincent van Gogh*, Arts Council (Tate, Birmingham and Glasgow), 1947, no.13a; letter from Lord Sandwich to John Rothenstein, 20 November 1947 (Tate archive); Korn 2001; Korn 2002, pp.131 and 136

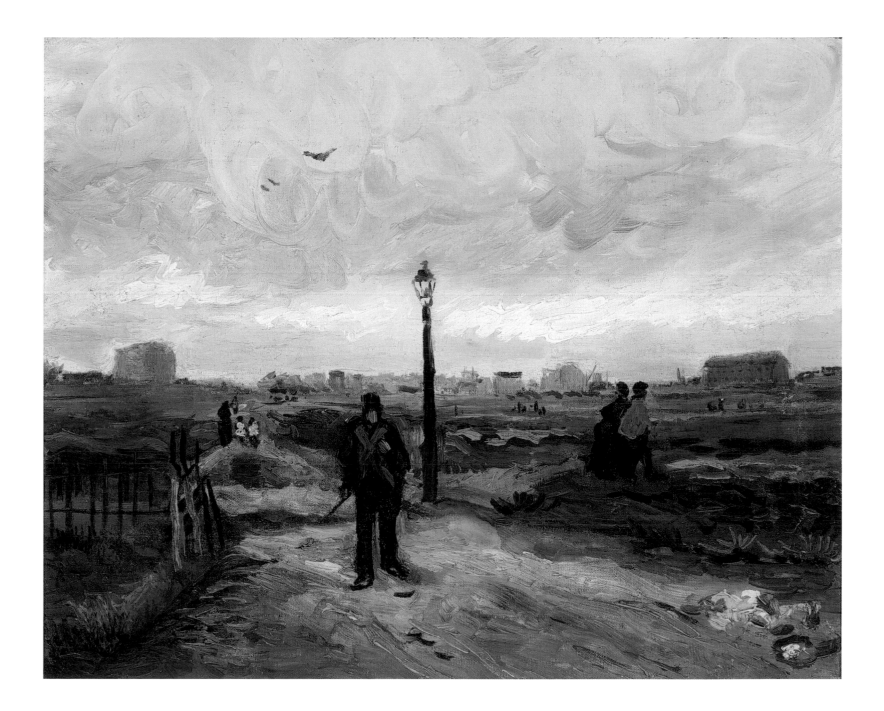

PEACH BLOSSOM IN THE CRAU
ACQUIRED BY SAMUEL COURTAULD IN 1927

SAMUEL COURTAULD

Samuel Courtauld was born in
Bocking, Essex on 7 May 1876. In 1917
he became joint managing director
(and chairman in 1921) of the family
textile firm Courtaulds Ltd, the
world's largest rayon manufacturer.
In 1923 he donated £50,000 to the
National Gallery, Millbank, to buy
modern art – including four Van
Goghs. Courtauld later became a
trustee of the Tate Gallery (1927–37)
and the National Gallery (1931–47). In
the 1920s he built up the finest British
collection of Impressionists and
Post-Impressionists, as well as earlier
works. His pictures hung in Home
House in Portman Square. In 1931 he
endowed the Courtauld Institute of
Art and it later acquired his collec-
tion, now on display in Somerset
House. He died in London on
1 December 1947.

Painted in early April 1889, this magnificent landscape shows a
view of the Crau, a plain which starts a few kilometres east of
Arles. It was one of the last pictures Van Gogh made before he left
the town for the asylum at St-Rémy. He described the scene in a
letter to fellow artist Paul Signac on around 5 April 1889: 'Little
cottages, blue skyline of the Alpines [Alpilles], sky white and blue.
The foreground, patches of land surrounded by cane hedges,
where small peach trees are in bloom – everything is small there,
the gardens, the fields, the orchards and the trees, even the moun-
tains, as in certain Japanese landscapes.'[25] It has recently been
established that *Peach Blossom in the Crau* was bought by the Belgian
artist Anna Boch, the only identified collector who purchased a
Van Gogh painting during the artist's lifetime, *The Red Vineyard*
[F495, now in the Pushkin Museum, Moscow]. She bought *Peach
Blossom in the Crau* in May 1891 from Père Tanguy in Paris, for 350
francs (£14), making it one of the earliest sales after Van Gogh's
death. In 1906 Anna Boch sold both Van Goghs to the Bernheim-
Jeune Gallery for 10,000 francs (£400). Nearly two decades later
Peach Blossom in the Crau was acquired by the Independent Gallery
in London and exhibited in May 1925. In June 1927 the painting
was sold to Samuel Courtauld for £9,000. He kept it at Home
House, in Portman Square, where it hung in the Etruscan Room,
above the fireplace. In March 1935 *Peach Blossom in the Crau* was lent
to a most unusual show, which is unrecorded in the Van Gogh
literature. The venue was the Village Hall in Silver End, near
Braintree, Essex, for an exhibition entitled *Art for the People*. Silver
End was a 'utopian' village which had been established nine years
earlier by steel window manufacturer Francis Crittall for his
workers. (Press reports at the time described it as 'the city of 2000
AD'.) Although long forgotten, the *Art for the People* project was a
fascinating venture. Organised by the British Institute of Adult
Education, its rationale was simple: 'Most of the smaller towns of
England have no art gallery; and their inhabitants rarely have the
opportunity to look at works of art.'[26] At Silver End, the display
was organised by the Workers' Educational Association, and sixty
pictures were shown, from Constable to Sickert, although the Van
Gogh landscape was the star attraction.[27]

Painted in Arles in 1889
Oil on canvas, 65 × 81 cm
The Samuel Courtauld Trust,
Courtauld Institute of Art Gallery,
London
F514 / JH1681

PROVENANCE

Theo van Gogh, Paris, 1889; Jo van
Gogh-Bonger, Paris, 1891; Père Julien
Tanguy Gallery, Paris, 1891; Anna
Boch, La Louvière, near Charleroi,
1891 ; Bernheim-Jeune Gallery, Paris,
1906; Independent Gallery, London,
1925; **Samuel Courtauld, London,
1927**; Courtauld Institute Gallery,
London, 1932 (Courtauld gift, Samuel
Courtaud Trust)

REFERENCES

Letters from Octave Maus to Jo van-
Gogh Bonger, 21 June and 29 June 1891
(Van Gogh Museum archive); *Vincent
van Gogh*, Bernheim-Jeune Gallery,
Paris, 1925, no.32; *French Painting*,
Independent Gallery, London, 1925,
no.26; receipt, Independent Gallery, 22
June 1927 (Courtauld records); *Dutch
Art*, Royal Academy, London, 1929,
no.454; Christopher Hussey, 'The
Courtauld Institute of Art', *Country Life*,
15 October 1932, pp.428–33; *Annual
Exhibition*, Royal Scottish Academy,
Edinburgh, March 1933, no.134;
Opening Exhibition, Graves Art Gallery,
Sheffield, June 1934, no.160;
Christopher Hussey and Arthur
Oswald, *Home House*, London, 1934,
p.24; *English and French Paintings and
Drawings*, Village Hall, Silver End, 1935,
no.86; *Art for the People*, British Insti-
tute of Adult Education, London, 1935,
cover and pp.19 and 41; Feilchenfeldt
1988, pp.8–9; *Anna Boch*, Musée royal
de Mariemont, 2000, pp.76–8 and 157;
Korn 2001 & 2002, p.136; ODNB;
Thérèse Thomas, *Anna Boch*, Brussels,
2005, pp.32–3

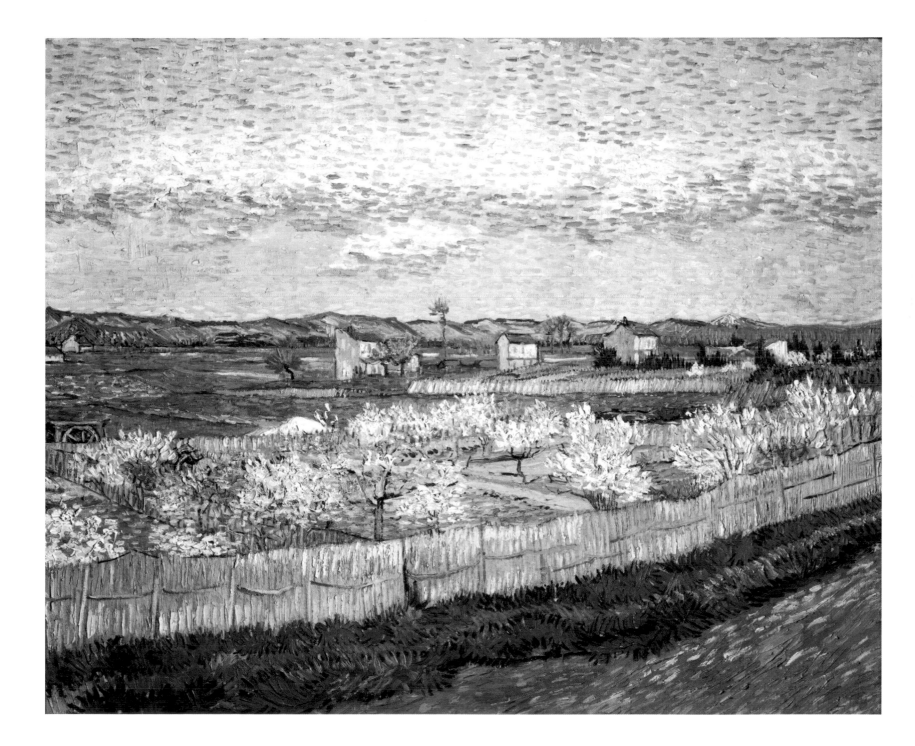

TILE FACTORY

Drawn in Arles in 1888
Pencil and pen on paper,
26 × 35 cm
The Samuel Courtauld Trust,
Courtauld Institute of Art Gallery,
London
F1500 / JH1373
[Edinburgh only]

PROVENANCE

Theo van Gogh, Paris, 1888; Jo van Gogh-Bonger, Amsterdam, 1891; V.W. van Gogh, Laren, 1925; Leicester Galleries, London, 1926; **Samuel Courtauld, London, 1927**; Courtauld Institute Gallery, London, 1948 (Courtauld bequest, Samuel Courtauld Trust)

REFERENCES

Vincent van Gogh, Leicester Galleries, London, 1926, no.37; Leicester Galleries receipt, 25 March 1927 (Courtauld records); Courtauld papers (Tate archive and Van Gogh Museum archive); Douglas Cooper, *The Courtauld Collection*, London, 1954; London, 1994

The location of the site of this drawing can now be identified as the Tarascon road, one kilometre north of Arles.[28] Van Gogh often sketched along the 'route de Tarascon' on his walks from the Yellow House to the hill of Montmajour. The drawing probably dates from March 1888, just a few weeks after his arrival in Arles. In *Tile Factory*, Van Gogh did the basic design in pencil and then used a reed pen to complete the work. The composition is divided in half by the small road, on which a pony and trap is being driven. Two large buildings, one with a distinctive roof, dominate the landscape. *Tile Factory* was included in the second Van Gogh exhibition at the Leicester Galleries in November 1926. It was bought in April 1927 for £178 by Samuel Courtauld, for his private collection. Courtauld acquired a total of six Van Goghs, three for his personal collection. In addition to this drawing, there were two paintings, *Peach Blossom in the Crau* (cat.26) and *Self-portrait with a Bandaged Ear* (fig.12). These were later shown in the Courtauld Institute of Art (now located in Somerset House), which he set up for the teaching of art history. In addition, Courtauld established a £50,000 fund to buy modern paintings for the Tate. Among the twenty-one works eventually acquired were four Van Goghs – *A Wheatfield, with Cypresses* (cat.17), *Van Gogh's Chair* (fig.10), *Sunflowers* (fig.1) and *Long Grass with Butterflies* (cat.22).

The Leicester Galleries exhibitions raised awareness of Van Gogh in Britain and in the late 1920s and 30s a number of new collectors emerged. They included a few eccentrics and individuals such as the flamboyant Edward Molyneux, a leading fashion designer between the wars, and William Cargill, an idiosyncratic recluse from Bridge of Weir in Renfrewshire, who stored most of his collection in packing cases and cupboards or hidden under beds. Another collector of this period was the artist Sir Matthew Smith, many of whose own paintings were influenced by Van Gogh. From about 1933 onwards the rise of Nazism in Germany resulted in a number of works being brought to Britain. The Berlin artist Curt Herrmann owned two Van Goghs which were brought to London by his son Frederick, who fled there in 1937. Valerie Alport, a Jewish amateur artist from Hamburg, took refuge in Oxford with her son Erich, the same year. Her collection included Van Gogh's *Restaurant de la Sirène at Asnières*, which was seen by Stephen Spender, and referred to in his autobiographical novel *The Temple*. Van Gogh's work was increasingly viewed as 'degenerate' by the Nazi authorities, and during this period a number of works were sold off by German museums. The war also affected works in British collections. The MP Victor Cazalet, who was later killed in action, lent two works by Van Gogh to an exhibition in Adelaide in August 1939. The pictures were stranded in Australia and one, *Head of a Man*, was acquired by the National Gallery of Victoria.

GARDENER BY AN APPLE TREE

ACQUIRED BY HENRY VAN DEN BERGH FOR THE BRITISH MUSEUM IN 1929

HENRY VAN DEN BERGH

Henry van den Bergh was born in Oss, the Netherlands in 1851. He moved to London in 1870 to help run the family's margarine business. In 1929 their company merged with Lever Brothers to create Unilever. He later lived at 8 Kensington Palace Gardens, the same exclusive road as Chester Beatty. He died on 12 March 1937.

This lithograph was done in July 1883, while Van Gogh was living in The Hague. It depicts a stooping, elderly man digging beneath an apple tree, with two houses in the distance. It was based on a scene the artist had witnessed in an old people's home where he went to find models. The man in the print is Adrianus Zuyderland. 'From the window I sketched an old gardener by a crooked apple tree,' Van Gogh wrote to his brother on about 6 June 1883. Five weeks later, around 13 July, he made another sketch.[29] From these sketches, Van Gogh produced the lithograph. The stooping old man digs beneath an apple tree, which seems to be just coming into blossom. He may be pruning the roots. In the background, beyond the orchard fence, are two cottages. *Gardener by an Apple Tree* is a rare print, with only five examples known to survive. This copy is a relatively fine impression, despite the smudge in the upper left corner. It was once owned by Henry Van den Bergh, a Dutch-born businessman who had moved to London in 1870. Van den Bergh bought *Gardener by an Apple Tree* in November 1929 from the J.H. de Bois Gallery in The Hague, paying £25. This was on the suggestion of Campbell Dodgson, keeper of the British Museum's Prints and Drawings Department. Van den Bergh immediately presented the lithograph to the museum, through the National Art Collections Fund. This was one of eighteen separate major gifts to the museum's Prints and Drawings Department. Van den Bergh's collecting interests were eclectic, and included Peruvian pottery, Persian ceramics, Indian coins and Dutch tiles.

Produced in The Hague in 1883
Lithograph drawn in pen, 25 × 33 cm
The British Museum, London
F1659 / JH379

PROVENANCE

J.H. de Bois Gallery, The Hague; **Henry Van den Bergh, London, 1929**; British Museum, London, 1929 (donation via National Art Collections Fund)

REFERENCES

Letter from Henry Van den Bergh to Campbell Dodgson, 25 October 1929 (British Museum records); Letter from Henry Van den Bergh to Sir Robert Witt, 29 October 1929 (Tate archive); *The Graphic work of Vincent van Gogh*, Zwolle, 1995, no.7.3

RESTAURANT DE LA SIRENE AT ASNIERES

VALERIE ALPORT

Valerie Alport was born on 3 May 1874 in Poznan, Poland. She studied art in Paris and then lived in Hamburg. She was the model for 'Frau Stockman' in Stephen Spender's autobiographical novel, *The Temple*. Her son Erich Alport (1903–1972), also born in Poznan, studied in Oxford and was later the author of *A History of the German People*, published in 1933. He began working in London in 1932, became a British citizen in 1937, and lived most of his life in Oxford. He was joined just before the Second World War by his mother, who was forced to flee Nazi Germany. They both lived in Oxford for the remainder of their lives. She died on 11 November 1960.

This painting depicts the Restaurant de la Sirène, a popular venue for day trippers from Paris. The complex of three buildings was situated on the banks of the Seine at 7 Boulevard de la Seine, in the north-west suburb of Asnières. This was around 500 metres downstream from the bank shown in *View of a River with Rowing Boats* (cat.12). The picture was done in the summer of 1887. It is probably an early morning scene, executed rapidly over a grey ground, part of which remains visible, particularly in the foreground and the sky. Van Gogh chose a slightly unusual view. He was close to the river, with his back to it, looking up the bank and the steps towards the restaurant. The history of *Restaurant de la Sirène at Asnières* is particularly interesting. It was bequeathed to the Ashmolean Museum by Oxford-based Erich Alport in 1972, and little was known about the painting's whereabouts for the previous fifty years. This led the museum in 2000 to place it on a list of works with an uncertain provenance for the Nazi period. The key which has revealed its whereabouts is a thinly-disguised autobiography by the writer Stephen Spender. In 1929, at the age of twenty, he fell in love with Erich, a young German man, visiting him at his parents' house in Hamburg. In his autobiographical novel, *The Temple*, written in 1930 (but not published until 1988), he recalls being struck by seeing a Van Gogh painting in the hall of the Hamburg house. He entitles the painting 'Still life with Irises' – but most names in the book are altered, and this is probably a reference to *Restaurant de la Sirène at Asnières*.[30] Valerie Alport was a wealthy artist and collector of modern art, but as Jews the family decided to flee Germany in 1937, moving to Oxford. *Restaurant de la Sirène at Asnières* was presumably brought to Britain at that time, giving it a clear provenance for the Nazi period. Valerie died in 1960 when the painting passed to her son, who bequeathed it to the Ashmolean Museum in 1972.

Painted in Paris in 1887
Oil on canvas, 52 × 64 cm
Ashmolean Museum, Oxford, bequeathed by Dr Erich Adolf Alport in 1972
F312 / JH1253

PROVENANCE

Jack Aghion, Paris, by 1901; Mauger (auction), Paris, 29 March 1918, lot 14; Christian Tetzen-Lund, Copenhagen, by 1921; Paul Guillaume Gallery, Paris; Tanner Gallery, Zurich; Otto Wacker Gallery, Berlin; G. Matthiesen Gallery, Berlin; **Valerie Alport, Hamburg and Oxford, by 1929**; Dr Erich (Eric) Adolf Alport, Oxford, 1960; Ashmolean Museum, Oxford, 1972 (Alport Bequest)

REFERENCES

Since the Impressionists, Wildenstein Gallery, London, 1945, no.14; Stephen Spender, *The Temple*, London 1988, pp.26 and 31; Hugh David, *Stephen Spender*, London 1992, pp.98–9; Maike Bruhns, *Hamburger Kunst im 'Dritten Reich'*, Hamburg 2001, pp.234–6; *Private Schätze*, Hamburger Kunsthalle, Hamburg 2001, p.214

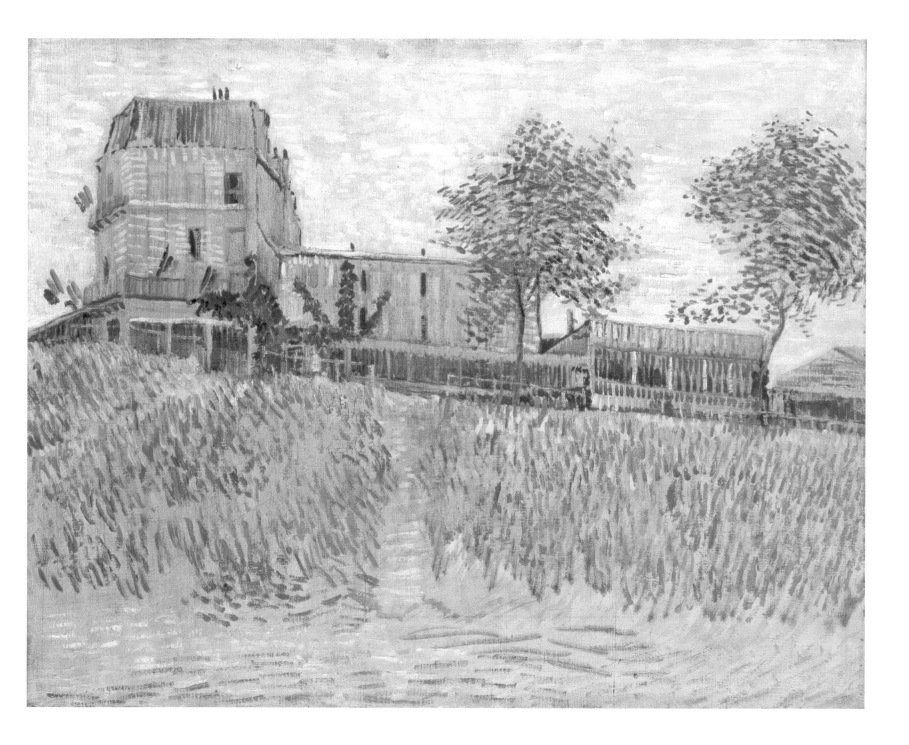

FARMHOUSE IN PROVENCE

ACQUIRED BY EDWARD MOLYNEUX IN AROUND 1934

EDWARD MOLYNEUX

Edward Molyneux was of Irish origin, but was born in London on 5 September 1891. He wanted to be an artist and started his career as a freelance sketcher, but later moved into fashion design. He lost an eye while serving as a captain during the First World War. After the war he opened his first salon in Paris and soon became a celebrated designer with branches in London, Monte Carlo, Cannes and Biarritz. He was based in London from 1940 until the end of the Second World War. It was during the 1930s that he built up his art collection, which included works by Manet, Degas, Monet, Pissarro, Cézanne, Seurat, and Bonnard. After the war he returned to Paris, later retiring to Jamaica. He died on 22 March 1974 in Monte Carlo.

Farmhouse in Provence was painted in the Crau at Arles, in June 1888. This was the plain which Van Gogh would later depict in *Peach Blossom in the Crau* (cat.26). *Farmhouse in Provence* shows three interlinked buildings and a yard with three stacks of wheat or hay. A farmer is working in the field. The various stone walls, meeting at an imposing gate, provide a strong framework for the composition. Van Gogh used complementary colours in the green plants and red flowers of the foreground and in the orange roofs set against the blue sky, but the dominant colour is the ochre of the wheat. In the distance lie the hills of Les Alpilles. This landscape is probably one of the 'two or three new painted studies' which Van Gogh reported were finished on 12 June 1888, as he worked on an important series of harvest paintings. The following day he wrote about the Crau: 'It has become very different from what it was in spring, and yet I have certainly no less love for this countryside, scorched as it begins to be from now on. Everywhere now there is old gold, bronze, copper, one might say, and this with the green azure of the sky blanched with heat.'[31] *Farmhouse in Provence* may have been a preliminary study for a larger oil painting, *Haystacks in Provence* [F425, now Kröller-Müller Museum, Otterlo]. *Farmhouse in Provence* was bought in about 1934 by Edward Molyneux. He had also acquired *Vineyards at Auvers* [F762] a few years earlier. Although having a London home, he spent much of this time in Paris, before escaping to Britain in 1940.

Painted in Arles in 1888
Oil on canvas, 46 × 61 cm
National Gallery of Art, Washington
F565 / JH1443
[Edinburgh only]

PROVENANCE

Theo van Gogh, Paris, 1888; Jo van Gogh-Bonger, Amsterdam, 1891; Père Julien Tanguy Gallery, Paris, 1891; Willy Gretor (Wilhelm Rudolph Julius Petersen), Paris, 1891; Otto Ackermann, Paris; Gaston Bernheim de Villers, Paris, by 1919; Bernheim-Jeune Gallery, 1933; Alex Reid & Lefevre Gallery, London, 1933; **Captain Edward Henry Molyneux, Paris and London, *c*.1934;** Ailsa Mellon Bruce, New York, 1955; National Gallery of Art, Washington, 1970 (donated by Ailsa Mellon Bruce)

REFERENCES

Reid & Lefevre photograph (Tate archive); *French Painting*, McLellan Galleries, Glasgow, 1934, no.28 (?); *Renoir, Cézanne and their Contemporaries*, Alex Reid & Lefevre Gallery, London, 1934, no.21; *French Paintings from the Molyneux Collection*, Museum of Modern Art, New York, 1952; letter from Jean Dauberville to David Rust, 22 June 1977 (National Gallery of Art records); Account Book, p.178; Korn 2001; Korn 2002, p.137

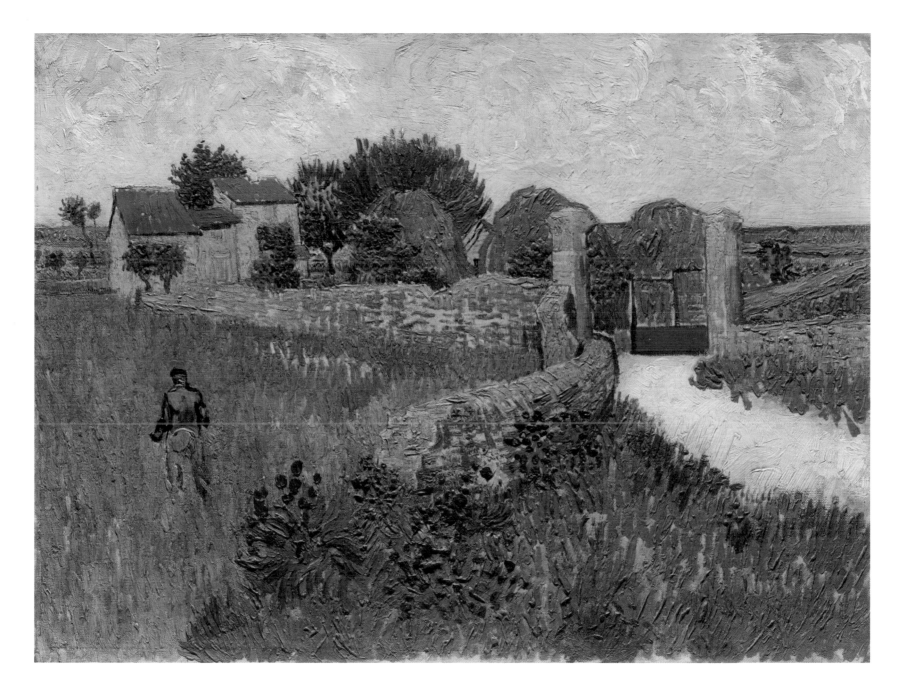

VIEW OF AUVERS WITH WHEATFIELD
ACQUIRED BY VICTOR CAZALET BY 1935

VICTOR CAZALET

Victor Cazalet was born in London on 27 December 1896. He served in the army, rising to Lieutentant Colonel and became Conservative Member of Parliament for Chippenham from 1924. He was killed on 4 July 1943 at Gibralter, when travelling by air with General Wladyslaw Sikorski, the exiled Polish leader.

View of Auvers with Wheatfield shows the church and a few houses, squashed into a narrow band at the top of the painting. Auvers, which lies thirty kilometres north-west of Paris, was then an agricultural village. There is little space for the sky, and the spire of the church is cut off, perhaps symbolically linking earth and heaven. The painting is dominated by the wheatfield, with sheaves lined up in rows, drawing the eye into the scene. Almost the entire canvas is filled with tones of greens and golden browns. Van Gogh produced the painting from just south of the village, near the railway station. It is probably one of his last works done before he shot himself in the wheatfields, higher up above the village, on 27 July 1890. Van Gogh died two days later. *View of Auvers with Wheatfield* belonged to the artist Isaac Israëls, a friend of Jo van Gogh-Bonger. He sold it in June 1934, five months before his death. The picture was then acquired by Lieutenant Colonel Victor Cazalet, Conservative Member of Parliament for Chippenham. He later bought a second Van Gogh, *Head of a Man* (cat.32). Both paintings were lent to an exhibition in Adelaide which opened on 21 August 1939, just before Britain and France declared war on Germany on 3 September. The pictures had to remain in Australia, and in 1943 Lieutenant Colonel Cazalet was killed near Gibraltar in an aircraft accident. *View of Auvers* was probably sold soon after the war ended and was not exhibited publicly until it went on show in Geneva in 1999.

Painted in Auvers in 1890
Oil on canvas, 44 × 52 cm
Fondation Garengo, Musées d'art et d'histoire de la Ville de Genève
F801 / JH2123

PROVENANCE

Theo van Gogh, Paris, 1890; Jo van Gogh-Bonger, Amsterdam, 1891; Isaac Israëls, The Hague, after 1914; H.E. d'Audretsch Gallery, The Hague, 1934; **Lieutenant Colonel Victor Alexander Cazalet, Cranbrook, Kent and London by 1935** (on loan to Australia 1939–43); Aline Baarnsdaal, Santa Barbara, California; Knoedler Gallery, New York, 1952; Mrs Edward F. Hutton, Westbury, New York, 1953; Sotheby's, London, 1 July 1964, lot 31; Beyeler Gallery, Basel; Ernst and Lucie Schmidheiny, Switzerland, by 1970; Fondation Garengo, Musées d'art et d'histoire, Geneva

REFERENCES

Report of the Visitors of the Ashmolean Museum, Oxford, 1935, p.20 (loan); *French and British Contemporary Art*, National Art Gallery of South Australia, Adelaide, Lower Town Hall, Melbourne and David Jones' Art Gallery, Sydney, 1939, no.136 (then on loan to Sydney and Melbourne 1940–3); Robert Rhodes James, *Victor Cazalet*, London, 1976; Korn 2001 & 2002, p.137; Eileen Chanin and Steven Miller, *Degenerates and Perverts: The 1939 Herald Exhibition*, Melbourne, 2005, p.270

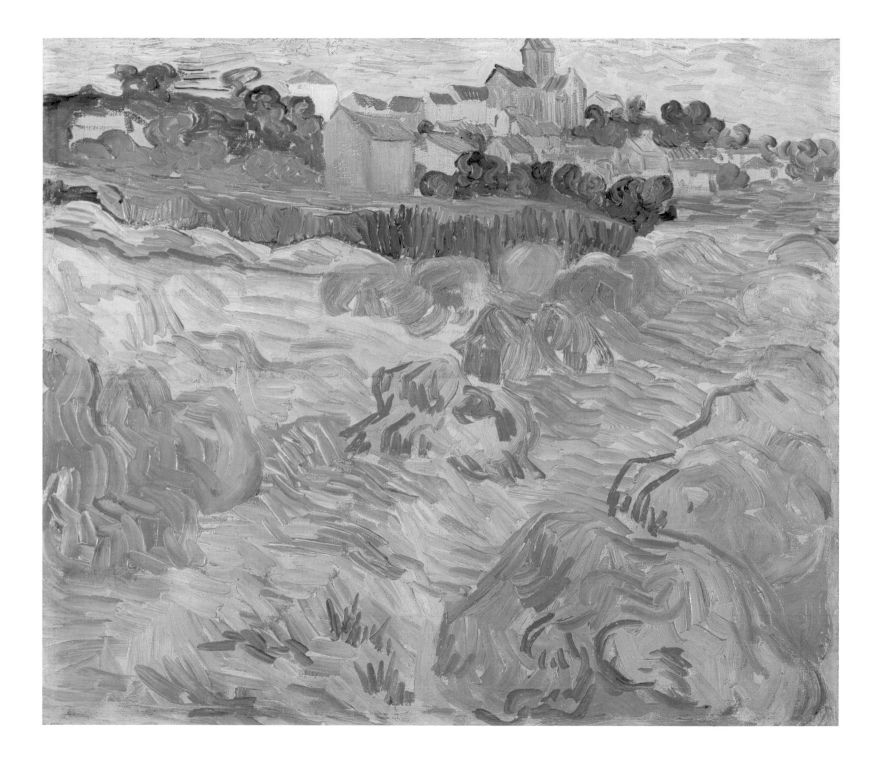

HEAD OF A MAN

ACQUIRED BY VICTOR CAZALET IN 1939

Painted in Paris in 1886–7
Oil on canvas, 33 × 40 cm
National Gallery of Victoria,
Melbourne, Felton Bequest, 1940
F209 / JH1201

PROVENANCE
Abels Gallery, Cologne, by 1928;
Frederik Muller (auction), Amsterdam, 13 June 1933, lot 17; G. Stein Gallery, Paris, by 1937; **Lieutenant Colonel Victor Alexander Cazalet, Cranbrook, Kent and London, 1939**; National Gallery of Victoria (funded by Felton bequest), Melbourne, 1940

REFERENCES
French and British Contemporary Art, National Art Gallery of South Australia, Adelaide, Lower Town Hall, Melbourne and David Jones' Art Gallery, Sydney, 1939, no.135; Korn 2001; Korn 2002, p.137

Head of a Man was painted in Paris in the winter of 1886 or possibly very early in 1887. This was probably very slightly earlier than the first portrait of Alexander Reid (cat.1). Dating of the Melbourne portrait is difficult because it shares some characteristics of the artist's work in Nuenen and Antwerp, such as the more naturalistic use of colour, the dark palette and denser brushwork. But a closer examination of the colours suggests that it must have been done in Paris, after Van Gogh had encountered Impressionism. The sitter is unknown, but it is likely to have been a friend of Van Gogh, possibly a fellow artist. His eyes look up, rather intensely, and his unruly hair is emphasised, the swirling lines almost giving it a life of its own. This is Van Gogh's only horizontal format portrait and it was originally larger: it has been cut down below the neck. *Head of a Man* was bought in 1939 by Victor Cazalet, who earlier had acquired *View of Auvers with Wheatfield* (cat.31). *Head of a Man* was immediately offered on loan for an exhibition of modern French and British art which opened in August 1939 in Adelaide, and went on to tour to Melbourne and Sydney. Cazalet had attended the Imperial Conference in Canberra in August 1938 and it may have been as a result of contacts made then that he agreed to the loan. Because of the war, it was impossible to return the painting to London, and in 1940 it was sold to the National Gallery of Victoria, Melbourne, which paid £1,750, funded by the Felton Bequest.

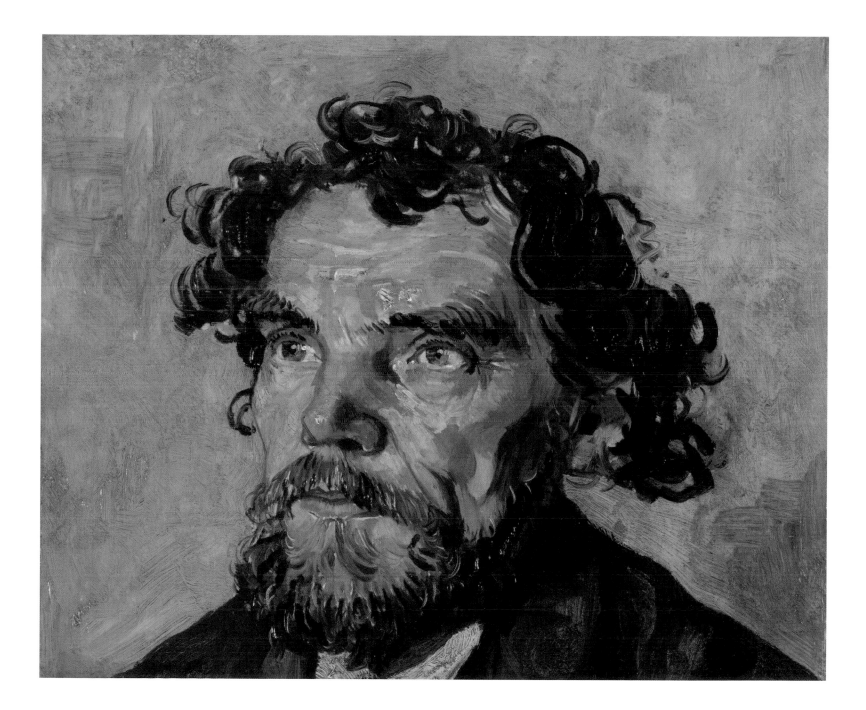

VAN GOGH: BRITISH COLLECTORS

This section records the ninety Van Gogh paintings and drawings which are known to have been in Britain before 1939, listed by collector.

'F' numbers refer to the De la Faille catalogue. JH numbers refer to the Hulsker catalogue. Seven works are now considered fakes, but are included since they were acquired as Van Goghs (Abdy, F521; Boise, F221a; Van Hofmannsthal, not in De la Faille; Lousada, not in De la Faille; Murray, F325; Stern, F813; and unknown, F725). Dealers are identified by the use of the word 'gallery/galleries'; they did not necessarily own the works, but often acted as agents. Works which passed through British dealers, but which were probably not bought by British collectors, are excluded. The data under 'references' relates primarily to British owners and exhibitions, rather than the entire history of the work. General publications relating to an individual collector are given in the references under the first of their Van Goghs. For abbreviations to literature, see bibliography. (VGM refers to the Van Gogh Museum, NGS refers to National Gallery of Scotland and ODNB refers to Oxford Dictionary of National Biography).

De la Faille has detailed provenance information on all the works listed in the catalogue, so it has not been recorded under references, but is a vital source. In addition to De la Faille's data, I would like to acknowledge the publications listed in the bibliography. With the additional help of primary sources, De la Faille's provenance data has been considerably fleshed out.

In our recorded provenance, it is assumed that when paintings and drawings passed to Theo van Gogh (in Paris), they generally did so in the year they were painted. Following Theo's death on 25 January 1891, the collection went to his wife Jo (Johanna) van Gogh-Bonger and their son Vincent Willem. Jo's place of residence in the provenance data is given as Amsterdam; from 1891–1903 she lived in the nearby town of Bussum and from then on in Amsterdam itself. In 1901 she married Johan Cohen-Gosschalk, who died in 1912. Jo died on 2 September 1925, and the collection passed to V.W. van Gogh, who lived mainly in Laren, a village near Bussum.

Exchange rates normally used in this catalogue for 1890–1914 are: French francs 25 = £1; German marks 20 = £1; Dutch guilders 12 = £1. After 1914 rates fluctuated.

Sir Robert Abdy

Born 11 September 1896. Aristocrat. Collected eighteenth-century furniture, English miniatures and Japanese art. He was a friend of Van Gogh collector Sir Alfred Chester Beatty. Died 16 November 1976.

Self-portrait

[not now attributed to Van Gogh]
Oil on canvas, 61 × 51 cm
Location unknown (possibly destroyed), F521 / JH –

PROVENANCE
Otto Wacker Gallery, Berlin; Hugo Perls Gallery, Berlin; **Sir Robert Henry Edward Abdy, Callington (Cornwall), London and Paris**; Thannhauser Gallery, Munich, by 1927; Rosengart Gallery, Lucerne

REFERENCES
Nineteenth Century French Paintings, Knoedler Gallery, London, 1926, no.3 (or F527?); Stefan Koldehoff, 'The Wacker forgeries', *Van Gogh Museum Journal* 2002, p.144

Valerie Alport

Biography: see page 110

Restaurant de la Sirène at Asnières (cat.29)

Mr & Mrs Anderson

Possibly Sir Colin Skelton Anderson (1904–1980) and his wife Morna Campbell. He was director of the P&O shipping company. He was also a trustee (1952–9) and chairman (1960–7) of the Tate.

Trees in the Garden of St Paul's Hospital

Oil on canvas, 42 × 32 cm, 1889 (St-Rémy)
Private Collection, F731 / JH1801

PROVENANCE
Theo van Gogh, Paris, 1889; Jo van Gogh-Bonger, Amsterdam, 1891; C.M. van Gogh Gallery, Amsterdam, 1908; Mrs Ernst-Sulzer, Winterthur; Fritz Meyer-Fierz, Zurich, by 1924; Frederik Muller (auction), Amsterdam, 13 July 1926, lot 13; Wildenstein Gallery, Paris; **Mr and Mrs Anderson, London, by 1936**; Private Collection, Lausanne, by 1964; Private Collection

REFERENCES
Feilchenfeldt 1988, p.116; Heijbroek & Wouthuysen 1993, p.195; Account Book, p.187; Korn 2001; Korn 2002 p.137; Essay on Sir Colin and Lady Anderson, *20th-century British Art*, Christie's, London, 18 November 2005, pp.37–40

Sir Thomas Barlow

Biography: see page 96

The Fortifications of Paris with Houses (cat.23)

Sir Alfred Chester Beatty & Edith Beatty

Chester Beatty was born New York, 7 February 1875. He became a mining developer and moved to London in 1911, where he founded Selection Trust Ltd three years later. In 1913 he married New York-born Edith Dunn, his second wife (born 1886) and they moved into Baroda House, at 24 Kensington Palace Gardens. In 1933 he became a British subject. His mining interests, primarily in Africa, brought him enormous wealth. During the Second World War he separated from his wife Edith, who continued to live in Baroda House until her death in 1952, while he moved to 28 Grosvenor House. He then moved to Dublin in 1950, where he made his home. Chester Beatty's art and manuscript collection, much of it from Asia, was very large. Most of the manuscripts are now at the Chester Beatty Library in Dublin. He also gave ninety-three Barbizon and other Continental paintings to the National Gallery of Ireland in 1950, as well as further donations over the next few years. Died Monte Carlo, 19 January 1968.

His son from his first marriage, Alfred Chester Beatty Jr (1907–1983) was born in New York and spent most of his life in London. He married Helen Gertrude.

opposite Sir Alfred Chester Beatty
Chester Beatty Library, Dublin

Sheaves of Wheat

Oil on canvas, 51 × 101 cm, 1890 (Auvers)
Dallas Museum of Art, F771 / JH2125

PROVENANCE

Theo van Gogh, Paris, 1890; Jo van Gogh-Bonger, Amsterdam, 1891; V.W. van Gogh, Laren, 1925; Leicester Galleries, London, 1926; **Edith Beatty (née Dunn), London, 1926**; Sir Alfred Chester Beatty, Dublin, 1952 (on loan to National Gallery of Ireland, 1954–7); Wendy and Emery Reves, Roquebrune, France, by 1962; Dallas Museum of Art (Wendy and Emery Reves Collection), 1985

REFERENCES

Vincent van Gogh, Leicester Galleries, London, 1926, no.12 (?); 'A modern picture collection', *Studio*, July 1932, pp.77–81; papers at Chester Beatty Library, Dublin; letter from Emery Reves to F.H. Landshoff, 9 July 1962 (Dallas Museum of Art records); A.J. Wilson, *The Life & Times of Sir Alfred Chester Beatty*, London, 1985; Brian Kennedy, *Alfred Chester Beatty and Ireland*, Dublin, 1988; Feilchenfeldt 1988, p.118; Korn 2001; Korn 2002, pp.132–3 and 136; Charles Horton, *Alfred Chester Beatty*, Dublin, 2003; Peter Somerville-Large, *The Story of the National Gallery of Ireland*, Dublin, 2004, pp.351–73; ODNB

Portrait of Patience Escalier (fig.15)

Oil on canvas, 69 × 56 cm, 1888 (Arles)
Private Collection, F444 / JH1563

PROVENANCE

Bernheim-Jeune Gallery, Paris, by 1917; Auguste Bauchy, Livry; Alex Reid & Lefevre Gallery, London, 1934; **Edith Beatty (née Dunn), London, 1934**; Sir Alfred Chester Beatty, Dublin, 1952; Alfred Chester Beatty Jr, London, 1968; Christie's, London, 15 April 1975, lot 75 (withdrawn); Alex Reid & Lefevre Gallery and Marlborough Gallery, London, 1975; Stavros Spyros Niarchos, Greece (and elsewhere), 1975; Private Collection, 1996

REFERENCES

Renoir, Cézanne and their Contemporaries, Alex Reid & Lefevre Gallery, London, 1934, no.20; *French Painting*, McLellan Galleries, Glasgow, 1934, no.28 (?); T.J. Honeyman, *Art and Audacity*, London, 1971, p.21; Feilchenfeldt 1988, p.95; Jack Webster, *From Dali to Burrell*, Edinburgh, 1997, p.84; Korn 2001; Korn 2002, pp.132–3 and 136

Sunflowers (fig.7)

Oil on canvas, 100 × 76 cm, 1888–9 (Arles)
Sompo Japan Museum of Art (formerly Yasuda Museum), Tokyo, F457 / JH1666

PROVENANCE

Theo van Gogh, Paris, 1889; Jo van Gogh-Bonger, Paris, 1891; Père Julien Tanguy Gallery, Paris, 1891; Claude-Emile Schuffenecker, Paris, 1894; Amédée Schuffenecker, Paris; Eugène Druet Gallery, Paris, 1908; J.H. de Bois Gallery, The Hague, 1910; Paul von Mendelssohn-Bartholdy, Berlin, 1910; Paul Rosenberg Gallery, Paris, 1934; **Edith Beatty (née Dunn), London, 1935**; Sir Alfred Chester Beatty, Dublin, 1952 (on loan to National Gallery, London, 1956–59); Alfred Chester Beatty Jr, London, 1968; Helen Gertrude Chester Beatty, London, 1983 (on loan to National Gallery, London, 1983–87); Christie's, London, 30 March 1987, lot 43; Seiji Togo Memorial Yasuda Kasai Museum of Art (later Sompo Japan Museum of Art), Tokyo, 1987

REFERENCES

Manet and the Post-Impressionists, Grafton Galleries, London, 1910, no.72; Feilchenfeldt 1988, p.96; Heijbroek & Wouthuysen 1993, p.195; Account Book, p.174; Korn 2001; Korn 2002, pp.132–3 and 136

Trunk of a Yew

Oil on canvas, 91 × 71 cm, 1888 (Arles)
Private Collection, F573 / JH1618

PROVENANCE

Theo van Gogh, Paris, 1888; Jo van Gogh-Bonger, Amsterdam, 1891; Paul Cassirer Gallery, Berlin, 1906; Prince de Wagram (Louis-Alexandre Berthier), Paris, 1906; Amédée Schuffenecker, Clamart; Paul Rosenberg Gallery, Paris; Paul von Mendelssohn-Bartholdy, Berlin, 1910; P. de Boer Gallery, Amsterdam; **Edith Beatty (née Dunn), London, 1935**; Sir Alfred Chester Beatty, Dublin, 1952; Private Collection, Paris, 1958; Carroll Carstairs Gallery, New York; Mr and Mrs Paul Mellon, Upperville, Virginia, 1958; Christie's, New York, 14 November 1989, lot 10; Helly Nahmad Gallery, London, 1989; Private Collection

REFERENCES

Paintings from Irish Collections, Municipal Gallery of Modern Art, Dublin, 1957, no.90; Feilchenfeldt 1988, p.105; Account Book, p.179; Korn 2001; Korn 2002, pp.132–3 and 136

Rocks with Oak Tree

Oil on canvas, 54 × 65 cm, 1888 (Arles)
Museum of Fine Arts, Houston, F466 / JH1489

PROVENANCE

Theo van Gogh, Paris, 1888; Jo van Gogh-Bonger, Amsterdam, 1891; Paul Cassirer Gallery, Berlin, 1905; Margarete Mauthner, Berlin, 1905; Josef Stransky,

New York, by 1933; Wildenstein Gallery, New York and London, 1936; **Sir Alfred Chester Beatty, London and Dublin, 1936** (on loan to National Gallery, London 1956–62); Arthur Tooth Gallery, London, 1963; John A. and Audrey Jones Beck, Houston, 1964; Museum of Fine Arts, Houston (Audrey Jones Beck gift), 1974

REFERENCES

Ingres to Matisse, Wildenstein Gallery, London, 1936, no.20; letter from Sir Alfred Chester Beatty to Thomas McGreevy, 6 February 1953 (Chester Beatty Library, Dublin); Tate trustee minutes, 20 June and 18 July 1963; Feilchenfeldt 1988, p.97; Account Book, p.174; Korn 2001; Korn 2002, pp.132–3 and p.137

Charles Beechman

No biographical details available.

Restaurant Rispal at Asnières

Oil on canvas, 72 × 60 cm, 1887 (Paris)
Mr and Mrs Henry W. Bloch, Shawnee Mission, Kansas, F355 / JH1266

PROVENANCE

Theo van Gogh, Paris, 1887; Jo van Gogh-Bonger, Amsterdam, 1891; V.W. van Gogh, Laren, 1925; Leicester Galleries, London, 1926; **N. Charles Beechman, London, 1926**; Alex Reid & Lefevre Gallery, London, 1929; Raphaël Gérard, Paris, 1930; Bernheim-Jeune Gallery, Paris; Mr & Mrs Hugo L. Moser, Berlin (?), Heemstede, near Haarlem and New York, by 1939; Sotheby's, New York, 7 November 1979, lot 541

REFERENCES

Vincent van Gogh, Leicester Galleries, London, 1926, no.13; *Modern French Masters*, Arthur Tooth Gallery, London, 1930, no.18; Alex Reid & Lefevre Gallery photograph (Tate archive); Feilchenfeldt 1988, pp.89–90; Korn 2001; Korn 2002, p.136

Henry van den Bergh

Biography: see page 108

Gardener by an Apple Tree (cat.28)

Charles Boise

Boise was born in America, and had moved to England by the 1920s. In 1927 he purchased Emmetts, a house near Sevenoaks in Kent (now National Trust). Boise was a geologist. He provided financial assistance to anthropologist Mary Leaky for her work in East Africa and a 1.5 million-year-old skull was named in his honour, Austalopithecus Boisei. Died 1964.

The Tramp

[not now attributed to Van Gogh]
Oil on canvas, 33 × 24 cm
Formerly Arthur Tooth Gallery, London, F221a / JH –

PROVENANCE
Arthur Fontaine, Paris; Drouot (auction), Paris, 13 April 1932, lot 72; Huinck & Scherjon Gallery, Amsterdam; **Charles Watson Boise, Sevenoaks, by 1943**; Arthur Tooth Gallery, London, by 1970

REFERENCES
Vincent van Gogh, Wildenstein Gallery, New York, 1943, no.20; Korn 2001; Korn 2002, pp.133 and 136

Lea Bondi-Jaray

Born Mainz, 12 December 1880. Lea (or Leah) Bondi, who married Sandor Jaray, was a Viennese art dealer and collector. She fled immediately after the Nazi Anschluss in 1938 and came to London. Died London, 1968.

Backyard with Two Figures

Charcoal on paper, 24 × 35 cm, 1882 (The Hague)
Jan Krugier and Marie-Anne Krugier-Poniatowski, Geneva, F939a / JH120

PROVENANCE
Charles Louis Philippe Zilcken, The Hague ; C.M. van Gogh Gallery, The Hague; J.H. de Bois Gallery, Haarlem, 1936 ; **Lea Bondi-Jaray, Vienna and London**; Private Collection, New York, 1953; St Etienne Gallery (Otto Kallir), New York, 1953; Jan Krugier and Marie-Anne Krugier-Poniatowski, Geneva

William Boyd

Biography: see page 74

Trees (fig.22)

Oil on canvas, 73 × 92 cm, 1890 (Auvers)
Private Collection, F817 / JH1319

PROVENANCE
Theo van Gogh, Paris, 1890; Jo van Gogh-Bonger, Amsterdam, 1891; Bernheim-Jeune Gallery, Paris, 1909; Paul Vallotton Gallery, Lausanne; Willy Russ-Young, Serrières, Neuchâtel, by 1916; Paul Vallotton Gallery, Lausanne; **William Boyd, Dundee**; Justin Thannhauser Gallery, Paris and New York, by 1939; Mr & Mrs Joseph H. Hazen, New York, 1954; Sotheby's, New York, 8 November 1995, lot 12; Private Collection

REFERENCES
Feilchenfeldt 1988, p.123; Fowle 1994; Korn 2001; Korn 2002, pp.135–6

Field with Ploughman (cat.13)

Orchard in Blossom (Plum Trees) (cat.14)

British Museum

Portrait of Dr Gachet (cat.16)

Gardener by an Apple Tree (cat.28)

David Cargill

Born 1872. Lived in Lanark. His wealth came from his father, David S. Cargill, who had founded the Burmah oil company. David Cargill, the son, assembled an important collection of Impressionist and modern French art, as well as work by Scottish artists. Most of his paintings were sold at Christie's, London, 2 May 1947 and Parke-Bernet, New York, 6 January 1949. Died on 5 September 1939. His half-brother William Cargill was also an important collector (see below).

Vase with Zinnias

Oil on canvas, 64 × 50 cm, 1888 (Arles)
Private Collection, F592 / JH1568

PROVENANCE
Elisabeth Huberta du Quesne-van Gogh, Baarn; Nico Eisenloeffel Gallery, Amsterdam; Alex Reid & Lefevre Gallery, London, 1928; **David William Traill Cargill, Lanark, 1930**; Stephen Carlton Clark, New York; Ralph Booth, Detroit; E & A. Silberman Gallery, New York; Harry S. Southam, Ottawa; Mrs Charles S. Payson, New York; Knoedler Gallery, New York; Florence Gould, California; Daniel Varenne, Geneva; Private Collection, 1972; Beyeler Gallery, Basel; Basil and Elise Goulandris, Athens; Private Collection

REFERENCES
Renoir and the Post-Impressionists, Alex Reid & Lefevre Gallery, London, 1930, no.16; *Annual Exhibition*, Royal Glasgow Institute, 1935, no.247; *Boudin and Some Contemporaries*, Alex Reid & Lefevre Gallery, London, 1936, no.34; *Post-Impressionists*, Bignou Gallery, New York, 1940, no.9; Fowle 2002, p.200; Korn 2001; Korn 2002, p.136

William Cargill

Half-brother of David Cargill. He lived with his mother at Carruth, Bridge of Weir. After her death he became an eccentric recluse, devoting himself to gardening and collecting. He too acquired a major collection of nineteenth-century French art, with money inherited from his father. Died November 1962.

Moulin de la Galette

Oil on canvas, 47 × 37 cm, 1886 (Paris)
Destroyed, F271 / JH1186

PROVENANCE
Theo van Gogh, Paris, 1886; Jo van Gogh-Bonger, Amsterdam, 1891; Artz and De Bois Gallery, The Hague, 1912; J.H. de Bois Gallery, Haarlem, 1913; Frederik Muller (auction), Amsterdam, 26 October 1920, lot 140; Eugène Blot Gallery, Paris; G. Urion; Georges Petit (auction), Paris, 30–31 May 1927, lot 35; R. Sauerbach, Paris; Drouot (auction), Paris, 11 March 1931, lot 34; Alfred (?) Lindon, Paris; Etiènne Bignou Gallery, Paris and New York, by 1938; Alex Reid & Lefevre Gallery, London, 1938; **William Alexander Cargill, Bridge of Weir, near Paisley, 1938**; Sotheby's, London, 11 June 1963, lot 49; Private Collection (destroyed by fire, 1967)

REFERENCES
Tragic Painters, Alex Reid & Lefevre Gallery, London, 1938, no.39; Heijbroek & Wouthuysen 1993, p.192–3; Korn 2001; Korn 2002, p.137; Fowle 2002, p.200

Elizabeth Carstairs

Biography: see page 90

Terrace and Observation Deck at the Moulin de Blûte-fin, Montmartre (cat.20)

Victor Cazalet

Biography: see page 114

View of Auvers with Wheatfield (cat.31)

Head of a Man (cat.32)

Herbert Coleman

Born Manchester, c.1882. His family name was origi-
nally Kullmann and his parents were from Germany.
He changed his surname during the First World War.
Coleman worked for the family shipping business,
Kolp, Coleman & Co. He lived in West Didsbury,
Manchester and moved to London in around 1930.
Died Petersfield, Hampshire, 16 February 1949.

Stairway at Auvers

Oil on canvas, 51 × 71 cm, 1890 (Auvers)
Saint Louis Art Museum, F795 / JH2111

PROVENANCE
Theo van Gogh, Paris, 1890; Jo van Gogh-Bonger,
Amsterdam, 1891; Bernheim-Jeune Gallery, Paris,
1909; **Herbert Charles Coleman (Kullmann),
Manchester and London, by 1913**; Bernheim-Jeune
(auction), Paris, 16 May 1914, lot 6 (unsold); Paul
Rosenberg Gallery, Paris, by 1934; Saint Louis Art
Museum, 1935

REFERENCES
Post-Impressionist Pictures & Drawings, Leeds Art Club,
1913, no.5; *Art Français*, Grosvenor House, London,
1914, no.88; letter from Roger Fry to Vanessa Bell,
14 December 1921, in Denys Sutton, *Letters of Roger Fry*,
London, 1972, vol.II, p.518; diary of Michael Sadler,
11 October 1922 (Tate archive); *Masterpieces of French Art
of the 19th Century*, Agnew Gallery, Manchester, 1923,
no.19; *Vincent van Gogh*, Oxford Arts Club, 1924, no.6;
Opening Exhibition, Tate, London, 1926, p.10; Percy
Colson, 'Mr Herbert Coleman's collection', *Apollo*,
April 1931, pp.215–8; Account Book, p.191; Korn 2001;
Korn 2002, pp.128 and 136

Samuel Courtauld

Biography: see page 102

Peach Blossom in the Crau (cat.26)

Tile Factory (cat.27)

Self-portrait with a Bandaged Ear (fig.12)
Oil on canvas, 60 × 49 cm, 1889 (Arles)
The Samuel Courtauld Trust, Courtauld Institute of
Art Gallery, London, F527 / JH1657

PROVENANCE
Theo van Gogh, Paris, 1889; Jo van Gogh-Bonger,
Amsterdam, 1891; Ambroise Vollard Gallery, Paris,
1897; Count Antoine de la Rochefoucauld, Paris, 1897;
Paul Rosenberg Gallery, Paris; **Samuel Courtauld,
London, 1928**; Courtauld Institute Gallery, London,
1948 (Courtauld bequest)

REFERENCES
Nineteenth Century French Paintings, Knoedler Gallery,
London, 1926, no.3 (or F521?); letter from Paul
Rosenberg to Samuel Courtauld, 6 October 1928
(Courtauld records); *Dutch Art*, Royal Academy,
London, 1929, no.453; *Annual Exhibition*, Royal
Scottish Academy, Edinburgh, 1929, no.333; *Annual
Exhibition*, Royal Glasgow Institute, McLellan Galler-
ies, 1929, no.318; *Vincent van Gogh*, Stedelijk Museum,
Amsterdam, 1930, no.66; Account Book, p.177; Korn
2001; Korn 2002, p.136

Gwendoline Davies

Biography: see page 70

Rain – Auvers (cat.11)

Martha Edwards

Lived in Gloucester. Member of the city council's
education committee (from 1926) and later chairman
(1946–67).

Portrait of Dr Gachet

Etching, 18 × 15 cm, 1890 (Auvers)
Location unknown, F1664 / JH2028
(for another example see cat.16)

PROVENANCE
Martha Lilian Edwards (née Moss), Gloucester,
by 1936

REFERENCE
Modern French paintings, drawings and prints, Guildhall,
Gloucester, 1936, no.108

Evelyn Fleming

Biography: see page 92

Head of a Peasant Woman (cat.21)

Edward & Thalia Gage

Edward Gage was born in London, 3 July 1906. Gradu-
ated from Oxford in 1927. Married the poet Thalia
Westcott Millet on 21 January 1931. He was a barrister.
Died 7 May 2000.

Shrub in the Public Garden

Ink on paper, 14 × 17 cm, 1888 (Arles)
Private Collection, F1465 / JH1583

PROVENANCE
Lutz Gallery, Berlin; G.F. Reber, Barmen, Wuppertal;
Max Silberberg, Breslau; Leicester Galleries, London,
1936; William Appleton Coolidge, Boston; **Edward
Fitzhardinge Peyton Gage and Thalia Westcott Gage
(née Millet), London, probably late 1930s**; Sotheby's,
London, 3 December 1958, lot 47; Private Collection,
Europe; Sotheby's, New York, 13 November 1997, lot
105; Private Collection

REFERENCES
Modern Artists, Leicester Galleries, London, 1936, no.165

Frederick Herrmann

Born 1893, the son of Berlin artist Curt Herrmann
(1854–1929). Frederick Herrmann became an architect.
He fled from Berlin to London in 1937. Died 1983.

Field with Green Wheat

Oil on canvas, 73 × 93 cm, 1889 or 1890 (St-Rémy)
National Gallery of Art Washington, F807 / JH1980

PROVENANCE
Theo van Gogh, Paris, 1890; Jo van Gogh-Bonger,
Amsterdam, 1891; Paul Cassirer Gallery, Berlin, 1906;
Curt Herrmann, Berlin, 1906; **Frederick (Fritz) Henry
Herrmann, Berlin and London, 1929**; Carstairs
Gallery, New York, 1955; Mr and Mrs Paul Mellon,
Upperville, Virginia; National Gallery of Art, Wash-
ington, 1999 (bequest, with life interest to Mrs Mellon)

REFERENCES

Curt Herrmann, *Der Kampf um den Stil*, Berlin, 1911, p.115; *Sonderbundes*, Ausstellungs-Halle, Cologne, 1912, no.42; *Vincent van Gogh*, Cassirer Gallery, Berlin, 1914, no.138; *Van Gogh-Matisse*, Nationalgalerie, Berlin, 1921, no.22; *Vincent van Gogh*, Cassirer Gallery, Berlin, 1928, no.89; Feilchenfeldt 1988, p.122; *Curt Herrmann*, Berlin Museum, 1989; Korn 2001; Korn 2002, p.137; Frank Herrmann, *Low Profile*, Nottingham, 2002

A Group of Houses

Oil on canvas, 51 × 58 cm, 1890 (Auvers)
Private Collection, Switzerland, F794 / JH2002

PROVENANCE

Bernheim-Jeune Gallery, Paris; Paul Cassirer Gallery, Berlin, 1904; Curt Herrmann, Berlin, 1904; **Frederick (Fritz) Henry Herrmann, 1929, Berlin and London**; Private Collection, Switzerland, after 1945

REFERENCES

Sonderbundes, Ausstellungs-Halle, Cologne, 1912, no.103; *Vincent van Gogh*, Cassirer Gallery, Berlin, 1914, no.139; *Van Gogh-Matisse*, Nationalgalerie, 1921, no.21; *Vincent van Gogh*, Cassirer Gallery, Berlin, 1928, no.86; Feilchenfeldt 1988, p.121

Gertrude von Hofmannsthal

Widow of Hugo von Hofmannsthal (1874–1929), a poet and dramatist, from Vienna. She fled to Britain in the late 1930s.

Flowers

[not now attributed to Van Gogh]
Oil on canvas, , 62 × 47 cm
Arabella Heathcoat Amory, Devon, not in De la Faille

PROVENANCE

Hugo von Hofmannsthal, Vienna; **Gertrude von Hofmannsthal (née Schlesinger), Vienna and London, 1929**; Raimund von Hofmannsthal, London, c.1956; Arabella Heathcoat Amory, Devon, 1980

REFERENCES

J.-B. de la Faille, *Les faux Van Gogh*, Paris, 1930, no.68 (plate xx); Marie-Thérèse Miller-Degenfeld, *The Poet and the Countess*, Woodbridge, Suffolk, 2000

John Holme

Born c.1870. Farmer at Billington, near Stafford. Died 1952.

Cottage in Brabant (fig.14)

Oil on canvas, 63 × 112 cm, 1885 (Nuenen)
Private Collection, F1669 / JH825

PROVENANCE

John Charles Holme, Billington Farm, near Stafford, 1920s; Charles Holme, Billington Farm, 1952; Bagshaws of Uttoxeter (farm auction), Billington Farm, 1968; antique shop in Hampstead, 1968; Dr Luigi Grosso, London, 1968; Parke-Bernet (auction), New York, 28 October 1970, lot 18 (unsold, but sold shortly afterwards); Mr & Mrs Joseph E. Levine, New York; Sotheby's, New York, 18 May 1983, lot 29; Private Collection, New York; Sotheby's, New York, 14 May 1985, lot 27 (unsold); Sotheby's, London, 3 December 1985, lot 14; Private Collection; Sotheby's, New York, 10 May 2001, lot 203; Private Collection

REFERENCES

The Times, 5 March 1969; Alan Bowness, 'A Van Gogh Discovery', *Burlington*, May 1969, pp.299–300; Tilborgh & Vellekoop 1999, pp.10–1, n.21

Birger Jonzen

Born in Sweden, c.1881. Came to London just before the First World War and became a timber and glass importer. His son Basil Jonzen (1916–67) was an artist and married sculptor Karin Jonzen née Löwenadler (1914–98). Birger died in Britain, 1961.

Peasant Woman Kneeling

Black chalk on paper, 53 × 42 cm, 1885 (Nuenen)
Private Collection, F1262a / JH838

PROVENANCE

Ambroise Vollard Gallery, Paris; Edgar Degas (?), Paris; Georges Petit (auction), Paris, 26–7 March 1918, lot 245; Rose Caron, Paris; Leicester Galleries, London, 1926; **Birger Jonzen, Caterham, 1926;** Sotheby's, London, 4 May 1960, lot 183; S. Milton; Eric Korner, London; Christie's, London, 22 June 2004, lot 3; Private Collection

REFERENCES

Modern French Art, Goupil, London, 1920, no.17 (?); *Vincent van Gogh*, Leicester Galleries, London, 1926, no.33; *The Private Collection of Edgar Degas*, Metropolitan Museum, New York, 1997, vol.II, p.66

Matthew Justice

Born 1875. Lived in Dundee. Proprietor of furniture makers Thomas Justice & Sons. Collected the Scottish Colourists and European Modern art. Moved to Lausanne in 1937. Justice also seems to have acted as an intermediary in bringing modern Continental art to Scotland. Around 1920 he had a gallery or office in London that handled art sales, particularly works by Vuillard. Died Locarno, May 1942.

Bouquet of Flowers (fig.4)

Oil on canvas, 58 × 46 cm, 1886 (Paris)
Schmit Gallery, Paris, F236 / JH1130

PROVENANCE

Matthew Low Justice, Dundee, by 1924; Bernheim-Jeune Gallery, Paris; Scott & Fowles Gallery, New York, 1924; Knoedler Gallery, New York and Paris, 1924; James W. Barney, New York, by 1929; Parke-Bernet (auction), New York, 26 October 1944, lot 84; Charles Sessler Gallery, Philadelphia, 1944; Charles Chaplin, Haverford, Pennsylvania; Parke-Bernet (auction), New York, 9 November 1955, lot 82; A. Ball Gallery, New York; Joseph Gruss, New York; Christie's, New York, 2 November 1993, lot 4; Schmit Gallery, Paris

REFERENCES

Salon Goupil, London, 1921, no.69 (?); Korn 2001 & 2002, pp.134–6
See also FISHER UNWIN

Anne Kessler

Born Dordrecht, 1889. She married Jean Baptiste August Kessler Jr, a senior executive of the Royal Dutch Petroleum Company. They moved to England in 1919. She collected Modern European paintings in the 1920s and 30s, and was a friend of the artist Raoul Dufy. Anne Kessler was the niece of Van Gogh collector Frank Stoop. She made a major bequest to the Tate. Died January 1983.

Harvest Landscape (fig.16)

Watercolour and ink on paper, 48 × 60 cm, 1888 (Arles)
Private Collection, United States, F1483 / JH1439

PROVENANCE

Julius Meier-Graefe, Berlin, by 1899; Jos. Hessel Gallery, Paris, by 1901; Paul Cassirer Gallery, Paris, 1914; Georges Bernheim Gallery, Paris, 1918; Alfred Flechtheim Gallery, Düsseldorf; F. Haniel, Wistinghausen; Paul Rosenberg Gallery, Paris; Alex Reid & Lefevre Gallery, London, 1929; **Anne Françoise Kessler, London and Preston, Rutland, 1930**; Kessler family trust, 1983; Sotheby's, London, 24 June 1997, lot 7; Private Collection (Wolfgang Flottl?); Sotheby's, New York, 5 November 2003, lot 6; Private collector, United States

REFERENCES

Renoir and the Post-Impressionists, Alex Reid & Lefevre Gallery, London, 1930, no.15; *19th-Century French paintings*, National Gallery, London, 1943, no.76; *Kessler Collection*, Wildenstein Gallery, London, no.30 and York City Art Gallery, no.6, 1948; *Kessler Bequest*, Tate, London, 1984; *Kessler Collection*, Leicestershire Art Gallery, Leicester, 1986, no.11; Feilchenfeldt 1988, p.135; *Annual Report*, Export Reviewing Committee, London, 1998, pp.17–18

Julian Lousada

Solicitor in London. His son Anthony was chairman of the Tate (1967–9). Julian Lousada died 1941.

Still life with Book, Bowl and Candle

[not now attributed to Van Gogh]
Oil on canvas, dimensions unknown, location unknown, not in De la Faille

PROVENANCE

Julian George Lousada, London, by 1928

REFERENCES

Photograph in Witt Library, London

William McInnes

Born Glasgow, 1868. He was a partner in the shipping company Gow, Harrison & Co. He collected work by the Scottish Colourists and the Impressionists. McInnes bequeathed his collection to Glasgow Art Gallery. Died 1944.

Le Moulin de Blûte-fin, Montmartre (fig.17)

Oil on canvas, 47 × 38 cm, 1886 (Paris)
Glasgow Art Gallery and Museum, F274 / JH1115

PROVENANCE

Theo van Gogh, Paris, 1886; Jo van Gogh-Bonger, Amsterdam, 1891; Tedesco Gallery, Paris, 1921; Bernheim-Jeune Gallery, Paris, 1921; Alex Reid Gallery, Glasgow, 1921; **William McInnes, Glasgow, 1921;** Glasgow Art Gallery and Museum, 1944 (McInnes bequest)

REFERENCES

Spirit of France, Glasgow Art Gallery, 1943, no.53; 'The McInnes Collection', *[Scottish] Art Review*, 1946, pp.21–3; letter from Jean Dauberville to Anne Donald, 1 December 1965 (Glasgow Art Gallery records); Korn 2001; Korn 2002, p.136; Glasgow 2002, pp.104–5, 185 and 202

Sir Alexander Maitland QC

Alexander Maitland, born in 1877, was the son of a Dundee merchant, Thomas Maitland, and grandson of Lord Barcaple. Born in Dundee, he read classics at Oxford and law at Edinburgh before being called to the Bar in 1903. In 1906 he married Rosalind Sellar, a young musician and the daughter of an MP. The couple built up an important collection of Impressionist and Post-Impressionist paintings, most of which were presented by Maitland to the National Gallery of Scotland in 1960, in memory of his wife. Maitland was made a Trustee of the National Galleries of Scotland in 1947 and was Deputy Governor of the Royal Bank of Scotland from 1953 to 1962, when he was knighted. He died on 25 September 1965 and bequeathed further works to the National Gallery of Scotland.

Orchard in Blossom (Plum Trees) (cat.14)

Head of a Peasant Woman (cat.21)

Royan Middleton

Lived in Dundee and Aberdeen. Publisher of greetings cards.

View of a River with Rowing Boats (cat.12)

Lane in Voyer d'Argenson Park at Asnières (fig.24)

See under LEOPOLD SUTRO for full provenance

Edward Molyneux

Biography: see page 112

Vineyards at Auvers

Oil on canvas, 65 × 80 cm, 1890 (Auvers)
Saint Louis Art Museum, F762 / JH2020

PROVENANCE

Theo van Gogh, Paris, 1890; Jo van Gogh-Bonger, Amsterdam, 1891; Paul Cassirer Gallery, Berlin, 1905; Hugo von Tschudi, Berlin and Munich, 1905; Angela von Tschudi, Munich, 1911; Paul Rosenberg Gallery, Paris, by 1929; **Captain Edward Henry Molyneux, Paris and London, by 1930**; Rosenberg & Helft Gallery, London, 1937; Paul Rosenberg Gallery, Paris, by 1950; Mrs Mark C. Steinberg, St Louis, 1953; Saint Louis Art Museum (gift of Mrs Mark C. Steinberg), 1953

REFERENCES

Ingres to Van Gogh, Rosenberg & Helft Gallery, London, 1937, no.33 (?); Feilchenfeldt 1988, p.118; Account Book, p.189

Farmhouse in Provence (cat.30)

Sir James Murray

Biography: see page 78

Still Life with Daisies and Poppies (cat.15)

[not now attributed to Van Gogh]

Sir Laurence Philipps

Born Warminister, Wiltshire, 24 January 1874. Shipping magnate. He became the first Baron Milford in 1939. Resided at Dalham Hall, Newmarket and Picton Castle, Haverfordwest. Died 1962.

Still Life with Daisies and Poppies (cat.15)

[not now attributed to Van Gogh]

Lucien Pissarro

Born Paris, 20 February 1863. His father was the artist Camille Pissarro (1830–1903). Lucien Pissarro also became an artist. He met Van Gogh in Paris in 1887. He settled in England in 1890, living in Epping and later Bedford Park. Died Hewood, Dorset, 10 July 1944.

Basket of Apples (fig.3)

Oil on canvas, 54 × 65 cm, 1887 (Paris)
Kröller-Müller Museum, Otterlo, F378 / JH1340

PROVENANCE

Lucien Pissarro, Paris and London, 1887; Aubry, Paris, by 1908; Eugène Druet Gallery, Paris; Mrs Hélène Kröller-Müller, The Hague, 1912; Kröller-Müller Museum, Otterlo, 1939

REFERENCES

Letters from Vincent to Theo, *c*.9 March and *c*.2 April 1888, *Complete Letters*, 1958, vol.II, pp.529 and 539; letters from Lucien to Julie Pissarro, 29 July 1906, another undated (1906, in 1909 file) and 12 October 1906 (in 1909 file) (Pissarro archive, Ashmolean Museum); letters from Claude Monet to Lucien Pissarro, 2 October 1906, 11 November 1906 and 5 April 1914 (Pissarro archive); letter from Esther to Julie Pissarro, October 1906 (Pissarro archive); letter from Lucien Pissarro to Dr Paul Gachet, 26 January 1928, Paul Gachet, *Lettres Impressionistes*, Paris, 1957, p.55; W.S. Meadmore, *Lucien Pissarro*, London, 1962, pp.41 and 105–6; Daniel Wildenstein, *Claude Monet*, Paris, 1985, vol.IV, pp.371 and 390; Feilchenfeldt 1988, p.91; Korn 2001; Korn 2002, p.136

W. Regendanz

Possibly Dr W. Ch. Regendanz, who was the author of *Searchlight on German Africa* (1939). If so, he moved from Berlin to Britain in 1934.

Fortifications of Paris

Watercolour and chalk on paper, 40 × 54 cm, 1887 (Paris)
Private Collection, London, F1402 / JH1280

PROVENANCE

Theo van Gogh, Paris, 1887; Jo van Gogh-Bonger, Amsterdam, 1891; C.M. van Gogh Gallery, Amsterdam, 1911; Artz & De Bois Gallery, The Hague, 1912; J. Th. Schall, Berlin, 1912; Cassirer (auction), Berlin, 26 October 1926, lot 8; **Dr W.C. (or G.) Regendanz, Berlin (?), Aberdovey (Wales) and London**; Christie's, London, 16 July 1948, lot 45; Alex Reid & Lefevre Gallery, London, 1948; Arthur Tooth Gallery, London, 1948; Charles Clore, London; Private Collection, Britain

REFERENCES

Recent Acquisitions, Arthur Tooth Gallery, London, 1948, no.26; photograph, Witt Library; Denys Sutton, *Christie's since the War*, London, 1959, p.92; Heijbroek & Wouthuysen 1993, pp.39 and 204; Account book, pp.193–4

Alexander Reid

Biography: see page 46

Portrait of Alexander Reid (cat.1)

Still Life, Basket of Apples (cat.3)

A.J. McNeill Reid

Biography: see page 48

Portrait of Alexander Reid (cat.2)

Victor Rienaecker

Born in London in 1887. Art historian and author of *The Paintings and Drawings of J.B.C. Corot* (1929), *John Sell Cotman* (1953) and *William Blake* (1957).

The Roofs of Paris and Notre Dame

Charcoal and chalk on paper, 25 × 32 cm, 1886 (Paris)
Private Collection, F1389 / JH1096

PROVENANCE

Theo van Gogh, Paris, 1886; Jo van Gogh-Bonger, Amsterdam, 1891; V.W. van Gogh, Laren, 1925; Leicester Galleries, London, 1926; **George Victor Robert Rienaecker, London, 1926**; R. Rienaecker, London; Private Collection

REFERENCES

Vincent van Gogh, Leicester Galleries, London, 1926, no.34; note by H. Stanley Ede, 26 March 1926 (Tate archive)

Gustav Robinow

Lived in Richmond Hill, Surrey in 1911. Presumably related to Hamburg collector Dr Paul Robinow (1865–1922) and his wife Emily.

Factories at Asnières

Oil on canvas, 54 × 73 cm, 1887 (Paris)
Saint Louis Art Museum, F317 / JH1287

PROVENANCE

Père Julien Tanguy Gallery, Paris; Georges Petit (auction), Paris, 2 June 1894, lot 61; Bernheim-Jeune Gallery, Paris; Eugène Blot Gallery, Paris; Maurice Fabre, Paris, by 1901; Bernheim-Jeune Gallery, Paris, 1901; Grafton Galleries, London, 1910; **Gustav Robinow, Richmond Hill, Surrey, 1910**; Dr Paul Melchior Robinow, Hamburg, 1911; Emily Robinow, Hamburg, 1922; Paul Cassirer (auction), Berlin, 30 October 1928, lot 58; Wilhelm Weinberg, Amsterdam and Scarsdale, New York, 1928; Sotheby's, London, 10 July 1957, lot 47; Knoedler Gallery, New York, 1957; Mrs Mark C. Steinberg, Saint Louis; Saint Louis Art Museum, 1958 (donated by Mrs Mark C. Steinberg)

REFERENCES

Manet and the Post-Impressionists, Grafton Galleries, London, 1910, no.69; letter from Gustav Robinow to Jo van Gogh-Bonger, 16 January 1911 (Van Gogh Museum archive); *Vincent van Gogh*, Cassirer Gallery, Berlin, 1914, no.23; Feilchenfeldt 1988, p.88; *Private Schätze*, Hamburger Kunsthalle, 2001, pp.74–5 and 240; Korn 2001; Korn 2002, pp.128 and 136

William Robinson

Biography: see page 56

Two Crabs (cat.5)

Peasant in a Cart Coupled to an Old White Horse

Not identified
(possibly F1677 / JH52, Van Gogh Museum)

PROVENANCE

William Cherry Robinson, Bournemouth and Amsterdam; Frederik Muller (auction), Amsterdam, 13 November 1906, lot 143

REFERENCES

Sjraar van Heugten, *Vincent van Gogh Drawings*, vol.I, Van Gogh Museum, 1996, pp.93–5 (on F1677)

Sir Michael Sadler

Biography: see page 84

Oleanders (cat.18)

Olive Trees (cat.19)

Orchard near Arles

Pencil and pen and ink on paper, 54 × 40 cm, 1888 (Arles)
Hyde Collection, Glens Falls, New York, F1516 / JH1376

PROVENANCE

Theo van Gogh, Paris, 1888; Jo van Gogh-Bonger, Amsterdam, 1891; Leicester Galleries, London, 1923; **Sir Michael Ernest Sadler, Oxford, 1923**; Mrs Cornelius J. Sullivan, New York, by 1935; Parke-Bernet (auction), New York, 6–7 December 1939, lot 157; Charlotte Hyde, Glens Falls, New York, 1939; Hyde Collection, Glens Falls, New York, 1952

REFERENCES

M. Sadler, *The Nation*, 10 December 1910; *Vincent van Gogh*, Leicester Galleries, London, 1923, no.10 and Sadler, introduction, pp.7–9; correspondence between Sadler and Oliver Brown, 1923 (NGS records); *Vincent van Gogh*, Oxford Arts Club, 1924, no.8; *Autumn Exhibition*, Walker Art Gallery, Liverpool, 1927, no.935; Sadler, *Modern Art and Revolution*, London, 1932; Michael Sadleir, *Michael Ernest Sadler*, London, 1949, pp.233, 235–6; Feilchenfeldt 1988, p.136; *Michael Sadler*, University Gallery, Leeds, 1989; Account Book, p.197; ODNB; *Gauguin's Vision*, National Galleries of Scotland, Edinburgh, 2005, pp.102–7

Cypresses

Pencil and ink on paper, 63 × 47 cm, 1889 (St-Rémy)
Brooklyn Museum of Art, New York, F1525 / JH1747

PROVENANCE

Theo van Gogh, Paris, 1889; Jo van Gogh-Bonger, Amsterdam, 1891; Leicester Galleries, London, 1923; **Sir Michael Ernest Sadler, Oxford, 1923**; Private Collection, Germany, after 1927; Knoedler Gallery, New York, 1935; Brooklyn Museum of Art, New York, 1938

REFERENCES

Vincent van Gogh, Leicester Galleries, London, 1923, no.5; *Vincent van Gogh*, Oxford Arts Club, 1924, no.7; *Autumn Exhibition*, Walker Art Gallery, Liverpool, 1927, no.1115; Feilchenfeldt 1988, p.136; Linda Kramer,

Karyn Zieve and Sarah Faunce, *French Nineteenth Century Drawings and Watercolours*, Brooklyn Museum, 1993, p.132; Account Book, p.197

Olive Trees with the Alpilles

Pencil and ink on paper, 47 × 63 cm, 1889 (St Rémy)
Museum of Modern Art, New York, F1544 / JH1741

PROVENANCE

Theo van Gogh, Paris, 1889; Jo van Gogh-Bonger, Amsterdam, 1891; Leicester Galleries, London, 1923; **Sir Michael Ernest Sadler, Oxford, 1923**; Max Silberberg, Breslau; Georges Petit (auction), Paris, 9 June 1932, lot 7 (unsold); Max Silberberg, Breslau; Paul Graupe (auction), Berlin, 23 March 1935, lot 37; Nationalgalerie, Berlin, 1935; Greta Silberberg, Leicester, 1999 (restituted); Sotheby's, London, 7 December 1999, lot 34; Museum of Modern Art, New York (promised gift of Ronald Lauder), 1999

REFERENCES

Vincent van Gogh, Leicester Galleries, London, 1923, no.9; *Vincent van Gogh*, Oxford Arts Club, 1924, no.9; Feilchenfeldt 1988, p.137; Account Book, p.198

9th Earl of Sandwich

Biography: see page 100

The Outskirts of Paris (cat.25)

Pollard Willows

Black chalk on paper, 48 × 31 cm, 1885 (Nuenen)
Private Collection, F1247 / JH953

PROVENANCE

Theo van Gogh, Paris, 1885; Jo van Gogh-Bonger, Amsterdam, 1891; V.W. van Gogh, Laren, 1925; Leicester Galleries, London, 1926; **9th Earl of Sandwich (George Charles Montagu), Huntingdon, 1926**; Amiya, Countess of Sandwich, Huntingdon, 1962; Christie's, London, 30 November 1962, lot 43 (withdrawn); Amiya, Countess of Sandwich, Huntingdon, 1962; Christie's, London, 27 November 1964, lot 100; McRoberts & Tunnard Gallery, London, 1964; Private Collection; Sotheby's, London, 28 June 1994, lot 12; Ikkan Sanada Gallery, New York; Private Collection

REFERENCES

Vincent van Gogh, Leicester Galleries, London, 1926, no.21; *Modern French Paintings, Drawings and Prints*, Guildhall, Gloucester, 1936, no.69; *Collection of the Earl of Sandwich*, Hinchingbroke, 1957, p.27

Sir Victor Schuster

Born 26 May 1885. Musician. Collected Impressionists and Post-Impressionists. Died 22 December 1962.

Olive Trees

Oil on canvas, 74 × 92 cm, 1889 (St-Rémy)
The Metropolitan Museum of Art, New York, F708 / JH1855

PROVENANCE

Theo van Gogh, Paris, 1889; Jo van Gogh-Bonger, Amsterdam, 1891; Artz and De Bois Gallery, The Hague, 1912; Paul Rosenberg Gallery, Paris, c.1926; Wildenstein Gallery, New York and Paris, c.1926; **Sir Frank Victor Schuster, London**; Sotheby's, London, 26 July 1939, lot 76; Carlson (?), London, 1939; Alex Reid & Lefevre Gallery, London, by 1942; Mayor Gallery, London, 1950; Walter Feilchenfeldt Gallery, Zurich; Mr and Mrs Simon, Switzerland; Alex Reid & Lefevre Gallery, London, 1953; Sam Salz Gallery, New York; Walter H. and Leonore Annenberg, Rancho Mirage, California, by 1957; Metropolitan Museum of Art, New York, 1998 (partial gift of Mr and Mrs Annenberg)

REFERENCES

French Paintings, Alex Reid & Lefevre Gallery, London, 1942, no.9; Heijbroek & Wouthuysen 1993, p.197; Korn 2001; Korn 2002, p.137

Gérard Slot

No biographical details available.

Peasant Digging (cat.10)

The Thatched Hut

Black chalk on paper, 14 × 36 cm, 1881 (Etten)
Private Collection, F875 / JH4

PROVENANCE

C.M. Van Gogh Gallery, Amsterdam; Van Wisselingh Gallery, London; **Gérard H. Slot, London**; Unidentified sale, London, 1913; Frank Wilson, London, by 1926; Private Collection

REFERENCES

De la Faille, 1928, p.13; *Opening Exhibition*, Tate, London, 1926, 'Landscape near The Hague' (probably F875); Walter Vanbeselaere, *De Hollandsche Periode in het Werk van Vincent van Gogh*, Antwerp, 1937, p.51

Sir Matthew Smith

Born Halifax, West Yorkshire, on 22 October 1879. Artist. Worked in London in Chelsea Cloisters, Sloane Avenue. Died London, 29 September 1959.

Cottage

Oil on canvas, 44 × 60 cm, 1885 (Nuenen)
Private Collection, F92 / JH810

PROVENANCE

Margot Begemann, Nuenen, 1885; J. van der Linden Sr, Amsterdam, 1908; J. van der Linden, Amsterdam; Frederik Muller (auction), Amsterdam, 15 December 1925, lot 270; Nico Eisenloeffel Gallery, Amsterdam; Etienne Bignou Gallery, Paris; Alex Reid & Lefevre Gallery, London, 1926; **Sir Matthew Arnold Bracy Smith, London, late 1930s**; Mary Keene, London, 1959; Sotheby's, London, 28 June 1961, lot 28; Private Collection

REFERENCES

Letter from Matthew Smith to Harold Smith, 15 April 1928 (Smith family collection); *The Times*, 17 December 1957; *Sir Matthew Smith*, Royal Academy, London, 1960, p.xv; Alice Keene, *The Two Mr Smiths*, London, 1995, pp.54, 75 and plate 166; Malcolm Yorke, *Matthew Smith*, London, 1997, pp.129–30 and 222; Korn 2001; Korn 2002, p.136; *ODNB*

Marie Stern

Lived in Berlin, with her husband Albert. Their daughter Eva moved to Manchester in the 1930s. Marie Stern followed just after the Second World War. Died Britain, 1952.

Orchard in Blossom

Oil on canvas, 72 × 59 cm, 1888 (Arles)
Private Collection, Switzerland, F406 / JH1399

PROVENANCE

Theo van Gogh, Paris, 1888; Jo van Gogh-Bonger, Amsterdam, 1891; J.H. de Bois Gallery, Haarlem, 1925 ; **Albert and Marie Stern, Berlin, Amsterdam and Manchester** ; Eva Friedlaender (née Stern), Manchester (lent to Manchester City Art Gallery 1969–76) ; Edward Speelman Gallery, London, 1976 ; Private Collection, Switzerland

REFERENCES

Heijbroek & Wouthuysen, 1993, pp.135–6 and 194; Feilchenfeldt 1988, p.92

The Fields

[not now attributed to Van Gogh]
Oil on canvas, 70 × 53 cm
Location unknown, F813 / JH –

PROVENANCE

Otto Wacker Gallery, Berlin; Hugo Perls Gallery, Berlin, 1928; Siegbert Stern, Neubabelsberg-Nicolassee; **Albert and Marie Stern, Berlin**

REFERENCES

Stefan Koldehoff, 'The Wacker forgeries', *Van Gogh Museum Journal 2002*, p.155

Frank Stoop

Biography: see page 58

Farms near Auvers (cat.6)

Thatched Roofs (cat.7)

A Corner of the Garden of St Paul's Hospital at St-Rémy (cat.8)

The Oise at Auvers (cat.9)

Esther and Alfred Sutro

Esther Sutro (née Isaacs) was born on 8 April 1869. She studied art in Paris. Married Alfred Sutro in 1894. She became a succesful artist and later wrote a study on Poussin. Died 3 December 1934. Alfred Sutro was born in London, 7 August 1863. He became a playwright in the 1890s, working partly in Paris for a few years, and by the early 1900s was a distinguished dramatist. Died Witley, Surrey, 11 September 1933. Their Van Gogh painting was inherited by Esther's sister, Florence van Gruisen, or her daughter Esther van Gruisen.

Interior of a Restaurant

Oil on canvas, 51 × 65 cm, 1887 (Paris) or 1888 (Arles)
Private Collection, F549 / JH1572

PROVENANCE

Theo van Gogh, Paris, 1887/8; Jo van Gogh-Bonger, Amsterdam, 1891; Ambroise Vollard Gallery, Paris, 1895; **Esther Stella (née Isaacs) and Alfred Sutro, London, 1896**; Florence (or Esther) van Gruisen, London, 1934; Alex Reid & Lefevre Gallery, London, 1935; Marcel Gieuré, 1936; Carroll Carstairs Gallery and/or Bignou Gallery, New York, 1935; Mrs Murray S. Danforth, Providence, Rhode Island, 1935;

Col. Murray S. Danforth Jr; Christie's, New York, 30 April 1996, lot 31; Simon Dickinson Gallery, London, 1996; Private Collection

REFERENCES

Accounts for 1896 and address book, Vollard archives (Musée d'Orsay, Paris); *Impressionist Painters* (?), New Gallery, London, 1909; Esther Sutro, 'Paintings that capture the sunshine', *Daily Herald*, 3 December 1923; *Vincent van Gogh*, Leicester Galleries, London, 1923, no.37; Esther Sutro, *Nicolas Poussin*, London, 1923; *Opening Exhibition*, Tate, London, 1926, no.7; *Dutch Art*, Royal Academy, London, 1929, no.463; *Vincent van Gogh en Zijn Tijdgenooten*, Stedelijk Museum, Amsterdam, 1930, no.68; correspondence on 1930 Stedelijk exhibition (Van Gogh Museum archive); *Vincent van Gogh*, Manchester City Art Gallery, 1932 (not in catalogue but recorded in De la Faille); Alfred Sutro, *Celebrities and Simple Souls*, London, 1933, p.26; Duncan Macdonald, 'Buying pictures', *Studio*, September 1934, p.126; Douglas Cooper, *The Courtauld Collection*, London, 1954, p.62; Oliver Brown, *Exhibition: The Memoirs of Oliver Brown*, London, 1968, p.84; Lewis Sawin, *Alfred Sutro*, Niwot, Colorado, 1989, p.25; Account Book, p.178; Korn 2001; Korn 2002, pp.125 and 136

Leopold Sutro

Born in London, 1858. Brother of Alfred Sutro (1869–1933). Successful banker and rubber merchant. Lived partly in Bournemouth. Died 1943.

Lane in Voyer d'Argenson Park at Asnières (fig.24)

Oil on canvas, 59 × 81 cm, 1887 (Paris)
Yale University Art Gallery, New Haven, F276 / JH1259

PROVENANCE

Theo van Gogh, Paris, 1887; Jo van Gogh-Bonger, Amsterdam, 1891; V.W. van Gogh, Laren, 1925; **Leopold Sutro, London, 1928**; Sotheby's, London, 10 November 1943, lot 103; Arthur Tooth Gallery, London, 1943; Royan Middleton, Dundee and Aberdeen, by 1951; Alex Reid & Lefevre Gallery, London, 1955; Sam Salz Gallery, New York; Mr & Mrs Henry R. Luce, New York, 1956; Yale University Art Gallery, New Haven, Connecticut, 1958 (donated by Mr and Mrs Henry R. Luce)

REFERENCES

Alfred Sutro, *Celebrities and Simple Souls*, London, 1933, pp.11 and 125; *Paintings from North-East Homes*, Aberdeen Art Gallery, 1951, no.145; Feilchenfeldt 1988, p.86; Korn 2001; Korn 2002, pp.135–6

Stanley Sykes

Born Huddersfield, 17 May 1884. Barrister. Lived in Cambridge. Honorary keeper of paintings and drawings, Fitzwilliam Museum (1956–66). Died 1966.

Road with Pollard Willows

Oil on canvas, 55 × 65 cm, 1889 (Arles)
Niarchos Collection, F520 / JH1690

PROVENANCE

Theo van Gogh, Paris, 1889; Jo van Gogh-Bonger, Amsterdam, 1891; Paul Cassirer Gallery, Berlin, 1907; Bernheim-Jeune Gallery, Paris, 1909; Curt Glaser (?), Berlin; Fritz Gurlitt, Berlin; Paul Cassirer Gallery, Berlin, 1914; Eva Cassirer, Berlin; Barbazanges-Hodebert Gallery, Paris; Etienne Bignou Gallery, Paris; Alex Reid & Lefevre Gallery, London, 1926; **Captain Stanley William Sykes, Cambridge, by 1927**; Alex Reid & Lefevre Gallery, London, 1938; Etienne Bignou Gallery, New York; Edward G. and Gladys Lloyd Robinson, Beverley Hills, by 1939 Knoedler Gallery, New York, 1957; Stavros Spyros Niarchos, Athens, 1957; Niarchos Collection, 1996

REFERENCES

Autumn exhibition, Walker Art Gallery, Liverpool, 1927, no.932; *Renoir and the Post-Impressionists*, Alex Reid & Lefevre Gallery, London, 1930, no.17; *Corot to Cézanne*, Alex Reid & Lefevre Gallery, London, 1936, no.46; *Tragic Painters*, Bignou, New York, no.2 and Alex Reid & Lefevre Gallery, London, 1938, no.40; Feilchenfeldt 1988, p.101; *Vincent van Gogh and the Modern Movement*, Van Gogh Museum, 1990, p.139; Account Book, p.177; Korn 2001; Korn 2002, p.136

Tate Gallery
(formerly National Gallery, Millbank)

A Wheatfield, with Cypresses (cat.17)

Van Gogh's Chair (fig.10)

Oil on canvas, 92 × 73 cm, 1888–9 (Arles)
National Gallery, London, F498 / JH1635

PROVENANCE

Theo van Gogh, Paris, 1889; Jo van Gogh-Bonger, Amsterdam, 1891; Leicester Galleries, London, 1923; Courtauld Fund Trustees, London, 1923; **Tate Gallery (formerly National Gallery, Millbank), London, 1923**; National Gallery, London, 1961

REFERENCES

Letter from H.S. Ede to Jo van Gogh-Bonger, 20 October 1923 (Van Gogh Museum archive); *Vincent van Gogh*, Leicester Galleries, London, 1923, no.28; letter from V.W. van Gogh to Samuel Courtauld, 9 February 1924 (and related letters) (Van Gogh Museum and Tate archives); letters between Oliver Brown and Jo van Gogh-Bonger, 1923–4 (Van Gogh Museum archive); letter from Jo van Gogh-Bonger to Paul Gachet, 12 March 1924 (Van Gogh Museum archive); Tate and National Gallery trustee minutes; Courtauld Fund papers (Tate archive); *Vincent van Gogh*, Manchester City Art Gallery, 1932, no.22; letter from Jim Ede to Ronald Alley, 30 July 1952 (Tate archive); Martin Davies, *The French School*, National Gallery, London, 1970, p.137; Feilchenfeldt 1988, p.100; Account Book, p.176

Portrait of Joseph Roulin (fig.9)

Oil on canvas, 64 × 55 cm, 1889 (St-Rémy)
Museum of Modern Art, New York, F436 / JH1675

PROVENANCE

Theo van Gogh, Paris, 1889; Jo van Gogh-Bonger, Amsterdam, 1891; Leicester Galleries, London, 1923; Courtauld Fund Trustees, London, 1923; **Tate Gallery (formerly National Gallery, Millbank), London, 1923**; Leicester Galleries, London, 1924; Thannhauser Gallery, Lucerne, 1924; Bernhard Mayer, Zurich, 1926; Ernst Mayer, Zurich and Ascona, 1946; Gabrielle Mayer, Switzerland; Private Collection, 1987; Thomas Ammann Gallery, Zurich; Museum of Modern Art, New York, 1989

REFERENCES

Vincent van Gogh, Leicester Galleries, London, 1923, no.21; letter from Jo van Gogh-Bonger to Charles Aitken (Tate archive); correspondence between Oliver Brown and Jo van Gogh-Bonger, 1923–4 (Van Gogh Museum archive); letter from Charles Aitken to Jo van Gogh-Bonger, 19 January 1924 (Van Gogh Museum archive); Tate and National Gallery trustee minutes; Courtauld Fund papers (Tate archive); letter from Jim Ede to Ronald Alley, 30 July 1952 (Tate archive); Account Book, p.173

Sunflowers (fig.1)

Oil on canvas, 92 × 73 cm, 1888 (Arles)
The National Gallery, London, F454 / JH1562

PROVENANCE

Theo van Gogh, Paris, 1888; Jo van Gogh-Bonger, Amsterdam, 1891 (on loan to Isaac Israëls, The Hague, 1917–20); Leicester Galleries, London, 1923; Courtauld Fund Trustees, London, 1924; **Tate Gallery (formerly National Gallery, Millbank), London, 1924**; National Gallery, London, 1961

REFERENCES

Vincent van Gogh, Leicester Galleries, London, 1923, no.26; letter from V.W. van Gogh to Samuel Courtauld, 9 February 1924 (and related letters) (Van Gogh Museum and Tate archives); letters between Oliver Brown and Jo van Gogh-Bonger, 1923–4 (Van Gogh Museum archive); letter from Jo van Gogh-Bonger to Paul Gachet, 12 March 1924 (Van Gogh Museum archive); Tate and National Gallery trustee minutes; Courtauld Fund papers (Tate archive); letter from Jim Ede to Ronald Alley, 30 July 1952 (Tate archive); Martin Davies, *The French School*, National Gallery, London, 1970, p.138; Feilchenfeldt 1988, p.96; Martin Bailey, 'Flower power', *Observer* (magazine), 19 January 1992; Account Book, p.173

Farms near Auvers (cat.6)

Thatched Roofs (cat.7)

A Corner of the Garden of St Paul's Hospital at St-Rémy (cat.8)

The Oise at Auvers (cat.9)

Long Grass with Butterflies (cat.22)

John Tattersall

Biography: see page 72

View of a River with Rowing Boats (cat.12)

Fisher Unwin

Born London, 24 January 1848. Founded the publisher Unwins, in 1882. In 1892 he married Jane Cobden (1851–1947), sister of Sickert's wife Ellen. Moved to 3 Adelphi Terrace, 1905. Retired in 1926, when Unwins was taken over by Ernest Benn. Died Midhurst, Sussex, 6 February 1935.

Bouquet of Flowers (possibly fig.4)

Oil on canvas, unknown dimensions, c.1886–7 (Paris)
Location and F number unknown (possibly F236 / JH1130, Schmit Gallery, Paris, see under JUSTICE)

PROVENANCE

Père Julien Tanguy Gallery, Paris; **Thomas Fisher Unwin, London, 1893**

REFERENCES

Letter from Jane Cobden Unwin to Ellen Cobden Sickert, 29 September 1893, (West Sussex County Council); [Annual exhibition], International Society, New Gallery, London, 1909, no.169; *Observer*, 10 January 1909; *Sunday Times*, 10 January 1909; *Saturday Review*, 6 February 1909; *Modern Art*, Sandon Studios, Liverpool, 1911, no.49; *Second Post-Impressionist Exhibition*, Grafton Galleries, London, 1913, no.43; *Second Post-Impressionist Exhibition*, Sandon Studios, Liverpool, 1913, no.49; *Post-Impressionist and Futurist Exhibition*, Doré Galleries, London, 1913, no.14; *Daily Telegraph*, 10 and 15 January 1913; *Observer*, 19 January 1913; Elizabeth Pennell, *Nights*, London, 1916, pp.247–9; Joseph Pennell, *Pen Drawing and Pen Draughtsmen*, London, 1921, p.337; *Salon*, Goupil Gallery, London, 1921, no.69 (?); A.S. Hartrick, 1939, p.47; Philip Unwin, *The Publishing Unwins*, London, 1972; Korn 2001; Korn 2002, pp.124–5 and 136; ODNB

Two unidentified paintings

PROVENANCE

Père Julien Tanguy Gallery, Paris; **Thomas Fisher Unwin, London, 1893**

REFERENCES

Elizabeth Pennell, *Nights*, London, 1916, pp.247–9

Sir Charles Wakefield-Mori

Born 17 June 1867. Established and later directed the National Museum of Monaco. He donated much of his personal collection to the museum in Menton, France. Died c.1959.

Unidentified painting

Possibly flower still-life and/or landscape

PROVENANCE

Sir Charles S. Wakefield-Mori, Monte Carlo, by 1936

REFERENCES

Tate trustee minutes, 17 November 1936

Sir Henry Wellcome

Born Almond, Wisconsin, 21 August 1853. Chemist. In 1880 he joined Sillas Burroughs to set up the pharmaceutical firm Burroughs Wellcome & Co, in London. In 1924 he established the Wellcome Foundation. Died London, 25 July 1936.

Portrait of Dr Gachet

Etching, 18 × 15 cm, 1890 (Auvers)
Wellcome Institute, London F1664 / JH2028
(for another example, see cat.16)

PROVENANCE

Paul Gachet Jr, Auvers; Captain Peter Johnston-Saint, London, 1927; **Sir Henry Solomon Wellcome, London, 1927**; Wellcome Institute, London, 1936

REFERENCES

Gertrude Prescott, 'Gachet and Johnston-Saint', *Medical History*, 1987, pp.217–23; *The Graphic Work of Vincent van Gogh*, Van Gogh Museum, 1995, no.10.41

Whitworth Art Gallery

Hayricks (cat.24)
The Fortifications of Paris with Houses (cat.23)

Frank Wilson

No biographical details available.

Peasant Digging (cat.10)
The Thatched Hut

See under SLOT for full provenance

Elizabeth Workman

Elizabeth Russe Workman, born in 1874, was the wife of Robert A. Workman, who was a shipbroker. She came from Rhu in Dunbartonshire and she and her husband bought regularly from Alex Reid's Glasgow gallery, although they were based at 3 Seamore Place, Park Lane, London. Mrs Workman began collecting in 1916 and owned three works by Van Gogh, as well as Degas's *Portrait of Diego Martelli* and Gauguin's *Martinique Landscape*, both now in the National Gallery of Scotland. During the 1920s she went on to collect Vuillard, Toulouse-Lautrec, Matisse, Picasso, Braque and Dufy before her husband lost his fortune and they were forced to sell the collection in 1931. She died in the 1930s.

Oleanders (cat.18)

Bridge at Trinquetaille

Oil on canvas, 65 × 81 cm, 1888 (Arles)
Private Collection, F426 / JH1468

PROVENANCE

Theo van Gogh, Paris, 1888; Jo van Gogh-Bonger, Amsterdam, 1891; Paul Cassirer Gallery, Berlin, 1906; H.O. Miethke Gallery, Vienna, 1906; Mr and Mrs Josef Redlich, Vienna; Hodebert Gallery, Paris; Etienne Bignou Gallery, Paris; Alex Reid & Lefevre Gallery, London, 1923; **Elizabeth Russe Workman (née Allan), London, 1924**; Alex Reid & Lefevre Gallery, London, 1928; Knoedler Gallery, London and New York, 1928; Mrs William A. Clark, New York, by 1934; Knoedler Gallery, New York; Mr and Mrs André Meyer, New York, by 1962; Sotheby's, New York, 22 October 1980, lot 27; Akram Ojjeh, Paris; Christie's, New York, 8 November 1999, lot 112; Private Collection, London; Christie's, New York, 3 November 2004, lot 41; Private Collection

REFERENCES

Post-Impressionist Masters, Lefevre Gallery, London, 1923, no.19; photograph, Alex Reid & Lefevre records (Tate archive); J.B. Manson, 'The Workman Collection', *Apollo*, March 1926, pp.139–44 and 156; *French Painting*, Knoedler Gallery, New York, 1928, no.30; Feilchenfeldt 1988, p.93; Account Book, p.172; Korn 2001; Korn 2002, p.136

The Hospital at Arles (fig.21)

Oil on canvas, 72 × 91 cm, 1889 (Arles)
Oskar Reinhart Collection, Winterthur, F646 / JH1686

PROVENANCE

Theo van Gogh, Paris, 1889; Jo van Gogh-Bonger, Amsterdam, 1891; Paul Cassirer Gallery, Berlin, 1906; Prince de Wagram (Louis-Alexandre Berthier), Paris, 1906; Alphonse Kann, Saint Germain-en-Laye, by 1917; Winkel & Magnussen Gallery, Copenhagen; Barbazanges-Hodebert Gallery, Paris; Alex Reid & Lefevre Gallery, London, 1923; **Elizabeth Russe Workman (née Allan), London, 1923**; Barbazanges-Hodebert Gallery, Paris, 1925; Oskar Reinhart, Winterthur, 1925; Oskar Reinhart Collection, Winterthur, 1965

REFERENCES

Post-Impressionist Masters, Lefevre Gallery, London, 1923, no.21; Douglas Cooper, *Alex Reid & Lefevre 1926–1976*, London, 1976, p.18; Feilchenfeldt 1988, p.109; Account Book, p.182; Korn 2001; Korn 2002, p.136

Unknown British Owners

Self-portrait

Oil on canvas, dimensions, date and location
unknown and not identified in De la Faille

PROVENANCE

Theo van Gogh, Paris, 1888; Sulley & Lawrie Gallery,
London, 1888

REFERENCES

Mark Tralbaut, *De Gebroeders Van Gogh*, Zundert, 1964,
pp.161–2 and 186; Martin Bailey, 'Van Gogh's first
Sale', *Apollo*, March 1996, pp.20–1

The Mower

Drawing on paper, 57 × 46 cm, date, location
unknown and not identified in De la Faille

PROVENANCE

Independent Gallery, London, 1922, no.11; Christie's,
London, 8 April 1929, lot 73 (probably same work;
dimensions given in Christie's catalogue); Larsen (?),
London

REFERENCES

British and French Artists, Independent Gallery, Lon-
don, 1922

Interior with Woman Spinning

Watercolour on paper, 36 × 41 cm, date, location
unknown and not identified in De la Faille

PROVENANCE

Sotheby, Wilkinson & Hodge (auction), London, 31
May 1922, lot 250

Road to Tarascon

Pencil and ink on paper, 25 × 34 cm, 1888 (Arles)
Kunsthaus, Zurich, F1502 / JH1492

PROVENANCE

Theo van Gogh, Paris, 1888; Jo van Gogh-Bonger,
Amsterdam, 1891; Artz & De Bois Gallery, The
Hague, 1912; J.H. de Bois Gallery, Haarlem, 1913 ;
Leicester Galleries, London, 1926; **Private Collection,
England**; Otto Wacker Gallery, Berlin, by 1927;
Aktuaryus Gallery, Zurich; Kunsthaus, Zurich, 1940

REFERENCES

Vincent van Gogh, Leicester Galleries, London, 1926,
no.28; Feilchenfeldt 1988, p.137; Heijbroek &
Wouthuysen 1993, p.205

Les Alyscamps

Oil on canvas, 93 × 72 cm, 1888 (Arles)
Private Collection, Athens, F568 / JH1622

PROVENANCE

Joseph and Marie Ginoux, Arles, 1889; Laget, Arles,
c.1894–1900; Ambroise Vollard Gallery, Paris;
Bernheim-Jeune Gallery, Paris, by 1925; **Private
Collection, London, 1930s**; Alfred Daber Gallery,
Paris; Mr and Mrs Edwin C. Vogel, New York, by 1953;
Sam Salz Gallery, New York; Basil and Elise
Goulandris, Athens, 1971; Private Collection

REFERENCES

Korn 2001; Korn 2002, p.137; Feilchenfeldt 2006,
p.302

Mountainous Landscape

[not now attributed to Van Gogh]
Oil on canvas, 53 × 70 cm
Private Collection, London, F725 / JH –

PROVENANCE

Eugène Blot Gallery, Paris; Antoine Villard, Paris;
Matthiesen Gallery, Berlin; Goldschmidt Gallery,
Frankfurt; G. Schweitzer, Berlin; Cassirer (auction),
Berlin, 20 October 1932, lot 127; Arthur Tooth
Gallery, London, 1937; **Private Collection, London**;
Marlborough Gallery, London, 1953; Private Collec-
tion, London

REFERENCES

La Flèche d'or, Arthur Tooth Gallery, London, 1937,
no.15; *French and British Contemporary Art*, National Art
Gallery of South Australia, Adelaide, Lower Town
Hall, Melbourne and David Jones' Art Gallery,
Sydney, 1939, no.134; *European Masters*, Marlborough
Gallery, London, 1953, no.29

DOCUMENTARY MATERIAL

The following items, listed in chronological order, were included in the documentary sections of the exhibition.

UNDATED
Scrapbook of press cuttings compiled by Jo van Gogh-Bonger
Van Gogh Museum (Vincent van Gogh Foundation), Amsterdam

1893
Account book owned by Jo van Gogh-Bonger family recording the purchase by William Robinson of *Two Crabs* (see cat.5)
Van Gogh Museum (Vincent van Gogh Foundation), Amsterdam

1906
Frederik Muller auction catalogue, Amsterdam, lot 33 is *Two Crabs* (cat.5), 13 November 1906
Netherlands Institute for Art History (RKD), The Hague

1910
'Maniacs or Pioneers?', *Daily Chronicle*, 7 November 1910, from the scrapbook of Jo van Gogh-Bonger
Van Gogh Museum (Vincent van Gogh Foundation), Amsterdam

'Anarchy in High Art', *Tatler*, 23 November 1910
National Library of Scotland, Edinburgh

'Post-Impressions of the Post-Impressionists', cartoon by H.M. Bateman, *Bystander*, 23 November 1910
National Library of Scotland, Edinburgh

Catalogue and poster of the exhibition *Manet and the Post-Impressionists* held at the Grafton Galleries, London
Courtauld Institute of Art Library, London

1920
Receipt for the purchase by Gwendolyn Davies of *Rain-Auvers* (cat.11), 1920
National Museums & Galleries of Wales, Cardiff

1922
Sotheby, William & Hodge auction catalogue, lot 250 is the watercolour *Interior with Woman Spinning*, the first Van Gogh work sold at auction in Britain, 31 May 1922
Courtauld Institute of Art Library, London

Samuel Courtauld's personal copy of *Vincent van Gogh: A Biography* by Julius Meier-Graefe, published in 1922
Courtauld Institute of Art Library, London

1923
Letter from Jo van Gogh-Bonger to Jim Ede regarding *Sunflowers* (fig.1), 18 October 1923
Tate archive, London

Invitation to the Van Gogh exhibition held at the Leicester Galleries, London, 30 November and 1 December 1923, the first solo Van Gogh exhibition in Britain
Van Gogh Museum (Vincent van Gogh Foundation), Amsterdam

Letter from Jo van Gogh-Bonger to Charles Aitken, director of the National Gallery, 3 December 1923
Tate archive, London

List of paintings on sale at the Van Gogh exhibition held at the Leicester Galleries, London, in December 1923, with annotations by Charles Aitken, director of the National Gallery
Tate archive, London

Catalogue of the Van Gogh exhibition held at the Leicester Galleries, London, in December 1923
Private Collection

1924
Catalogue of the Van Gogh exhibition held at the Oxford Arts Club, from May to June 1924
Ashmolean Museum, Oxford

Letter from Charles Aitken, director of the National Gallery to Jo van Gogh-Bonger, 29 February 1924
Van Gogh Museum (Vincent van Gogh Foundation), Amsterdam

Letter from Vincent Willem van Gogh to Samuel Courtauld referring to the purchase of *Sunflowers* (fig.1), 9 February 1924
Tate archive, London

Receipt for the purchase by Samuel Courtauld of *Sunflowers* (fig.1), 24 March 1924
Van Gogh Museum (Vincent van Gogh Foundation), Amsterdam

1926
Catalogue of the second Van Gogh exhibition held at the Leicester Galleries, London from November to December 1926
National Library of Scotland, Edinburgh

Receipt for the purchase by Samuel Courtauld of *Long Grass with Butterflies* (cat.22) for the Tate, 30 March 1926
Tate archive, London

1927
Christie, Mason & Woods auction catalogue, lot 44 is *Still Life with Daisies and Poppies* (cat.15), 29 April 1927
Private Collection

1929
Commemorative catalogue of the exhibition *Dutch Art 1450–1900* held at the Royal Academy, London and which included nineteen paintings by Van Gogh
Courtauld Institute of Art Library, London

1930
Catalogue of the third Van Gogh exhibition held at the Leicester Galleries, London, from May to June 1930
Private Collection

1932
Catalogue of the Van Gogh exhibition held at Manchester Art Gallery, the largest Van Gogh exhibition held in Britain before the Second World War
Courtauld Institute of Art Library, London

1935
Catalogue of the exhibition *English and French Paintings* held in the Village Hall, Silver End, Essex
Courtauld Institute of Art Library, London

Report on the exhibition *Art for the People* held in the Village Hall, Silver End, Essex and featuring *Peach Blossom in the Crau* (cat.26)
Bodleian Library, Oxford

1936
Letter of complaint from Lord Sandwich to Charles Scott's Road Service, regarding the transport of Van Gogh's drawing *Pollard Willlows* by open dray-lorry to the City of Gloucester Municipal School of Arts and Crafts, 30 April 1936
Collection Lord Sandwich

Letter from City of Gloucester Municipal School of Arts and Crafts regarding *Pollard Willows*, 1 May 1936
Collection Lord Sandwich

1937
Receipt for the purchase by Sir Alexander Maitland of *Orchard in Blossom* (cat.14)
National Gallery of Scotland, Edinburgh

SELECT BIBLIOGRAPHY

ACCOUNT BOOK
Chris Stolwijk and Han Veenenbos, *The Account Book of Theo van Gogh and Jo van Gogh-Bonger*, Van Gogh Museum, Amsterdam, 2002

AMSTERDAM 1990
Evert van Uitert, Louis van Tilborgh and Sjraar van Heugten, *Vincent van Gogh: Paintings*, Van Gogh Museum, Amsterdam, 1990

BAILEY 2006
Martin Bailey, 'Van Gogh's Portraits of Alexander Reid', *Burlington Magazine*, February 2006, pp.116–19

BREMEN 2003
Wulf Herzogenrath and Dorothee Hansen (eds), *Van Gogh: Fields*, Kunsthalle, Bremen, 2003

BROOKS 2002
Vincent van Gogh: The Complete Works, CD-rom catalogue raisonné (compiled by David Brooks), 2002 (www.vggallery.com)

BROWN 1968
Oliver F. Brown, *Exhibition: The Memoirs of Oliver Brown (1885–1966)*, London, 1968

BULLEN 1988
J.B. Bullen (ed.), *Post-Impressionists in England: The Critical Reception*, London, 1988

COMPLETE LETTERS 1958
The Complete Letters of Vincent van Gogh, 3 vols., London, 1958

COOPER 1954
Douglas Cooper, *The Courtauld Collection*, London, 1954

DE LA FAILLLE 1928
J.-B. de la Faille, *L'Oeuvre de Vincent van Gogh: Catalogue Raisonné*, 4 vols., Paris, 1928

DE LA FAILLE 1939
J.-B. de la Faille, *Vincent van Gogh*, 2nd ed., London, 1939

DE LA FAILLE 1970
J.-B. de la Faille, *The Works of Vincent van Gogh: His Paintings and Drawings*, London, 1970

ESSEN & AMSTERDAM 1990
Vincent van Gogh and the Modern Movement 1890–1914, Folkwang Museum, Essen and Van Gogh Museum, Amsterdam, 1990

FEILCHENFELDT 1988
Walter Feilchenfeldt, *Vincent van Gogh & Paul Cassirer, Berlin: The Reception of Van Gogh in Germany from 1901 to 1914*, Van Gogh Museum, Amsterdam, 1988

FEILCHENFELDT 2006
Walter Feilchenfeldt, *By Appointment Only: Cézanne, Van Gogh, and some Secrets of Art Dealing*, London, 2006

FOWLE 1994
Frances Fowle, 'Alexander Reid in Context: Collecting and Dealing in Scotland 1880–1925', unpublished Ph.D thesis, 2 vols, University of Edinburgh, 1994

FOWLE 2000
Frances Fowle, 'Vincent's Scottish Twin: the Glasgow art dealer Alexander Reid', *Van Gogh Museum Journal* 2000, pp.90–9

FOWLE 2002
Frances Fowle, 'West of Scotland Collectors of Nineteenth-Century French Art' in Vivien Hamilton, *Millet to Matisse: Nineteenth- and Twentieth-Century French Painting from Kelvingrove*, Glasgow, 2002

GLASGOW 2002
Vivien Hamilton, *Millet to Matisse: Nineteenth- and Twentieth-Century French Painting from Kelvingrove*, Kelvingrove Museum and Art Gallery, Glasgow, 2002

HARTRICK 1939
A.S. Hartrick, *A Painter's Pilgrimage through Fifty Years*, Cambridge, 1939

HEIJBROEK & WOUTHUYSEN 1993
J.F. Heijbroek and E.L. Wouthuysen, *Kunst, kennis en commercie: De kunsthandelaar J.H. de Bois, 1878–1946*, Amsterdam, 1993

HEIJBROEK & WOUTHUYSEN 1999
J.F. Heijbroek and E.L. Wouthuysen, *Portret van een Kunsthandel: De firma Van Wisselingh en zijn compagnons 1838 – heden*, Rijksmuseum, Amsterdam, 1999

Detail from cat.22

HEUGTEN & VELLEKOOP 1996, 1997, 2001
Sjraar van Heugten, *Vincent van Gogh Drawings: The Early Years 1880–1883*, vol.I, 1996; *1883–1885*, vol.II, 1997; Sjraar van Heugten and Marije Vellekoop, *1885–1888*, vol.III, 2001, Van Gogh Museum, Amsterdam

HULSKER 1990
Jan Hulsker, *Vincent and Theo van Gogh: A Dual Biography*, Ann Arbor, Michigan, 1990

HULSKER 1996
Jan Hulsker, *The New Complete Van Gogh*, Amsterdam, 1996

KOLDEHOFF 2003
Stefan Koldehoff, *Van Gogh: Mythos und Wirklichkeit*, Cologne, 2003

KORN 2001
Madeleine Korn, 'Collecting Modern Foreign Art in Britain before World War Two', unpublished Ph.D thesis, 3 vols., University of Reading, 2001

KORN 2002
Madeleine Korn, 'Collecting Paintings by Van Gogh in Britain before the Second World War', *Van Gogh Museum Journal 2002*, pp.120–37

KORN 2004
Madeleine Korn, 'Exhibitions of Modern french art and their influence on collectors in Britain 1870-1918: the Davies Sisters in context', *Journal of the History of Collections*, vol. 16, no. 2, 2004

LONDON 1992
Martin Bailey, *Van Gogh in England: Portrait of the Artist as a Young Man*, Barbican Art Gallery, London, 1992

LONDON 1994
John House, *Impressionism for England: Samuel Courtauld as Patron and Collector*, Courtauld Institute Galleries, London, 1994

LONDON 1997
Anna Gruetzner Robins, *Modern Art in Britain 1910–1914*, Barbican Art Gallery, London, 1997

MARTIGNY 2000
Ronald Pickvance, *Van Gogh*, Fondation Pierre Gianadda, Martigny, 2000

MOTHE 2003
Alain Mothe, *Vincent van Gogh à Auvers*, 2nd ed., Paris, 2003

NEW YORK 1984
Ronald Pickvance, *Van Gogh in Arles*, The Metropolitan Museum of Art, New York, 1984

NEW YORK 1986
Ronald Pickvance, *Van Gogh in Saint-Rémy and Auvers*, The Metropolitan Museum of Art, New York, 1986

NEW YORK & AMSTERDAM 2005
C. Ives, S.A. Stein, S. van Heugten and M. Vellekoop, *Vincent van Gogh: The Drawings*, The Metropolitan Museum of Art, New York and Van Gogh Museum, Amsterdam, 2005

OTTERLO 2003
Jos Ten Berge *et al.*, *The Paintings of Vincent van Gogh in the Collection of the Kröller-Müller Museum*, Kröller-Müller Museum, Otterlo, 2003

PARIS 1988
Bogomila Welsh-Ovcharov, *Van Gogh à Paris*, Musée d'Orsay, Paris, 1988

'S-HERTOGENBOSCH 1987
Van Gogh in Brabant, Noordbrabants Museum, 's-Hertogenbosch, 1987

SWEETMAN 1990
David Sweetman, *The Love of Many Things: A Life of Vincent van Gogh*, London, 1990

CRIMPEN & BERENDS-ALBERT 1990
Han van Crimpen and Monique Berends-Albert (eds.), *De Brieven van Vincent van Gogh*, 4 vols., The Hague, 1990

VAN TILBORGH & VELLEKOOP
Louis van Tilborgh and Marije Vellekoop, *Vincent van Gogh Paintings*, vol.I, Van Gogh Museum, Amsterdam, 1999

ZEMEL 1980
Carol Zemel: *The Formation of a Legend: Van Gogh Criticism, 1890–1920*, Ann Arbor, Michigan, 1980

NOTES AND REFERENCES

AUTHOR'S ACKNOWLEDGEMENTS
PAGE 9

1 See: Walter Feilchenfeldt, *Vincent van Gogh & Paul Cassirer, Berlin: The reception of Van Gogh in Germany from 1901 to 1914*, Zwolle, 1988 (henceforth cited as Feilchenfeldt 1988); Korn 2002, pp.120–37 (henceforth cited as Korn 2002); Ten Berge and Meedendorp 2003, pp.403–27; and Op de Coul, 'In search of Van Gogh's Nuenen studio', *Van Gogh Museum Journal* 2002, pp.104–19. See also Heijbroek and Wouthuysen 1993 and 1999.

INTRODUCTION
PAGES 13–15

1 *The Daily Chronicle*, 7 November 1910.
2 Desmond McCarthy, *Listener*, 1 February 1945, p.124.
3 The pre 1896 collectors were: Lucien Pissarro [F378], Alexander Reid [F270 and F379], Fisher Unwin (a flower still life, and possibly two other works), William Robinson [F606 and F1677?] and Alfred Sutro [F549]. The two recorded by De la Faille in Britain are those owned by Robinson [F606] and Sutro [F549]. Lucien Pissarro is noted as an owner [F378], but his residence in Britain is not. By 1914 there was also Gustav Robinow [F317], Frank Stoop [F793, F1242, F1497 and F1639], Gérard Slot/Frank Wilson [F860 and F875] and Herbert Coleman [F795]. In addition, there is some evidence that an unknown self-portrait may have come to London in 1888. 'F' numbers refer to the De la Faille catalogue.
4 Our data records ninety-five works. Of these eight have not been fully identified and seven are no longer attributed to Van Gogh (but some still were in 1939). The numbers refer to works which at one time had been acquired by British collectors by 1939, rather than those which remained there in that year.
5 Three Britons who lived partly abroad are also included (William Robinson, Edward Molyneux and Charles Wakefield-Mori). Ireland was included, since it remained part of the UK until 1921, but in fact no Irish collectors of Van Gogh emerged (other than Beatty, who moved to Dublin in 1950).

6 See under 'unknown collector' in the guide at the back of this catalogue.
7 The only comparable show was *Van Gogh and the Modern Movement*, held at Van Gogh Museum and Folkwang Museum, Essen in 1990–1, but it concentrated on the artist's impact on modern art up until 1914, rather than on collectors. There have also been a number of exhibitions with works from collections currently in a single country (particularly the Netherlands), but these have not reassembled works which belonged to earlier collectors.
8 The family paintings were lent for major shows in 1910 (London), 1923 (London), 1926 (London), 1930 (London), 1932 (Manchester), 1947–8 (London, Birmingham and Glasgow), 1955–6 (Liverpool, Manchester and Newcastle) and 1968–9 (London).
9 *The Complete Letters of Vincent van Gogh*, London, 1958, *Letters*, vol.II, pp.618–9 (letter 513, c.22 July 1888), henceforth cited as *Complete Letters 1958*.
10 Reminiscences of Anton Kerssemakers, *Complete Letters 1958*, vol.II, pp.447–8.

THE BRITISH DISCOVER VAN GOGH
PAGES 17–35

1 *Complete Letters 1958*, vol.I, p.206 (letter 136, 24 September 1880).
2 For biographical details on Van Gogh, the best study is Hulsker 1990.
3 Feilchenfeldt 1988, pp.8–9; Julius Meier-Graefe, *Die Entwicklungsgeschichte der Modernen Kunst*, Stuttgart, 1904, vol.III, p.34; Thérèse Thomas and Cécile Dulière, *Anna Boch 1848–1936*, Musée Royal de Mariemont, 2000, p.77; Thérèse Thomas, *Anna Boch: Catalogue raisonné*, Brussels, 2005, pp.31–3; and Account Book, p.25, note 33.
4 Mark Tralbaut, *De Gebroeders Van Gogh*, Zundert, 1964, pp.161–2 and 186. See also Martin Bailey, 'Van Gogh's first sale', *Apollo*, March 1996, pp.20–1.
5 Martin Bailey, 'Theo van Gogh identified', *Apollo*, June 1994, pp.44–6.
6 See letters from Claude Monet to Lucien Pissarro, 2 October 1906 and from Lucien to Julie Pissarro, 12 October 1906 and undated 1906, Ashmolean Museum, Oxford (Pissarro archive).

7 A.S. Hartrick 1939, p.46 and *Post-Impressionism*, Central School of Arts & Crafts, London, 1916, p.13. See also Martin Bailey, 'Memories of Van Gogh and Gauguin: Hartrick's reminiscences', *Van Gogh Museum Journal 2001*, pp.96–105. The version of *Basket of Apples* seen by Hartrick appears to have been lost.

8 The subject matter suggests this is *Donkey and Cart* [F1677], now at the Van Gogh Museum. But F1677 is believed to have been owned by Willemina Maria Dorothea Spies-van Linden from 1892 and then handed down her family. Either the early recorded provenance for F1677 is incorrect or Robinson owned a similar drawing which is now lost.

9 Elizabeth Pennell, *Nights*, London, 1916, pp.247–9 and Hartrick 1939, p.47. A letter from Jane Cobden Unwin (Fisher's wife) to Ellen Cobden Sickert (first wife of artist Walter Sickert) of 29 September 1893 records that the previous day Jane, 'fetched away Fisher's Van Gogh' (West Sussex County Council, Cobden papers 967), which suggests there may have been only one, rather than three paintings, although the other two could have been elsewhere.

10 Unwin still had his *Flower Still Life* in 1916 (Elizabeth Pennell, *Nights*, London, 1916, pp.247–9). F236 was acquired by Dundee collector Matthew Justice by 1924 and was the only Van Gogh flower still life known to be in Britain by this time. It also matches contemporary newspaper reviews which describe the Unwin picture as flowers in a jug, set against a black background, and painted in prominent impasto.

11 It has not been appreciated that Alfred's elder brother Leopold Sutro, a wealthy trader known as the Rubber King, also owned a Van Gogh. In 1928 he acquired *Lane in Voyer d'Argenson Park at Asnières* (fig.24).

12 Sadler note of 11 October 1922, Tate archive (no.8221.5.38).

13 The paintings Stoop returned were *Wild Roses* [probably F597 or F749] and *Apples* [probably F99 or F254]. Stoop may also possibly have bought an unidentified drawing entitled 'Montmartre ', but this has not been traced. See Van Gogh Museum archive, b53916 v/1996.

14 In 1930 Frank Stoop's niece, Anne Kessler, was to buy an important Van Gogh watercolour, *Harvest Landscape* (fig.16).

15 *Burlington*, April 1904, pp.110–1 and June 1904, p.329. The second article, signed 'F.L.', was by Dutch connoisseur Frits Lugt, who would have known about Van Gogh, so the error must have been due to the *Burlington's* staff. There are also three passing references to Van Gogh in Wynford Dewhurst, *Impressionist Painting*, London, 1904, pp.16, 55 and 105.

16 *Le Tisseur* has not been identified, but the most likely candidate is *Interior with Weaver* [F1110], then owned by Dutch collector Hidde Nijland (see also A. Ludovici, *An Artist's Life in London and Paris*, London, 1926, p.110). The works exhibited in 1909 were: *Flower Still Life*, owned by Unwin, shown in January 1909, and, possibly, *Interior of a Restaurant* [F549], owned by Sutro (recorded by De la Faille in a show entitled *Impressionist Painters*, but exhibition catalogue untraced).

17 *Manet and the Post-Impressionists*, Grafton Galleries, London, 1910. The Van Goghs recorded in the catalogue were: no.49 (?), no.50 [F765], no.52 (? possibly a repetition of entry no.49), no.61a [F781?], no.64 [F409], no.65 [F678], no.66 [F435], no.67 [F787], no.68 [F301], no.69 [F317], no.70 (?), no.71 [F779], no.72 [F457], no.73 [F753], no.74 [F630], no.75 [F677], no.76 [F504 or F505], no.123 [F409?], no.143 (?), no.144 (?) and no.145 [F454?]. The Gauguin incorrectly ascribed to Van Gogh was no.88. Uncatalogued Van Goghs probably included: F350?, F476, F486 [or F487], F522, F643?, F650, F658 and F760. See also C.J. Holmes, *Notes on the Post-Impressionist Painters*, London, 1910; London 1997, pp.187–8, notes in Van Gogh Museum file on 1910 London exhibition; and Madeleine Korn, 'Exhibitions of modern French art and their influence on collectors in Britain 1870–1918: the Davies Sisters in context', *Journal of the History of Collections*, vol.16, no.2, 2004, pp.216–7 and Korn 2001.

18 Letter from Desmond MacCarthy to Jo van Gogh-Bonger, 1 November 1910 (Van Gogh Museum archive, B5865 V/1996).

19 See *Morning Post*, 7 November 1910; *The Graphic*, 19 November 1910; *Bystander*, 23 November 1910; *Daily Sketch*, 16 November 1910; *Illustrated London*

News, 3 December 1910; and *Nineteenth Century*, February 1911.

20 Letters from Desmond MacCarthy to Jo van Gogh-Bonger, 29 November and 9 December 1910 (Van Gogh Museum archive, B58678 V/1996).

21 The *Star*, 8 November 1910.

22 Cited in London 1997, p.16. In fact the National Art Collections Fund later assisted with the purchase of only one Van Gogh, *Portrait of Alexander Reid* (cat.2), acquired by Glasgow Art Gallery in 1974 for £166,250, with £57,500 from NACF. A print was given via NACF (cat.28).

23 Lord Redesdale was responding in February 1914 to a proposal that the National Gallery should accept the loan of modern European paintings from Sir Hugh Lane. Quoted in London 1994, p.228.

24 Letter from Gustav Robinow to Jo van Gogh-Bonger, 16 January 1911 (Van Gogh Museum archive, B5872 V/1996). See also London 1994, p.35.

25 The Van Goghs exhibited were as follows: Dublin 1911 [?, F435, F787 and F677], Liverpool 1911 [F435, F787 and Unwin's *Flower Still Life*], London 1912 [F423 or F424], London 1913 (Unwin's *Flower Still Life*), Liverpool 1913 (Unwin's *Flower Still Life*), Leeds 1913 [F795], London Doré 1913 [F549, Unwin's *Flower Still Life*, and F300?, plus nine Van Gogh reproductions], Edinburgh [F649 and F661 or F662] and London 1914 [F445 and F795]. See Korn 2001 and Korn, note 17.

26 Feilchenfeldt 1988, pp.41–2.

27 The three paintings which had gone abroad were those once owned by Reid [F343 and F379] and Pissarro [F378], leaving Unwin's *Flower Still Life* and those owned by Sutro [F549], Stoop [F793] and Coleman [F795]. It is also possible that Unwin had acquired two other paintings. The drawings were those belonging to Stoop [F1242, F1497 and F1639] and Wilson [F860 and F875].

28 See M. Evans 'The Davies sisters of Llandinam and Impressionism for Wales, 1908–1923' *Journal of the History of Collections*, November 2004, pp.219–53.

29 See footnote 10 above.

30 In June 1920 Goupil exhibited *Paysanne* (no.17), an unidentified drawing or print in their show on Modern French Art. In the Goupil Salon of November 1921, no.69 was Van Gogh's *Flowerpiece* (see footnote 10).

31 These were *Soleil couchant* [F437] and *Effet de pluie* [F650].

32 Letter of 20 October 1923 (Van Gogh Museum archive, B5937 V/1996).

33 Brown 1968, pp.83–4.

34 Sales to British buyers were: no.5 [F1525, to Sadler], no.9 [F1544, to Sadler], no.10 [F1516, to Sadler], no.15 [F140, to Fleming], no.18 [F272, to Carstairs], no.21 [F436, to National Gallery], no.26 [F454, to National Gallery], no.28 [F498, to National Gallery, but returned] and no.38 [F714, to Sadler]. After the exhibition three sales were made abroad: no.13 [F320, to Paris dealer Rosenberg], no.28 [F436, to Lucerne dealer Thannhauser, after being returned by National Gallery] and no.36 [F773, to French dealer]. Data compiled from numerous sources, including Korn 2001 and Korn 2002, p.131.

35 *Vincent van Gogh*, Leicester Galleries, London, 1923, p.11.

36 The exhibition was held at Barnett House, 7 May-2 June 1924. The only known copy of the catalogue is in the Ashmolean Museum archive. The works were: no.1 [F593, Sadler], no.2 [F714, Sadler], no.3 [F793, Stoop], no.4 [F1639, Stoop], no.5 [F325 no longer attributed to Van Gogh, Murray], no.6 [F795, Coleman], no.7 [F1525, Sadler], no.8 [F1516, Sadler], no.9 [F1544, Sadler], no.10 [F1242, Stoop] and no.11 [F1497, Stoop].

37 Brown 1968, p.85.

38 See minutes of National Gallery, Millbank trustees, 21 November 1922 and 16 January 1923. It was exhibited at the Lefevre Gallery, London, October 1923, no.21 (*L'Hôpital d'Arles*).

39 Letter from H. Stanley Ede to Jo van Gogh-Bonger, undated (October 1923) (Van Gogh Museum archive, B5883 V/1996).

40 Letter from H. Stanley Ede to Jo van Gogh-Bonger, 20 October 1923 (Van Gogh Museum archive, B5941 V/1996), see also Frances Spalding, *The Tate: A History*, London, 1998, p.59.

41 London 1994, p.13.

42 See Percy Moore Turner, *The Appreciation of Painting*, London, 1921, pp.180 and 187–9.

43 Initially six paintings were considered: no.14 *A pair of Boots* [F255, now Van Gogh Museum, Amsterdam], no.17 *Parisian Novels* [F358, now Van Gogh Museum, Amsterdam], no.21 *The Postman* [F436, now Museum of Modern Art, New York], no.24 *Berceuse* [F507, now Stedelijk Museum, Amsterdam], no.28 *The Yellow Chair* [F498, now National Gallery, London] and *Landscape: Trees in Wind* (?).

44 Minutes of Courtauld Fund trustees, 18 January 1924 (Tate archive).

45 Letter from H. Stanley Ede to Ronald Alley, 30 July 1952 (Tate archive).

46 *Independent*, 18 December 1987 (this referred to a slightly earlier sale in 1987, shortly before it was offered to the Museum of Modern Art).

47 Letter from Jo van Gogh-Bonger to Charles Aitken, 24 January 1924 (Courtauld Fund, Tate archive).

48 Note by H. Stanley Ede, 26 March 1926 (Courtauld Fund, Tate archive).

49 Letter from Charles Aitken to Jo van Gogh-Bonger, 9 January 1924 (Van Gogh Museum archive, B4106 V/1962).

50 Annotated list, undated (1923) (Courtauld Fund, Tate archive).

51 Letter from Oliver Brown to V.W. van Gogh, 16 December 1926 (Van Gogh Museum archive, b4096 V/1962).

52 Sales were: no.1 [F1529, to John Rockefeller, New York], no.6 [F264, to Sandwich], no.9 [F818, to ?], no.10 [F?, to ?], no.11 [F773, to unidentified French dealer], no.12 [F771, to Beatty], no.13 [F355, to Beechman], no.18 [F631, to Thannhauser Gallery, Berlin], no.19 [F?, to?], no.21 [F1247, to Sandwich], no.25 [F1643, to Whitworth], no.28 [F1502, to private collection, England)], no.33 [F1262a, to Jonzen], no.34 [F1389, to Rienaecker], no.37 [F1500, to Courtauld] and no.38 [F1403, to Barlow]. Data compiled from numerous sources.

53 Two other works were considered for the Whitworth, but rejected: no.1 *A Corridor of the Hospital at St Rémy* [F1529] and no.31 *The Garden, 1888* [F?]. See Whitworth Art Gallery trustee minutes, 2 December 1926 and 3 February 1927. F1529 was later exhibited at the Royal Scottish Academy, Edinburgh, 1927, no.276, and sold to John Rockefeller, New York.

54 The valuation for *Sunflowers* is given in a Beatty insurance list, dated 25 August 1937 (Chester Beatty Library, Dublin).

55 Letter from Matthew Smith to Harold Smith, 15 April 1928 (Smith family collection). The publication was *The Letters of Vincent van Gogh to his Brother*, London, 2 vols, 1927.

56 Letter from Alice Kadel, 2 March 2002.

57 My thanks to the Holme family, for information. *Cottage in Brabant* could have been among works which Van Gogh sent in August 1885 to Wilhelmus Leurs, his paint supplier in The Hague, or it might have remained behind when he suddenly left Nuenen in November 1885 (some of these works were sold by Rotterdam's Oldenzeel Gallery in 1903).

58 Minutes of National Gallery, Millbank trustees, 15 May 1928.

59 Letter from Oliver Brown to V.W. van Gogh, 13 June 1930 and reply of 30 June 1930 (Van Gogh Museum archive, b6008–9 V/1996).

60 Letter from Sir Robert Witt to James Manson, 24 March 1934 (Tate archive). See also Tate trustee minutes, 20 January, 20 February and 20 March 1934. The painting had been offered by London dealer Arthur Ruck, who had been approached by Robert Lutyens (son of the architect Sir Edwin Lutyens), a friend of the Berlin owner Mrs Julius Freudenberg.

61 Tate trustee minutes, 17 November 1936. Wakefield-Mori died in *c*.1959, and most of his pictures went to the Musée de Menton. The Van Gogh painting left his collection earlier; it has been variously described as a 'vase of flowers' and 'landscape', although he may have had two works.

62 T.J. Honeyman, *Art and Audacity*, London, 1971, p.21 and Jack Webster, *From Dalì to Burrell: The Tom Honeyman story*, Edinburgh, 1997, p.84.

63 To complete the record, post-1939 exhibitions should also be recorded. There have been three retrospectives with works from the Van Gogh family collection: 1947–8 (Tate, Birmingham and Glasgow; 177 works from family collection), 1955

(Liverpool, Manchester and Newcastle; 133 works from family collection, plus three other loans) and 1968–9 (Hayward Gallery, London; 202 works from family collection, plus four other loans). There were a significant number of Van Gogh works in the following shows: *Post-Impressionism* (Royal Academy, London, 1979–80, 13 works), *The Age of Van Gogh: Dutch painting 1880–95* (Burrell Collection, Glasgow, 1990–1, 17 works) and *Van Gogh in England* (Barbican Art Gallery, London, 1992, 33 works).

64 A Van Gogh work on paper had been sold at auction earlier. The watercolour *Interior with woman spinning* (14 × 16 inches, 36 × 41 cm) had been offered at Sotheby, Wilkinson & Hodge, London on 31 May 1922. It has not been identified, but could possibly have been F68 (now Kobosa Museum, Japan) or F1139 (now Samuel Karlon, New York).

65 Five other fakes with pre-1939 Britain links should be recorded. *Landscape* [F824], a Wacker work, was at the London branch of the Knoedler Gallery in 1930 (photo in Witt Library). *The Fields* [F813], another Wacker picture, was owned by Albert and Marie Stern, whose daughter Eva Friedlaender came to Manchester (the fate of the picture is unknown); the family also brought an authentic Van Gogh [F406] to Britain. *Mountainous Landscape* [F725], no longer attributed to Van Gogh, was in an unidentified London collection after 1937 and again after 1953. *Flowers* (deattributed as no.68 in J.-B. de la Faille, *Les faux Van Gogh*, Paris, 1930, p.17 and plate xx) was owned by the Viennese poet and dramatist Hugo von Hofmannsthal, who died in 1929. It was brought to London by his wife Gerturde in the 1930s, when she fled the Nazis (the painting is still with their descendants). *The Tramp* [F221a], was owned by Boise.

66 The following works were deaccessioned by German museums in the 1930s: *Self-portrait* [F476, from Neue Staatsgalerie, Munich], *The Lovers* [F485, from Nationalgalerie, Berlin], *Garden of Daubigny* [F776, from Nationalgalerie, Berlin], *The Harvest* [F268, not now attributed to Van Gogh, from Nationalgalerie, Berlin], *Portrait of Dr Gachet* [F753, from Städtisches Galerie, Frankfurt] and *Portrait of Armand Roulin* [F493, from Wallraf-Richartz Museum, Cologne]. See also Feilchenfeldt 1988, p.42.

67 It should be stressed that the figure of thirty works for those that had left the country is approximate. The figures cited from our study include seven works which are no longer considered to be by Van Gogh.

68 More recent comparative data is not available. Collectors today are much more reluctant to be named, making it increasingly difficult to locate works in private hands.

69 Insurance valuation for the 1947–8 Van Gogh exhibition (Tate archive).

70 Letter from D.H. Nicholls (Birkbeck Montagu) to Michael Wilson (National Gallery), 12 October 1983 (National Gallery archive).

71 To summarise the acquisitions: The etched *Portrait of Dr Gachet* (cat.16) was donated to the British Museum in July 1923. In October 1923 the Millbank gallery bought the first painting, *A Wheatfield, with Cypresses* (cat.17), and this was quickly followed in the December 1923 by *Van Gogh's Chair* (fig.10) and in January 1923 by *Sunflowers* (fig.1), and then *Long Grass with Butterflies* (cat.22) in 1926. The Whitworth Art Gallery acquired two works on paper in 1927, *Fortifications of Paris with Houses* (cat.23) and *Hayricks* (cat.24). The lithograph *Gardener by an Apple Tree* (cat.28) was donated to the British Museum in 1929. The Stoop bequest followed in 1933, with the painting *Farms near Auvers* (cat.6) and three drawings, *Thatched Roofs* (cat.7), *A Corner of the Garden at St Paul's Hospital, St-Rémy* (cat.8) and *The Oise at Auvers* (cat.9). The National Gallery of Scotland bought *Olive Trees* (cat.19) in 1934.

72 The price for *Peasant Woman Digging* is our informed estimate. The auction estimate for *Autumn Landscape* was £70–80,000. It was withdrawn shortly before the Sotheby's, London sale on 1 July 1980 (lot 34) and then offered to the Fitzwilliam Museum for what was probably a slightly lower sum.

1 See Korn 2002, pp.120–37.

2 A.S. Hartrick 1939, p.50.

3 Hartrick 1939, pp.50–1.

4 For a discussion of Reid's relationship with the Van Gogh brothers, see Fowle 2000, pp.90–9.

5 Letter from Robert Macaulay Stevenson to D.S. MacColl, Glasgow University Library, Special Collections, ref. S431.

6 S. Cursiter, *Looking Back: A Book of Reminiscences*, privately published Edinburgh, 1974, p.44

7 Possibly F662 / JH 1804, *Les Peiroulets Ravine*, October 1889 (Museum of Fine Arts, Boston).

8 For Van Gogh's critical reception in Britain, see London 1997, pp.35–40.

9 Ion, 'Some Phases of Modern Art III: Post Impressionism', *The Scots Pictorial*, 6 September 1913, p.573.

10 Press cutting entitled 'Revolt in Art' from *The Herald*, 17 November 1913.

11 Sadler's notes on Herbert Coleman's collection at Greystoke, West Didsbury, 11 October 1922, Tate archive, ref. 8221.5.38.

12 The picture, previously with Bernheim-Jeune, was bought by McInnes as 'Montmartre' on 6 July 1921, stock no.3117. See Alex Reid's Glasgow stockbook, Lefevre Fine Art, London.

13 T.J. Honeyman, *Art and Audacity*, Glasgow, 1971, p.125.

14 See Frances Fowle, 'Three Scottish Colourists: Early patronage of Peploe, Hunter and Cadell', *Apollo*, October 2000, pp.26–33.

15 This was catalogued as *Les Lauriers Roses* (no.20).

16 This was catalogued as *Bord du Rhone à Arles* (no.19).

17 Her first purchase was the *Bridge at Trinquetaille*, which she bought for £1,550 in March 1924. The following March she acquired the *Still Life* (previously in Michael Sadler's collection) for £2,500, Alex Reid stock book, Lefevre Fine Art, London.

18 A three day auction was held around 10 December 1931, conducted by Curtis & Henson of Mount Street. See Korn 2002, p.135, n.122.

19 See *Illustrated Catalogue of a Loan Collection of Paintings, Water Colours & Engravings in the Victoria Art Galleries, Dundee on the Occasion of the British Association Meeting*, 1912. Boyd also owned pictures by De Bock, Van Mastenbroek, Bauer, Wingate and Edwin Alexander.

20 Letter dated 5 April 1953 from A.J. McNeill Reid to Douglas Cooper, Douglas Cooper Papers, Getty Research Institute, Box 14, folder 5.

21 Letter dated 2 January 2002 from Professor David Walker to Helen Smailes. I am grateful to Helen Smailes for passing this information on to me.

22 Letter dated 5 April 1953 from A.J. McNeill Reid to Douglas Cooper, Douglas Cooper Papers Getty Research Institute, Box 14, folder 5. McNeill Reid comments specifically on 'a couple of Van Goghs bought through Justice'.

23 Letter in Honeyman archive, Acc.9787, ref. 2/25/10/27, National Library of Scotland.

24 Letter to Douglas Cooper, see note 20.

25 A later still life, dated to August 1888, *Still Life: Vase with Zinnias* [F592, Basil P. and Elise Goulandris Collection, Lausanne], was acquired in 1930 by the Glasgow collector D.W.T. Cargill for no less than £5,000.

26 Lecture given by A.J. McNeill Reid to the Art Society in Dundee (date unknown), recently donated to the Scottish National Gallery of Modern Art archive by Professor Walker. I am grateful to Helen Smailes for passing this on to me.

27 *The Scotsman*, 18 November 1922.

28 *The Scotsman*, 24 October 1924, p.6.

29 The picture was catalogued as 'Canots amarrés' (no.122).

30 He also owned works by Seurat and Dunoyer de Segonzac.

31 The collection was gradually dispersed by his widow, but some works were left to the Dundee School of Dentistry.

32 This was F271.

33 Letter from Stanley Cursiter to Dr A. Martin de Wild, 31 May 1937, National Archives of Scotland, ref. NG/6/7/24.

34 Letter from De Wild to Cursiter, 3 February 1937, National Archives of Scotland, ref. NG/6/7/24.

35 Letter from De Wild to Cursiter, 19 February 1937, National Archives of Scotland, ref. 6/7/24.

36 *The Scotsman*, 21 February 1948.

1 Martin Bailey, 'Vincent van Gogh's portraits of Alexander Reid', *Burlington*, February 2006, pp.116–19.

2 Johannes van der Wolk, *The Seven Sketchbooks of Vincent van Gogh*, New York, 1987, pp.201–2 and 279–80.

3 Hartrick 1939, pp.50–1.

4 D.S. MacColl, 'Vincent van Gogh', *Artwork*, summer 1930, pp.136 and 141. A similar story appears in the notes of A.J. McNeill Reid (National Library of Scotland). I would like to acknowledge the kind assistance of Frances Fowle in the three entries relating to Reid (cats.1–3).

5 *Félix Vallotton*, Yale University Art Gallery, 1992, p.287.

6 *Complete Letters 1958*, vol.III, pp.113–4 and 118 (letters 569 and 571 of 7 January and 17 January 1889).

7 *Le Japon Artistique*, May 1888 and *Complete Letters*, vol.III, pp.52–3 (letter 542 of 24 September 1888).

8 *Complete Letters 1958*, vol.III, p.469 (letter w21).

9 *Complete Letters 1958*, vol.III, p.296 (letter 650 of c.11 July 1890).

10 *Complete Letters 1958*, vol.III, p.404 (letter R45 of c.24–29 March 1884)

11 *Complete Letters 1958*, vol.III, p.184 (letter 595).

12 *Complete Letters 1958*, vol.I, pp.239 and 244 (letter 150).

13 *Vincent and Theo van Gogh*, Hokkaido Museum of Modern Art, 2002, p.271.

14 *Complete Letters 1958*, vol.III, p.195 (letter 602).

15 F753, Private Collection, and F754, Musée d'Orsay, Paris.

16 *Complete Letters 1958*, vol.III, p.185 (letter 596).

17 *Complete Letters 1958*, vol.III, pp.15 (letter 524), 22 (letter 529), 46 (letter 540) and p.47 (letter 541).

18 In the gallery's history (*Alex Reid & Lefevre 1926–1976*, London, 1976, p.18) it is said that 'for some reason he [Sadler] regretted his purchase at once and returned the picture with a week.' However, Sadler's name is given as the owner for exhibitions in Oxford (May 1924) and Paris (January 1925), so he presumably kept the picture until then.

19 *Complete Letters 1958*, vol.III, pp.220 (letter 608).

20 Brown 1968, p.85.

21 Letter from Oliver Brown to Colin Thompson, 24 April 1961 (National Gallery of Scotland records).

22 *Complete Letters*, vol.III, pp.267 (letter 631) and 264 (letter 630).

23 This can be seen by comparing the work with a photograph published in *Report to the Governors for 1926*, Whitworth Art Gallery, Manchester, 1927, p.13.

24 Bremen 2002, pp.104–5 and Otterlo 2003, p.379.

25 *Complete Letters 1958*, vol.III, p.149 (letter 583b).

26 *Art for the People*, British Institute of Adult Education, London 1935, p.1.

27 In 1939 *Art for the People* led to the establishment of the Council for the Encouragement of Music and the Arts, which in 1946 became the Arts Council.

28 The drawing has traditionally been known as the 'Tile Factory'. Archival research has shown that in the 1880s there was only one tile factory in or around Arles, located on the route de Tarascon (Carnet des contributions des patentes, P1/1637, Archives Départementales, Marseille – my thanks to Arlette Playoust).

29 *Complete Letters 1958*, vol.II, pp.54 and 78 (letters 291 and 300).

30 The only possible known work which could have been entitled *Still Life with Irises* is F680 (now Metropolitan Museum of Art, New York), which was exhibited in 1928 at the Cassirer Gallery in Berlin, on loan from Giulietta von Mendelssohn-Bartholdy, Berlin. Even if, for the sake of argument, F680 had been acquired by Valerie Alport in the period between the closure of the exhibition in March 1928 and Spender's arrival in July 1929, it demonstrates that Mrs Alport had the inclination and resources to buy works by Van Gogh at that time. But it is much more likely that Spender had disguised the title of the Van Gogh, as he did with many names in the book. It has also been established that Mrs Alport certainly owned *Restaurant de la Sirène at Asnières* [F312] in 1945, when it was loaned to an exhibition in London. Although the 1939 and 1970 De la Faille catalogues record Mrs Paret as the owner in 1928, this appears to be an error (she was the owner of the previous painting in the catalogue, another Asnières scene [F311, now Virginia Museum of Fine Arts, Richmond], and this may well have led to the confusion.) To conclude, it is therefore certain that Valerie Alport owned *Restaurant de la Sirène at Asnières* by 1945 and Spender's account provides very strong evidence that she had acquired it by 1929.

31 *Complete Letters 1958*, vol.II, pp.581 and 583 (letters 496 and 497).

INDEX OF COLLECTORS

Detail from cat.19

PHOTOGRAPHIC CREDITS